Understanding Transparent Watercolor

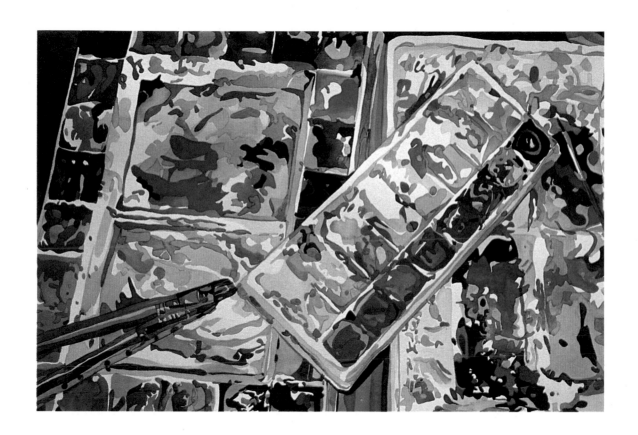

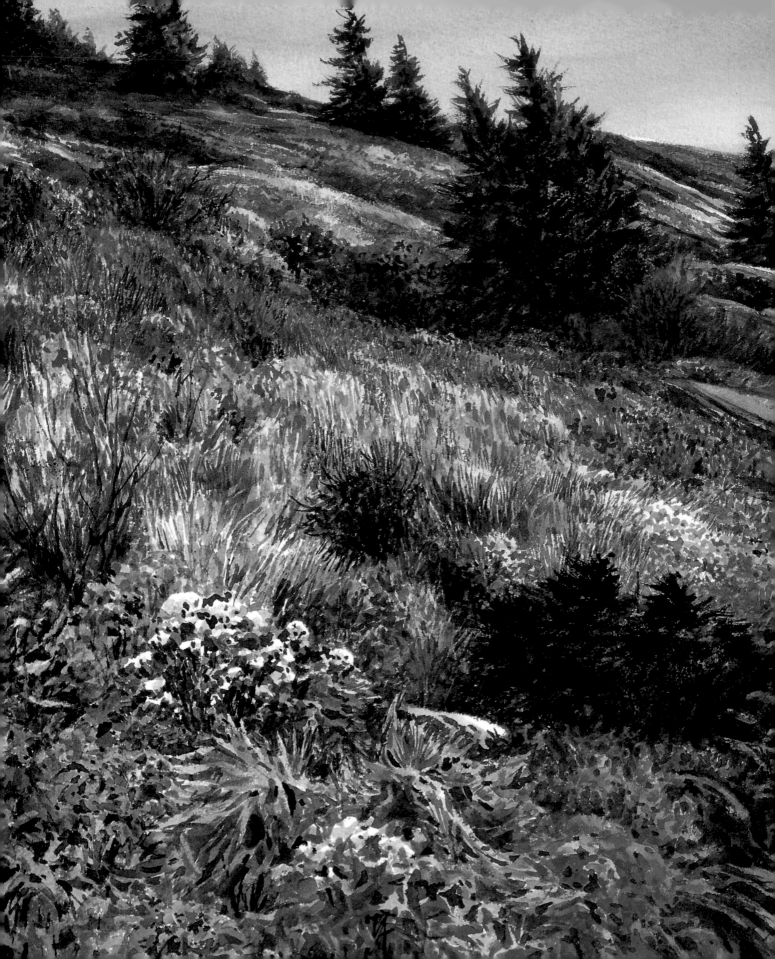

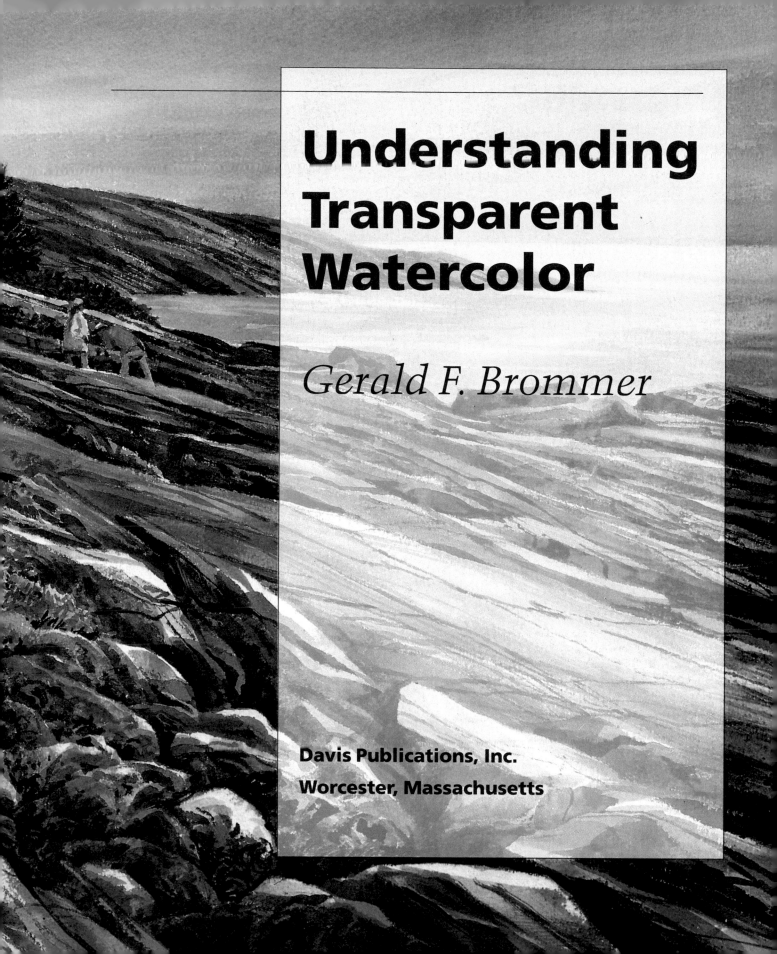

Understanding Transparent Watercolor

Gerald F. Brommer

Davis Publications, Inc.

Worcester, Massachusetts

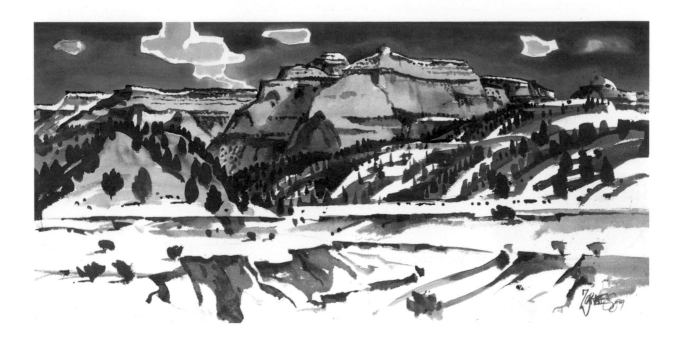

To Georgia

Thank You
. . . to all my students, from 7 to 70 years of age,
who have constantly taught me about art, life and
learning . . . to the many contemporary American
artists, who generously furnished examples of
their work for our enlightenment and joy . . . to the
art teachers, who have shared ideas and student
work for this and other books . . . to Davis
Publications, Inc. and their staff, for their encour-
agement and help, but especially for their massive
contribution to art in American schools.

COVER: Carolyn Lord, *Harry's Bench*.
22 x 30" (56 x 76 cm).
HALF-TITLE PAGE: Sandra Beebe, *Ruth's
Palette*. 22 x 30" (56 x 76 cm).
TITLE PAGE: Gerald F. Brommer, *Picnic at
Prout's Neck*. 22 x 30" (56 x 76 cm).
ABOVE: Milford Zornes, *Carmel Cliffs, Utah*.
24 x 48" (61 x 122 cm).

Copyright 1993
Davis Publications, Inc.
Worcester, Massachusetts U.S.A.

Editor: Martha Siegel

Design: Susan Marsh

Printed in Korea

Library of Congress Catalog Card Number:
92-072328

ISBN 87192-245-2

10 9 8 7 6 5 4 3 2

CONTENTS

Painted after direct observation, this man and his dog are captured in both attitude and spirit. Serge Hollerbach, *Frenchman with Dachshund.* 12 x 9" (30 x 23 cm).

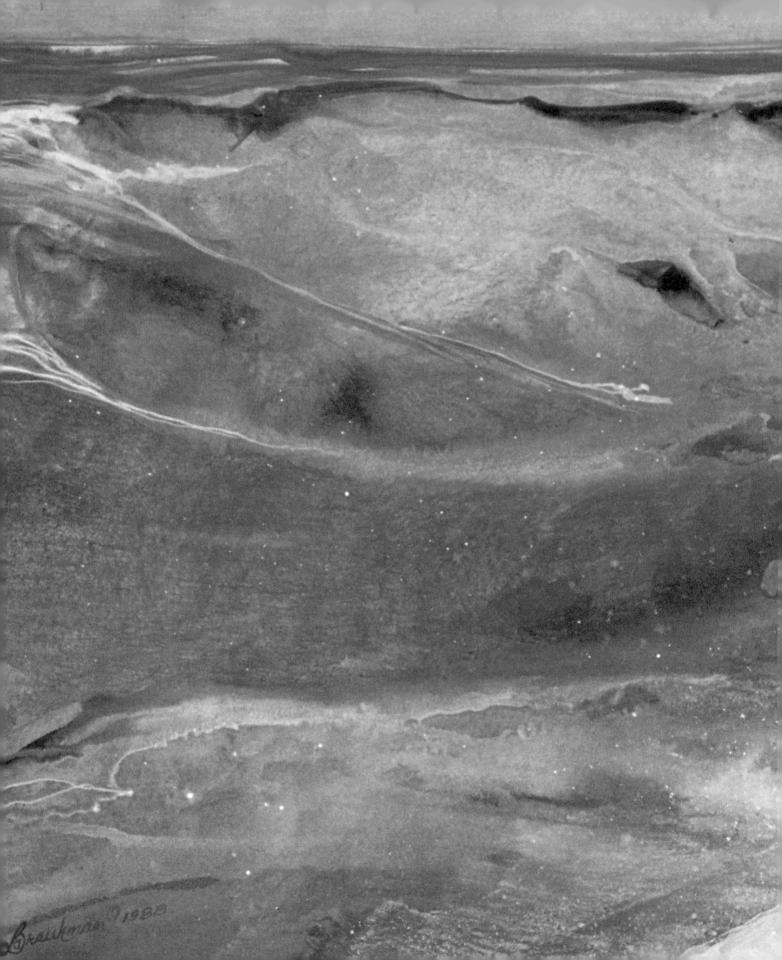

Braukman 1988

Understanding Transparent Watercolor

Watercolor is a dynamic medium. It runs, drips, puddles and spatters. There is nothing like creating a watercolor wash — the pure, liquid movement, the directness of brush applying color, the sheer beauty of a transparent overglaze, of light radiating through color.

Transparent watercolor can seem awesome in its complexity. While it is easy to apply to paper, it is difficult to control. It may look wet or dry, thin or thick. It has been called the medium of the masters, yet it is offered to kindergarten classes for daily use. It is both fun and work, both easy and difficult.

How should you approach this contradictory medium? Which of the many directions should you take? What is the best way to start? There are no single answers, no one "best way" to paint a watercolor. Throughout this book you'll see how other artists think and work, and you'll be encouraged to try many of their approaches. Gradually, as you realize your strengths, weaknesses and preferences, you'll decide for yourself which approach feels most comfortable to you.

Learning new techniques demands time and practice, and raises more questions. How much water should you use? How should you mix colors? How wet should the paper be, if at all? Which brushes are best? Can you make corrections? The wide selection of techniques and examples in this book will help answer some of these questions. But technique is only part of the answer. You must learn to look carefully and *see* what you are looking at. You must learn to see color, texture, shape, size relationships and mood. Learn to see and think with a watercolor vocabulary: color washes, blending edges, brushstrokes. Explore and experiment: that is how you'll learn.

The first chapters of this book will help you understand the language of watercolor painting and a little of its history. This important initial contact with the medium will provide you with the tools and skills to explore transparent watercolor.

What is Transparent Watercolor?

Simply stated, transparent watercolor is a painting medium. Whether in tube or pan form, watercolor is a blend of pigment (powdered color), gum arabic (a water-soluble adhesive that bonds the pigment to paper), and enough water to make the mixture workable. This simple medium, however, has always generated a surprising amount of controversy. It is praised ecstatically by its adherents, and discussed with reverence by some painters and collectors. Yet others — artists, critics, museum curators — consider it simply colored drawing, and not a serious medium. Watercolor, in one form or another, has been used longer than any other medium, and yet is considered a relative newcomer on the art scene.

Watercolor painters themselves disagree about how the medium should be used. Purists wish to preserve watercolor's integrity by not adulterating it with any other medium. They say they work in *aquarelle*. Experimenters wish to explore any and all possible combinations of watermedia to express themselves more fully. They call their work *watermedia* or *mixed media.*

The term watercolor often makes people think of small paintings of country scenes. While early, traditional watercolor subjects *were* small landscapes painted on location, today's artists work with innumerable subjects in a broad range of styles and sizes. Today's watercolors are as varied as the artists who work in the medium, as you will see when you glance through this book.

Watercolor is a basic medium — simple to use, easy to clean up, relatively inexpensive, compatible with a variety of papers. Yet it is also an important medium. There are probably more watercolor artists than artists in any other single medium. Watercolor exhibitions abound; watercolor societies with high numbers of dedicated members can be found in many communities. Scores of watercolor books are published every year, and collectors are continually adding watercolors to their collections. Many oil painters now work in watermedia to expand their means of communication. While some artists still consider watercolor a poor cousin to oil, there is a continually growing interest in serious watercolor painting.

Characteristics of the Medium

"But what's so great about watercolor?" you might ask. Artists who love and use the medium usually mention its transparency, luminosity, speed and spontaneity. Let's look at how those characteristics work in a watercolor painting.

To create transparency, color is picked up from the paint supply with a wet brush and added to a

Previous page:
Mary Alice Braukman, *Waves and Rocks* (detail).

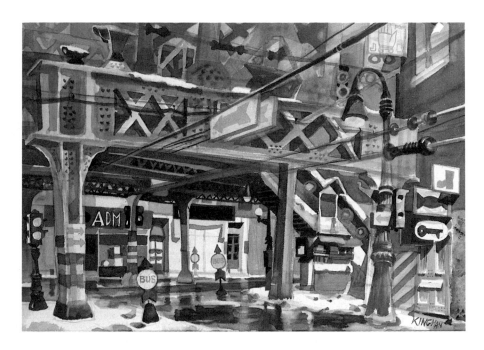

Dong Kingman, *The El and Snow*, 1949.
Watercolor, 21 x 29⅜ (53 x 75 cm).
Collection of The Whitney Museum of
American Art. Purchase.

puddle of water to make a pool of liquid color. Basically, this is tinted water, and is light or dark, depending on the amount of color added. When you brush this color onto white paper, light passes through the transparent color layer, much like light passing through stained glass. Light reflecting off the white of the paper makes the medium work. If the paper ground were black or colored instead of white, there would be no transparency or clear, bright color. If white is required in a watercolor painting — a white wall, perhaps, or a patch of snow — parts of the white paper are left unpainted. Watercolor purists never use white paint, as they feel it interferes with the natural transparency of the medium. Other artists, however, use white if they feel it is needed.

Light passing through color creates a luminous effect, and many watercolors seem to glow with reflected light. It is easy to see that the more layers of color there are, or the more thickly the pigment is applied, the less luminosity is evident.

When the water evaporates, the applied color wash is dry. As long as it is wet or even damp, the color can be manipulated, but this requires much experimentation and great care. Later suggested

exercises will help you understand this process. Because the drying time is so critical, some watercolor techniques require each step to dry completely before proceeding. Working this way allows artists to produce detailed surfaces. Other techniques take advantage of the wetness of the wash and call for speed and deftness to make it all work. Artists who work this way generally plan their paintings ahead of time so that the painting process can be spontaneous and rapid. Their brushwork is usually free and loose.

The characteristics that make watercolor so attractive to some artists also make it a challenging medium. Speed and spontaneity can be exhilarating — if you know exactly what you want to paint and how to go about it. Being unable to paint over unwanted surfaces or make changes can be frustrating if you're not accustomed to working that way. Many artists give up on watercolor before they've even begun to use the medium effectively. So as you start to work with watercolor, remember: All these difficulties can be overcome with patience and practice. The transparency and fluidity of the medium become more and more compelling as you gain experience.

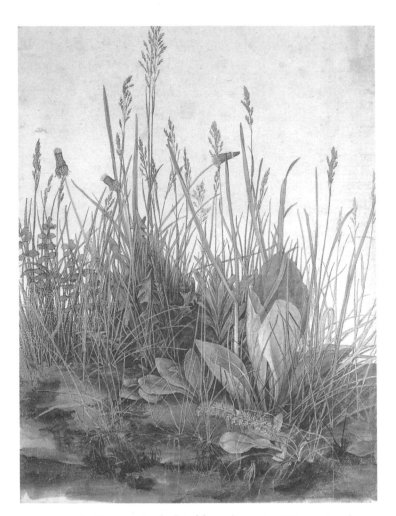

In Germany in the late fifteenth century, Dürer painted many watercolors for their own sake — not as studies for oil paintings — and was the first Renaissance artist to consider his watercolors finished art. Albrecht Dürer, *The Great Piece of Turf*, 1503. Watercolor, 16 x 12½" (41 x 32 cm). Albertina Museum, Vienna.

Baroque artists of the seventeenth century such as Tiepolo, often used ink washes to make quick studies which have the spontaneity of watercolor painting. Colors were often limited to browns and grays, but emphasis was on creating dimension with light and dark values. Giovanni Domenico Tiepolo, *St. Jerome in the Desert Listening to Angels*. Pen and brown ink, brown wash, heightened with white, over black chalk on buff paper, 16¾ x 10⅞" (43 x 28 cm). National Gallery of Art, Washington, D. C. Promised Gift of the Armand Hammer Foundation.

The "Look" of Watercolor

Generally speaking, the look of watercolor can be described as either wet or dry. The wet look is juicy and fluid, with soft edges and colors running into each other. The dry look has hard, crisp edges; the color is applied with controlled washes on dry paper. Both are painted with the same pigments and brushes, but the amount of water used with the color and the wetness or dryness of the paper influence the finished product. Often these methods are combined. Initially, color can be applied on a wet surface to produce soft edges, but later, when the surface is dry, crisp edges can be added to provide contrast to the soft shapes.

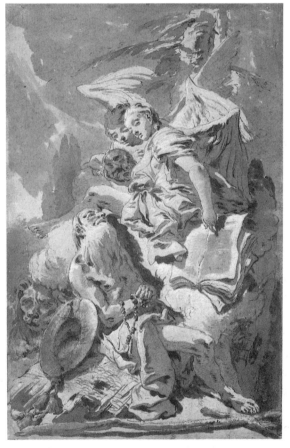

Painting: How, What, Why?

Beginning artists must learn how to use their medium. Your early work with watercolor will help you understand how it can be used, how to mix colors, control edges, deepen values, run washes — in general, how to use the techniques of effective watercolor painting. Such background in handling the medium is essential. Technique is the "how" part of the painting experience. It takes many years and much practice to perfect essential techniques.

In order to make a painting, you must paint something. That something is the subject matter of your work. Trees, still lifes, apples, sunsets, mountains and people are examples of subject matter. Everything around you — everything you can see or feel — is possible subject matter. But so are ideas and thoughts. The paint itself, or color, texture or light can also be subject matter. Subject matter can be nonobjective, abstract or representational; it can be line, shape or idea. Subject matter is the "what" part of the painting experience.

Painting is not simply the process of placing subject matter on paper with superb technical ability. Although subject matter and skill are important to effective painting, there is another vital element in the painting process: content. Content in painting refers to the awareness and sensitivity of the artist and his or her ability to express ideas through painting. There are thousands of contemporary painters who can handle the watercolor medium with skill and flair, but who simply repeat formulas and never produce works of great feeling or depth. When you become too conscious of the medium and its techniques, it is difficult to paint with ease. When you become absorbed in your subject and what you wish to say about it, the reason for making the painting begins to dominate technique and subject matter.

The content of any painting is the answer to the questions "Why did you paint it that way?" and "What did you want to say?" So content is the

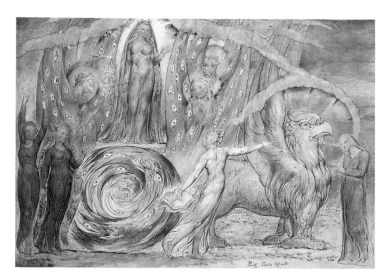

William Blake's watercolors are often mystical in feeling and based on literary themes, such as this one from Dante's *Divine Comedy*. William Blake, *Beatrice Addressing Dante from the Car*, 1827. Watercolor, 14⅝ x 20¾" (37 x 53 cm). The Tate Gallery, London.

"why" of the painting experience. The ability to answer such questions visually comes after many years of exploration. Content cannot be taught, because its source is inside you. But you should know what it is and try to make it part of your approach to painting.

The Importance of Concept

Paintings should begin with a concept, a motivating idea that excites you into painting. Look at a landscape (or any other subject) and study it for a while. Allow a painting concept to develop. What parts of the scene will you use? How will you paint it? What do you want to say about it? What will you emphasize? How can you best interpret it? Why are you painting it? Your answers will shape your concept.

For example, you might decide: *For this landscape I will use a high horizon, muted colors, busy foreground, light values and a combination of wet-in-wet and drybrush techniques. The reason is to present a foggy-bright sensation of*

This artist chose a high horizon for this landscape painting. A golden, glowing sun creates a sense of summer heat. Charles Burchfield, *Indian Summer*, 1941. Watercolor, 24 x 36" (61 x 91 cm). Wichita Art Museum, Wichita, Kansas. The John W. and Mildred L. Graves Collection. Photo by Henry Nelson.

cool light and a sense of isolation from the viewer. While you might develop a concept like this before starting the painting, your final concept might be somewhat different. Concepts, like paintings, can change as you go along! Your concepts gradually become part of your painting style, as you get used to developing underlying plans for your paintings.

Personal Style

Developing your own way of seeing and painting is a process that starts early in life. Everything you see can influence your style: the books you read, the vacations you take, the movies you see, the paintings you study, the teachers you listen to — all can have a bearing on how your work will look.

As you develop a painting vocabulary, your style of work will probably change. You try this and experiment with that. You switch media. You look and draw, discuss and paint. And your way of painting — what you want to say and how you say it — changes as you do.

Such change is a sign of growth and new awareness, and can result in different "periods" in an artist's life. Jean Dubuffet, a restlessly prolific French artist, claimed to have gone through more than twenty-three recognizable periods. Most artists search for and experiment with new stylistic directions throughout their lives. Some keep examples of their work from every year so they can be aware of their changing styles. An early one-man show of the work of American artist Max Weber was described by a critic as looking like a forty-five person show. At that stage the artist was searching for identity, trying to find a style with which he was comfortable.

The way to become aware of your own style is to try to work in many different ways. Then step back and study your work. How is it different from the work of others? What are its strengths? What unique strokes, colors, edges, shapes or techniques are evident? What do you like about it? What do you dislike? How well have you expressed your ideas? These questions help identify the emerging aspects of your own style.

Another way to become aware of style is to study the work of others. Ask the same questions you asked about your own work. Look through this book carefully. Can you recognize the work of one

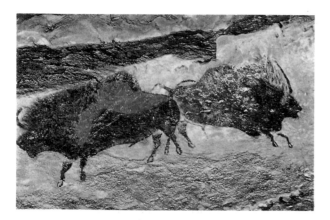

The world's earliest artists used earth colors and water to brush, daub and spray colors on cave walls. Their sophisticated stylization of animals indicates a wonderful sense of observation and design. Cave painting, Lascaux, France.

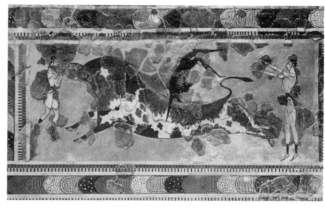

The Minoan sport of jumping over charging bulls is graphically described in this early fresco. *Bull Dance*, from the Palace at Knossos. Fresco, c. 1500 BC. Archaeological Museum, Heraklion, Crete.

particular artist without looking at a caption? If so, you are beginning to understand the components of style.

A Short History

Earliest Beginnings

The very first watercolor paintings were applied to cave walls in what is now Southwestern Europe and in Africa. At Lascaux (France), Altamira (Spain) and Mtoko (Zimbabwe), the earliest known artists dissolved earth colors and mineral oxides in water and painted animal shapes on limestone walls with their fingers, sticks and crude brushes of feathers or hair.

Artists from ancient cultures that lacked paper often painted images on walls. Egyptian artists decorated tomb walls with intricate designs in water-based pigments. When the Egyptians learned to process papyrus to make a paper-like surface, artists immediately began to make the first watercolors on paper.

Classical artists of Greece and Rome invented fresco. By adding water-soluble colors to a freshly plastered surface, artists could see their colors sucked permanently into the surface. Minoan artists were among the first to paint these watercolor walls of fresco, but succeeding Greek and Roman artists refined the process and created wonderful walls that survive to this day.

While European artists went on from watercolor to explore many media, only in the Far East was pure watercolor used continuously as a means of visual expression. At an early age, Chinese children were given pointed brushes with which to practice calligraphic writing. Landscape and historical events, painted meticulously on silk and paper, were a natural extension of their writing skills.

Traditional Versus Contemporary

The modern development of watercolor began in the nineteenth century, when English painters interpreted their diverse landscape on paper with water-soluble color. They sometimes added an opaque white (called body color) to their transparent colors so that they could place lighter values over darker hues. Their work was often loose and free (as Joseph Mallord William Turner's was), but could also be tight and carefully composed (as was the work of John Sell Cotman).

For many years watercolor was considered a sketching medium, and was used to record spontaneous responses to light and color. Such quick work requires instantaneous decisions and the ability to suggest more than is actually recorded. Nineteenth century artist J.M.W. Turner produced thousands of such little glimpses of his environment. J.M.W. Turner, *An Artist Painting in a Room with a Large Fanlight*, 1828. Watercolor, 5¼ x 7½" (13 x 19 cm). The Tate Gallery, London.

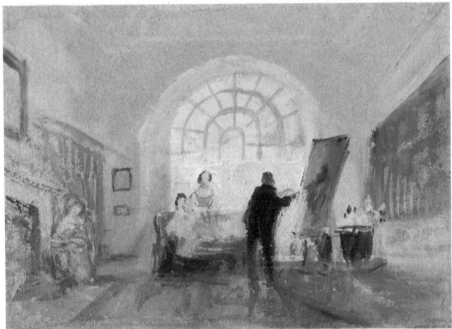

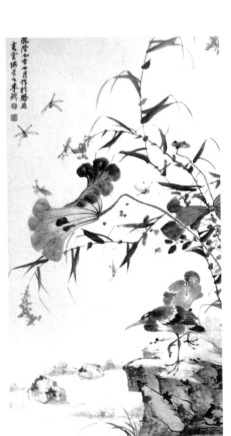

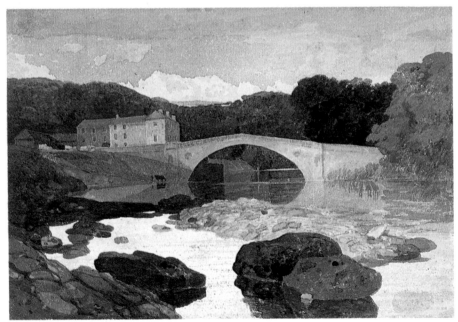

The deft brush strokes of a Chinese watercolorist create extreme simplicity from a complicated visual world. Li Shan, *The Charm of Lotus Pond*, c. 1750. Watercolor, 50" (127 cm) high. National Museum, Beijing.

The English artist, Cotman, painted on location and learned to eliminate extraneous detail and build up planes of large, simple shapes. John Sell Cotman, *Greta Bridge*, 1805. Watercolor. Reproduced by courtesy of the Trustees of the British Museum.

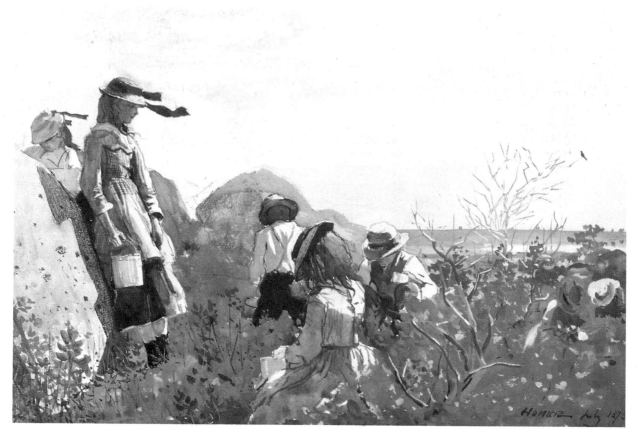

The look of traditional American watercolor was established by Winslow Homer. His paintings were often dominated by middle values with strong dark and light contrasts. The whites are unpainted paper and the darks are intensified by overlapping layers of color. Winslow Homer, *The Berry Pickers*, 1873. Watercolor, 9¼ x 13⅛" (23 x 33 cm). Collection of Mr. and Mrs. Paul Mellon, Upperville, Virginia.

Americans Winslow Homer and John Singer Sargent developed their watercolor techniques in the late nineteenth and early twentieth centuries, and established a traditional look in the medium that would become a standard for many years — and to some extent it remains a standard even today. Their loosely-applied transparent washes are spontaneous, yet controlled. The whites are brilliant paper left unpainted, and darks are achieved by applying overlays of color until the right value contrasts are attained. Their subjects are generally landscapes, still lifes and portraits, painted in a representational style.

Contemporary watercolorists, freed of conventional restrictions and no longer inhibited by the tastes of a few patrons, are exploring in many new directions. The look of today's watercolors is extremely diverse — from superrealism to pure abstraction, from traditional treatments of traditional subjects to experimental explosions on paper. Andrew Wyeth, one of the traditionalists, interprets people and landscapes in spare, precisely detailed paintings. Robert E. Wood's figure and landscape paintings virtually dance with visual excitement. Fran and Hal Larsen interpret the Southwest and its native cultures in a variety of styles. Maxine Masterfield explores experimental techniques. These and hundreds of other artists are producing powerful images in watercolor today, providing stimulation to every watercolor painter.

John Marin painted the coast of Maine and the city of New York with vibrant emotion. John Marin, *Sand Dunes and Sea, Small Point, Maine,* 1917. Watercolor and black chalk, 16¼ x 18½" (41 x 47 cm). Smith College Museum of Art, Northampton, Massachusetts. Gift of the estate of Mary Virginia Carey, 1972.

Grosz used watercolor to express surrealist fantasies and make satirical comments on events of his day. George Grosz, *The City (Man and Woman),* 1930-31. Watercolor, 25½ x 18⅛" (65 x 46 cm). Los Angeles County Art Museum, California. Mr. and Mrs. William Preston Harrison Collection.

Charles Sheeler, *Horses,* 1946. Watercolor, 6¼ x 8⅓" (16 x 19 cm). Mount Holyoke College Art Museum, South Hadley, Massachusetts. Gift of Mr. and Mrs. Roy R. Neuberger, 1955.

Maurice Prendergast uses layers of subject
matter to organize his paintings. Color
washes with light spaces left between them
are characteristic of his work. Maurice
Prendergast, *Festival Day*, 1898-99.
Watercolor over graphite, 12⅔ x 20"
(32 x 51 cm). Mount Holyoke College Art
Museum, South Hadley, Massachusetts.
Gertrude Jewett Hunt Fund in memory of
Louise R. Jewett, 1951.

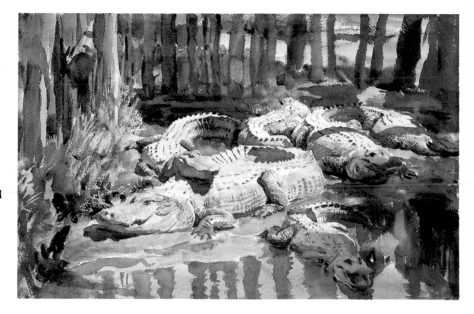

Sargent was known in Europe and America
watercolors had a profound effect on
American artists. Here, he allows white
paper to create the lightest value of reflected
sunlight on the alligators' bodies. Cool
shadows produce a sense of form, while
warm and cool colors effectively describe
the tropical day. John Singer Sargent,
Muddy Alligators, 1917. Watercolor,
13⁹⁄₁₆ x 20⅞" (34 x 53 cm). Worcester Art
Museum, Massachusetts.

CHAPTER TWO

Basic Materials and Tools

Basic watercolor equipment can be basic indeed: brushes, paint and paper. Of course, you must add a water container, a mixing pan, pencils, and sponges. But the basics are easily available and can be relatively inexpensive, unless you feel you must use only materials of the highest quality. Prices range from cheap to very expensive, so let your budget determine the quality of your tools and materials.

Paints

Artists must choose paints that suit their subjects and work. This selection process can take months of experimentation; the artist's palette (as the selection of colors is called) becomes a very personal thing, and changes often.

When selecting watercolor paints, you run immediately into the matter of dollars and cents. The best paints usually come in tubes. They are brilliant, more permanent, and made from better pigments than cheaper paints. They come in a fantastic array of hues and in several quality grades, and they are, of course, quite expensive.

Most of us learned to paint with watercolors that come in pans. These watercolor sets vary in pan size (full or half pan) and also in the number of colors available (between 8 and 180!). Refills and alternate colors are available for them. Pan colors are drier than those in tubes and require vigorous

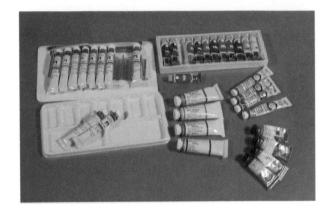

Most advanced artists use moist, tube watercolors. Less expensive grades of tube colors are also available.

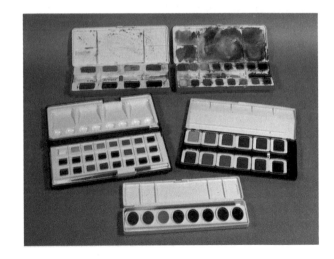

Watercolors in pan sets vary in quality, number of colors, pan size and cost. The set at top left contains eight full pans; at top right sixteen half pans. The set with the smallest inserts and most colors is a professional quality set.

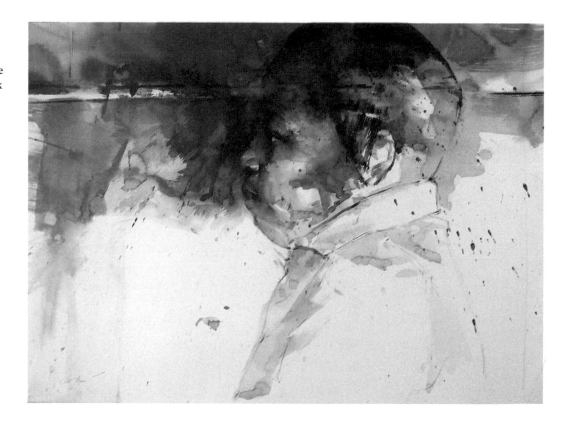

In addition to watercolor, pencils, pens, brushes, and pieces of cardboard were used to create this sensitive portrait painting. The work has a unified feeling, with carefully designed passage from foreground to background. Alex Powers, *Connie III*. Watercolor and ink, 20 x 25" (51 x 64 cm).

brushwork to pick up color. They will soften, however, if you put a few drops of water on them before you begin to paint.

Eight-color watercolor sets can produce an almost infinite variety of hues, since they include the primary colors (red, blue and yellow) and the secondary hues (orange, green and violet), with brown and black added. So don't feel you must buy a great deal of expensive paint right from the start. Most artists use a relatively small number of colors in their palettes, even though many dozens are available. (For help in mixing colors, see Chapter 4.)

Brushes

Brushes are made in almost endless variety, and no single brush is best for everyone. Experiment with several before selecting the ones that will suit you best. A few good brushes are generally more useful than many mediocre ones.

Brushes are usually numbered by size. The larger the brush, the higher the number. Traditional watercolor brushes are made of animal hair (sable, ox or squirrel) but most companies now produce several grades of excellent synthetic fiber brushes. Kolinsky sable hair brushes are very expensive and are considered best, but the less costly synthetic brushes are equally useful in most cases. Good brushes should hold lots of water, come to fine points when wet, and remain resilient while working. They are made in either round or flat shapes.

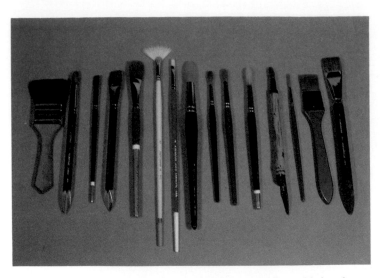

A selection of watercolor brushes, including sable brushes, inexpensive synthetics and bristle brushes.

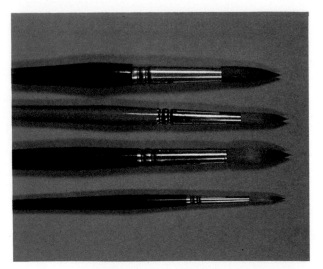

Good watercolor brushes, both sables and synthetics, form fine points when wet.

Round brushes
- Sized from number 000 to 16
- Kolinsky sable, ox hair, synthetic fibers, mixtures
- Some handles have chisel ends for scratching

Flat brushes
- ⅛ inch to 2 inches wide
- Kolinsky sable, sabeline, synthetics or mixtures
- Some handles have chisel ends

Oriental brushes
- Various sizes, often with decorative handles
- Often double ended, with bamboo quill pen at one end
- Soft deer hairs but pointed - excellent for linear work

Bristle brushes
- Generally used for oils or acrylics
- Many sizes and widths and types of hog or synthetic bristles (try several)
- Use for textures, vigorous brushwork, and lifting color

Stencil brushes, toothbrushes, varnish brushes
- Varieties of sizes, shapes and materials
- Good for experimentation, spattering, scrubbing, etc.

Practice making marks on white drawing paper with a variety of brushes. Use a very wet brush or a partially dry one on damp and on dry paper. Notice the differences and remember them when choosing your brushes. Hold the brushes in different ways (across your palm; near the tip; at the end) while you make your practice strokes.

All brushes should be cleaned carefully after each painting session. They'll last longer and won't introduce unwanted colors into the next painting. Wash them under a faucet or use mild soap and water and wash them in the palm of your hand. Shake out most of the water, but don't squeeze the brushes firmly between your fingers. Instead, let them shape themselves or gently coax them to points. Do not let them stand on the bristles when drying. Brushes are your most important tools, so it makes sense to take good care of them.

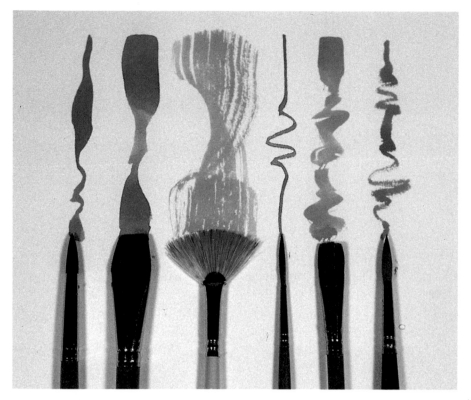

Six kinds of brushes make six different kinds of marks. Experiment with brushes to see what each will do.

Any brush can be held in several ways to produce different effects. Holding the handle near the end allows for free movement, finger manipulation and long strokes.

Holding the handle across the palm allows you to use wrist and arm action in making strokes and is good for sketching and roughing in colors.

Holding the brush near the ferrule (the metal that holds the hair to the handle) affords the most control and is useful for painting details, making short marks and signing your name.

These five papers are made by Winsor & Newton (England) and are (top to bottom): 90 lb cold pressed, 90 lb rough, 140 lb cold pressed, 140 lb rough, and 260 lb cold pressed. Notice the variety of textures.

These three papers are all 300 lb rough, but each manufacturer's paper has a slightly different surface.

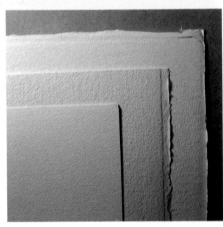

These five papers have different surfaces and different weights. They include drawing papers, Bristol papers and student grade watercolor papers. It is worthwhile to experiment with different papers to see how watercolor acts on each. Then use papers with which you feel comfortable.

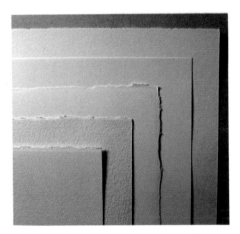

Papers

Paper is the traditional ground for watercolor painting. Because white paper produces the medium's values and color intensities, papers must be chosen carefully. Try several before you decide on any one kind.

The best papers are expensive ones made in England, Italy and France. Surface qualities vary from *hot pressed* (smooth) to *cold pressed* (medium rough) to *rough* (very textured). Paper thicknesses also vary, from 72 pound (thin) to 400 pound (very thick and heavy). The poundage is based on the weight of a ream of 500 sheets. For example, a sheet of watercolor paper might be called "300 pound cold pressed," indicating its thickness, weight and surface quality. Such papers are usually 22" x 30" (56 cm x 76 cm) in size (referred to as a full sheet) but are made in larger sizes also, and are sometimes available in pads. *Sizing* is put on most watercolor papers to keep sheets from sticking together and to seal the surface. If you find you want more color absorption, the sizing can be sponged off.

Lighter weight papers will often wrinkle when water is applied and need to be stretched to prevent wrinkling. This is done by soaking the paper, spreading it on a flat board and fastening the edges by stapling or applying paper tape. Once dry, the paper will not wrinkle when watercolor washes are put down. If papers wrinkle, dampen them and place them under weighted boards.

Most watercolor papers are expensive and might prohibit you from experimenting. Student grade papers are much less expensive, and many are excellent for experimentation. Heavy white drawing paper is another good choice, as it absorbs easily and holds color well. Try oatmeal paper, tagboard, the back of charcoal paper, white construction paper. No paper should be ruled out until it has been tried. You may find the unpredictable action of watercolor washes on various papers downright exciting!

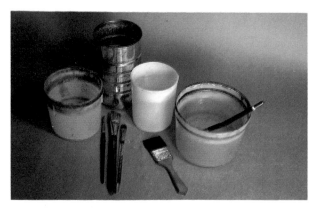

Water containers can generally be found in the kitchen, garage or in kitchen supply stores, so don't look for them in art stores!

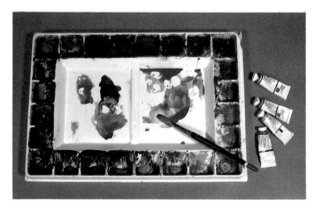

The author's palette in use. Color is taken from the compartments with a brush and mixed in the space in the center. The colors shown here follow the general arrangement of the color wheel.

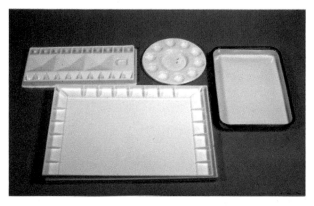

Palettes are made in many styles. Those with lids help keep colors moist and clean.

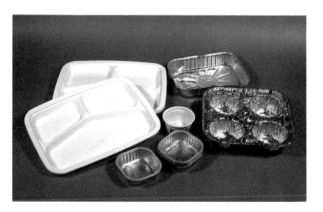

A search around the kitchen will probably reveal several "found palettes."

Water Containers

Plenty of water is necessary for mixing washes and keeping brushes clean. Jars, bowls, cans or plastic containers work well — the larger the better. One-gallon plastic water jugs with the tops cut off make excellent containers.

Palettes and Mixing Trays

White plastic or metal palettes come in all sizes and shapes, and provide space for holding tube colors and mixing paints and water. The lids of boxed watercolor sets have small mixing areas, but they are too small for mixing large washes.

Washes require large quantities of watercolor paints and water, and ingenuity can provide all sorts of mixing trays. Look for items that offer separated flat spaces where colors and water can be mixed. Some artists use enamel drip trays from old ranges. Discarded TV dinner trays and other metal throw-aways work well, as do old Army mess trays. Even plastic-coated paper plates with divisions can be used. If they are not white already, spray them with white acrylic to provide a good background on which to mix colors.

Two books placed under a drawing board provide an ideal tilted surface for working with watercolor washes. Experiment to find the degree of slant that feels best. Here, push pins hold the 300 lb paper sheet to the drawing board.

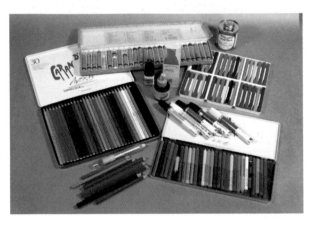

The watercolor surface can be supplemented with other coloring media that can help create beautifully complex images. Shown here are pastels, watercolor crayons, colored markers, colored pencils, watercolor pencils, and rubber cement to use as a blockout and for resists.

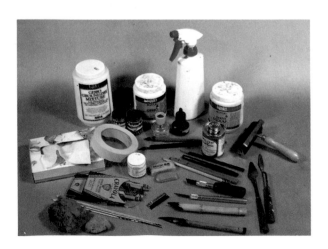

Working Surfaces

The surface on which the paper is laid should be firm enough to stand some pressure. It should be as large as or larger than the paper and must be able to be slanted, as horizontal surfaces will produce "wells" or "pools" of color that can be objectionable. The angle of slant should be adjustable. A table easel is an inexpensive working surface that can be adjusted to many slants. The angle will vary according to the type of work — wet or dry — that you do.

Masonite or plywood panels make good working surfaces, as do the traditional softwood drawing boards. If the painting sheet is to remain wet for extended working periods, the working surface should be a non-absorbent material such as acrylic or Formica.

Other Tools and Materials

Experimenting with unique effects is part of contemporary watercolor painting. Techniques should never dominate what you wish to say, but sometimes you can get your ideas across better by using some non-traditional methods. Here are a few items to try:

- *Ballpoint pens:* for sketching in shapes; drawing details; lines
- *Blotting paper:* for soaking up unwanted water or color
- *Brayers:* to spread color around on wet surfaces

Here are some of the media and tools that can help produce fascinating effects when used with watercolor. Media: Masking tape, colored inks, dry pigment, masking fluid, rubber cement, gesso, pencils, acrylic medium and wax crayons (for color and resists). Tools: Sticks for drawing, pens, absorbent tissues, erasers (for lifting dry color), reed pens, knives, palette knives, sponges, razor blades, spray bottle and a brayer.

Exciting surfaces can be achieved by combining watercolor with other media and by using a variety of tools. Here bristle brushes, pens, sticks, palette knives and pencils were used with white gesso, India ink and collage. Gerald F. Brommer, *Texas Still Life*. Mixed watermedia, 22 x 30" (56 x 76 cm).

- *Cardboard:* to scrape wet areas; dip in color and print
- *Crayons:* for resist techniques; color accents
- *Erasers:* for lifting dry color; erasing pencil lines
- *Facial tissue:* for wiping wet surfaces; dab with it to create textures
- *Felt-tipped pens:* for drawing lines; touching up areas
- *Gesso:* creates interesting surfaces; use it to overpaint opaque whites
- *Hair dryer:* speeds up drying time in damp weather
- *Colored inks:* for accent and transparency; touch up
- *Knives:* for scratching out color, revealing white
- *Markers:* for lines, colors, shading
- *Masking fluid:* for blocking out lines and shapes
- *Masking tape:* to shield areas when painting or sponging out color
- *Palette knives:* to add surface interest in wet areas
- *Pastels:* to add accent colors, textures
- *Pen and ink:* for details, texture
- *Pencils:* for sketching, roughing in big shapes; details; shading
- *Razor blades:* to scratch out white areas; create lines, textures
- *Rubber cement:* use as resist and blocking out medium
- *Salt:* makes star-like effects when sprinkled in wet areas
- *Sponge:* to lighten dark areas; lift color; create texture
- *Toothbrush:* spatter; texture; dry brush techniques
- *Watercolor crayons:* For painting; accent colors; texture
- *Watercolor pencils:* use as accent colors; for fine details, lines
- *Wood scraps:* to paint and stamp on paper

Some of these tools will mar the paper's surface. Good papers will stand much more abuse than the more inexpensive kinds. Experiment to see how some processes will affect your papers.

PART TWO

The Painting Process

Your experiences with watercolor should begin with getting to know the medium itself — learning how it looks and works, and with which techniques you feel most comfortable. Play with watercolor; have fun with it. A free and easy approach will teach you the most.

The term *watercolor* is made up of two words: water and color. After you explore the uses of water combined with pigments, and understand some basic applications, you should spend time learning about the uses of color. Chapter 4 provides an extensive overview of color, color mixing, dominance, neutralizing and practical applications.

Design and composition are aspects of painting that you may have studied before, but their importance to painting is always worth reviewing. The information in Chapter 5 will help you critique your own paintings and solve visual problems. Correcting errors — a subject of special interest to beginning painters — and combining watercolor with other media are dealt with in Chapters 6 and 7.

The need for good drawing skills is emphasized in Chapter 8. While it is vital that you are uninhibited in your experimentation with watercolor, it is just as essential to learn the role of drawing in developing meaningful visual imagery.

Getting Started

Only when greatly diluted with water are transparent colors really see-through. Slightly diluted, they appear translucent; when applied with little or no water, they are nearly opaque. Lighter tints are obtained by thinning the color with more water; the white paper will lighten it further.

Transparent watercolor is a method as much as a material. Applied in a particular way, watercolor allows the white of the paper to sparkle through applied color. Overlapping colors and the see-through quality of the medium give watercolor paintings their unique depth and sparkle.

Wash: The Basic Watercolor Technique

The term "wash" usually implies laying color down on a broad area of paper. Some artists, however, describe each brushstroke of watercolor as wash, regardless of size. The term therefore is somewhat ambiguous, but will be used in this book to refer to paint applied to large areas of paper.

Mixing a Wash
First, use a large brush to dip clean water from a container into your mixing area. Do not use too much water at first; more can always be added.

Previous page:
Gerald F. Brommer, *Pemaquid Point* (detail).

Pick up some color from your palette or watercolor box and add it to the water, mixing thoroughly with the brush. Add more water and more paint until you like the color and intensity, and feel there is enough to cover your paper. A few tips:
- Prepare a little more wash than you think you need
- Mix carefully so no pigment particles are left undissolved
- Use a large, soft brush (round or flat) that holds much water
- Washes dry to a lighter color; make them a bit more intense than you think necessary
- More water makes a pale wash; less water makes a darker wash

It is best to test the color on a piece of scratch paper first, since it is difficult to change the hue or intensity of a wash once it has been put down.

Laying Down a Flat Wash
Applying a wash to paper is the process on which all watercolor painting is based. Watercolor painters spend their entire lives developing and altering their wash applications to suit their ideas.

Slant your working surface slightly toward yourself (put several books under the top edge) so the brushstrokes will flow into each other. You can work on either a wet or dry surface, and should try both so you know how each one responds. Start

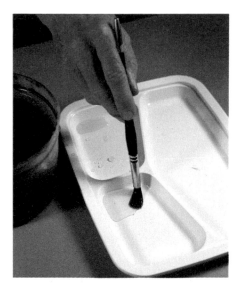

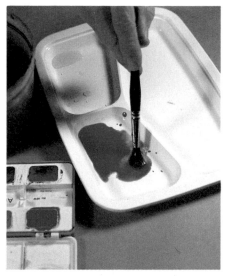

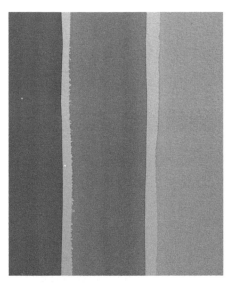

Mixing a wash Use a brush to move water into mixing areas; it will give you greater control over the amount of water you use.

Load your brush with color and bring it to the mixing area. Mix the wash thoroughly to dissolve all pigment particles.

Three or more values of the same color wash can be made by adding more water (lighter value) or more color (darker value) to the wash in the mixing tray.

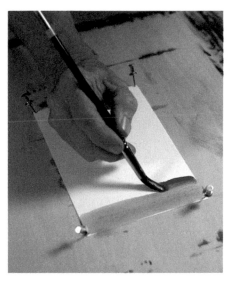

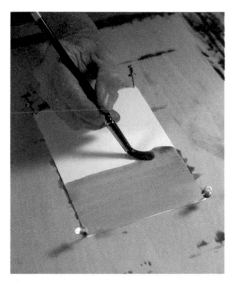

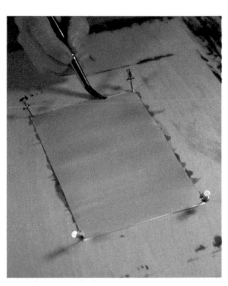

Laying down a flat wash Flow the first horizontal strokes onto the paper with an easy, light touch, using either a round or flat brush. Do not press the brush to the paper, and do not go back to correct or touch up the painted surface.

A slanted working surface allows color to "bead" at the bottom of the wash stroke. Succeeding strokes should gently touch the bead to allow it to flow down into the new stroke. Do not wait too long to add strokes, or the waiting color will produce irregularities in the flat wash.

Pick up excess wash at the bottom of the run to prevent "blooms" and "run-backs." Allow the sheet to dry on the slanted board to prevent disturbing run-backs.

with several pieces of your chosen paper, cut to about 5 x 8" (13 x 20 cm). If the paper is dry, do not fasten it all around, but only with tacks or pins at the top. This will allow for expansion as the paper gets wet. If you use wet paper (soak it first, or wet it with a sponge or brush on both sides) it can be taped or tacked all around.

Here are the fundamentals of laying down a wash:

- Prepare a sufficient amount of wash color
- Load a large brush (round or flat) with wash color
- Start at the top edge and brush horizontally across the paper
- Always use plenty of wash color; too little creates problems
- Brush the second stroke just overlapping the bottom of the previous stroke, so they blend together; stroke in the same or opposite direction, as you wish
- Continue the process until the paper is filled
- With a squeezed-dry brush or facial tissue, pick up color from the bottom edge. If you do not, the color might seep back up into the work to create "blooms"

Graded Washes

Nature rarely provides us the opportunity to use perfectly flat washes, so it is necessary to experiment as well with gradations of color. To grade your wash evenly from *dark to light,* you should start with a fairly intense color wash. Then:

- Mix sufficient wash for your paper
- Lay down the first horizontal stroke
- Add a little clear water to the wash reserve for each stroke as you work down the sheet (mix thoroughly)

It is tricky to make a perfectly graded wash — a slightly striped effect often results. If you work quickly, before the color settles, the results will be smoother. Never work back into a developing wash to "correct" it; it will only make matters worse.

To make a graded wash from *light to dark,* start with a light-valued wash. Then:

- Mix sufficient wash for your paper
- Lay down the first horizontal stroke
- Add a little color to your wash reserve (mix thoroughly); brush the second stroke
- Try to add the same amount of color to the wash reserve each time to produce an even gradation

Variegated Washes

Variegated washes use more than one color and can be visually exciting. They can also be unpredictable, however, and require a good deal of practice. One method is to start with one color of wash (pale blue, for example). With each succeeding stroke, add a bit of red to the wash in your mixing tray. The wash will gradually turn from blue to violet.

You may also try another method:

- Prepare two or three washes in your trays
- Brush one or two strokes of the first color
- Clean the brush in clear water
- Add color from your second wash as you work down the sheet
- Clean your brush before using a new color

As you experiment, try mixing several of these wash techniques together to produce different effects.

Granulated Washes

Some pigments separate a bit from water and will produce a granulated (granular) effect if applied with much water to a textured paper. The degree of granulation can only be determined by experimentation. Some colors separate more easily when applied over a previous wash. The thicker, more opaque colors generally granulate more easily. Granulated washes can produce fascinating areas of color, and with experimentation can be quite carefully controlled.

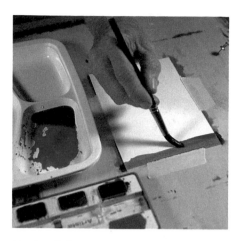

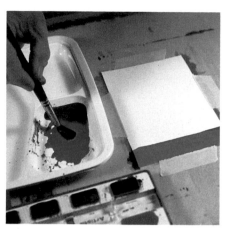

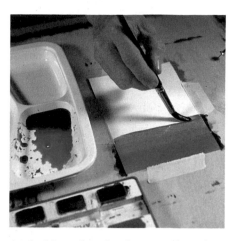

Dark to light graded wash Mix enough of a dark-valued wash to cover the sheet, and apply the first several horizontal strokes. Be sure to leave a bead of color.

Clean your brush, and add a brushful of water to the wash mixture to lighten it slightly.

Apply this wash to the sheet, touching the bead of the previous stroke. After each stroke, rinse out the brush and add water to the wash mixture, stirring thoroughly. Then add the next horizontal stroke. Continue until the area is covered with a graded wash.

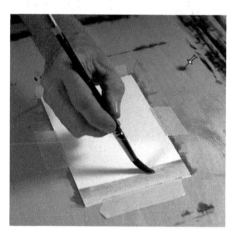

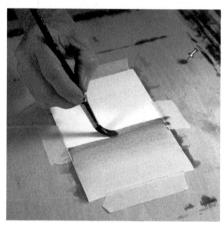

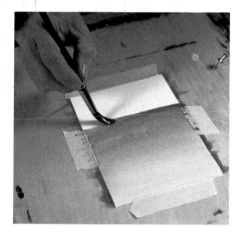

Light to dark graded wash Mix a light-valued wash and apply the first horizontal stroke to the sheet.

Add color to the wash mixture and stir thoroughly. Then brush down the next stroke.

Continue to add the same amount of color at each mixing, to keep the transition of value smooth. Work down to the bottom, lift the last bead with a thirsty brush, and allow to dry without moving the paper.

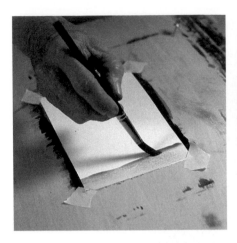

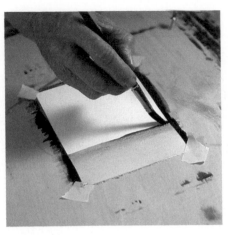

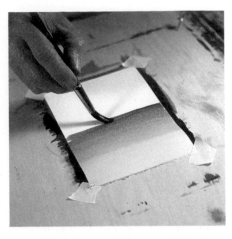

Variegated wash Make a wash of one color, enough to fill the sheet. Begin by laying down several strokes of that color (green).

Clean your brush and add a small amount of a second color (orange). Mix thoroughly and apply the resulting color.

Continue the process, cleaning the brush and mixing carefully each time.

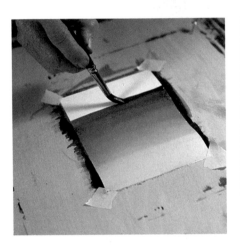

Here a third color was added (brown) to intensify the color contrasts. All washes shown here were made with pan colors on student-grade watercolor paper.

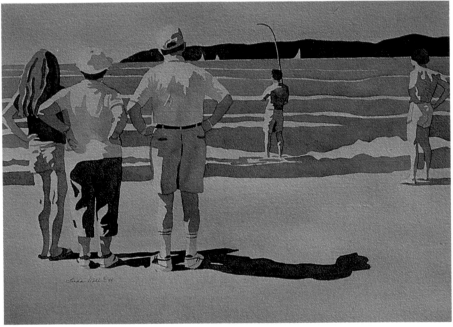

Flat, graded and variegated washes are combined in this painting of figures on the beach. Notice the gradual value change in the water and on the sand, to indicate space. Where else are variegated and graded washes used to indicate form and depth? Linda Doll, *Sunshine Series #5.* 20 x 28" (51 x 71cm).

Layering Color Washes (Glazing)

Glazing is a term that originated with oil painting, referring to the technique of applying one transparent layer over another to achieve richness and luminosity. In watercolor, glazing is a fundamental way of working.

Glazing can be done with large wash areas or smaller parts of the surface. The size brush you use depends on the size of the area to be covered. Soft brushes will give the best results because they will not disturb the underlying colors. To create a successful glaze, do not scrub, as that will affect other colors. Instead, flow the new color gently over the previous ones. Practice this technique often to make it a familiar working method.

Glazes are most effective when contrasting hues are used: warm over cool; cool over warm; blue over orange; red over yellow, and so on. Moderate the intensity of your washes. If a glaze is too intense, the underlying colors will not show through.

Glazes work best when laid over a dried surface, because each color then retains its integrity. If the first colors are still wet, blending rather than layering will take place.

One graded wash is glazed over another. The graded red wash (darker at the bottom) was allowed to dry completely. The graded blue wash was run over the red, from light to dark, as the paper was turned upside down. All wash examples were created on student-grade paper.

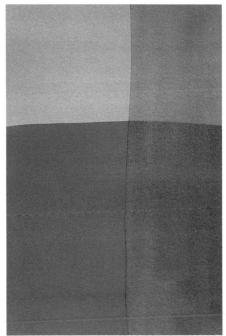

Transparent glazes change the colors under them. The red was evenly washed over the entire surface. When dry, the blue glaze was brushed on. When dry, the greenish glaze was added. Try several color combinations, but keep the glazes transparent.

 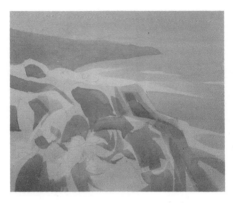 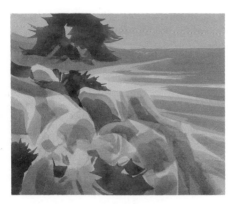

Building up the surface After a light pencil drawing to block in major shapes, light blue and light tan washes are put down first, leaving white shapes in several areas. A flat brush was used in the first four steps.

When the washes are dry, the build-up begins by laying darker values over the initial washes. Some white and light values are left untouched.

Green washes are added; a darker blue is glazed over the ocean shapes. Note the same blue added to rocks to change color and add depth.

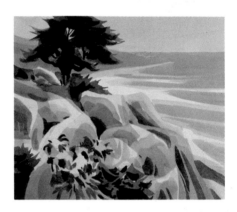

Darker greens provide dimension and form to the tree and foreground foliage. Tree trunk and branches are added, and dark browns begin to describe the thistle plant and add more dimension to the rocks.

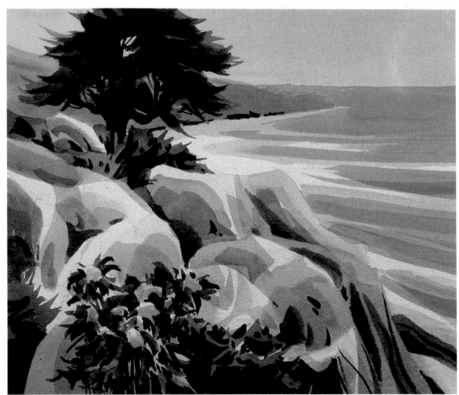

Very dark marks are built up with a round brush. Notice them in the tree, foliage and rocks. The headland shape is darkened to provide contrast with the water, and a purplish glaze is applied to parts of water, rocks and plants to create unity of color. Notice how whites and light values glow next to darker shapes.

Painting on a Dry Surface

Besides laying down large wash areas, there are several other basic ways to paint watercolor on paper. You can work with a dry or a wet surface, according to your subject and style.

Because of watercolor's transparency, the painted surface is usually built up from light values to dark. Some artists plan carefully and lay a flat wash over the entire sheet, except where white is needed. Several washes of various light colors and values can also be the foundation for a painting. Such washes should be light-valued to allow overpainted transparent colors to work properly. Initial washes can be an overall treatment of the entire surface, or can be applied to previously drawn large shapes that suggest the final direction of the painting.

Building Up the Surface

After the first washes are dry, the *building up* or *wet-on-dry* process begins. Slightly deeper washes or brush marks are overpainted to intensify some colors, create value contrast and suggest textures. Do not scrub the colors into each other; brush them down evenly. Overpaint only on dry surfaces if you want to keep colors fresh and crisp. A hair dryer can speed up drying times, if necessary. Do not overpaint areas that are to remain light-valued; leave them either white or give them one light-valued wash covering. The darker areas should receive the layering treatment of color over color. This creates value and intensity contrast. Paint many small studies to try various aspects of this wet-on-dry procedure.

Other Wet-on-Dry Procedures

Some artists draw very carefully and put final-color and final-value, intense washes down immediately, not repainting them unless necessary. This takes much practice and requires that you know your subject very well.

Instead of building up surfaces, this artist draws each shape in pencil and paints intense washes in each space. She must determine the value and intensity of each color before putting it down. The finished surface contains vibrant contrasts of color, value and hard edges, with a minimum of glazing. Sandra Beebe, *Palette in Red and Brown*, 22 x 30" (56 x 76 cm).

Some artists feel more comfortable putting the darkest areas down first, then brushing down the lightest places, and finally adding the middle tones. Some do not start with large washes at all, but paint small marks directly, gradually building the complete surface. Some artists add glazes over such a painted surface to unify areas and strengthen composition.

Practice making marks on dry paper with several kinds of color washes (pale, intense, middle-valued) and several kinds of brushes.

Dry Brush Painting

As the name implies, dry brush techniques require very little water. Blot color off the brush with a tissue or paint rag and drag the brush over the paper. Hairs of an old brush can be spread out to create multiple lines and textures. A bristle brush can be used also. A scumbling stroke can be tried, but be sure to use old or synthetic brushes for this.

With some practice on various papers, you can easily create textures and spiky, linear marks that may indicate grass or weeds. Use dry brush techniques to produce contrast in wash areas and in combination with other wash techniques. Too much dry brush work in a painting can become monotonous.

Dry brush **Squeezing almost all color and water from the brush creates dry, broken marks. How might such marks be used in a painting?**

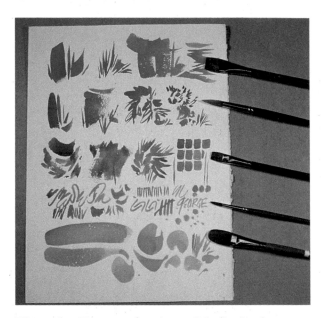

Wet-on-dry **Five rows of marks, made by five brushes on dry paper. Try various amounts of water and color and different pressures on each brush.**

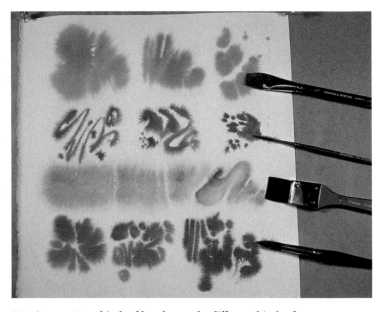

Wet-in-wet **Four kinds of brushes make different kinds of marks on wet paper. Soft, fuzzy edges are common to all, however. The most intense colors bleed the least.**

Wet-in-Wet Techniques

Wet-in-wet watercolor techniques are only partially controllable, so they provide the artist with exciting and challenging possibilities. Soft edges, running colors, slurpy skies, fuzzy flowers and large blended surfaces can all be flowed onto wet papers with color-loaded brushes. No verbal explanation can describe it adequately — the process must be experienced.

When working on wet paper, you must use fairly intense colors, because they will dry lighter than they first appear. Use a fairly flat surface, or all the colors will run downhill. Rougher papers generally work better than those with smooth surfaces.

Brush background colors down first, leaving white areas for later color additions. Experiment — notice the differing effects of wet and dry brushes on wetter and drier papers. Edges will be soft at first, but as the sheet dries, applying the same color will produce more definite marks, shapes and edges.

Try several landscape, flower, or animal paintings on small sheets, and explore the various possibilities. Or just flow wet colors into each other, if you prefer. Contrast the softest forms with harder or even with crisp edges by applying color to drying or completely dried surfaces. Most artists use such contrasts, because an entire painting done on a wet surface tends to look woolly and formless.

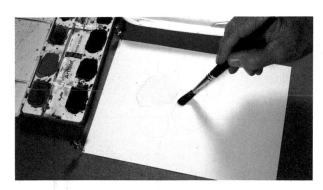

If you brush water within certain shapes, the added color will remain in the wet area.

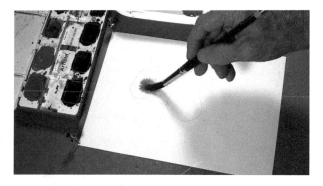

Wet-in-wet color will have blurred edges inside the shapes.

The outside edges of the shapes will be crisp, but the inside colors will run into each other and blend.

The Properties of Color

There are four words that form the foundation of a color vocabulary: *hue, value, intensity* and *temperature.* Your understanding of and response to each of these properties will help you understand your own color personality.

Hue is the name of a color in its purest form. Red, yellow and blue are primary hues. Orange, green and purple are secondary hues. There are many reds, but the hue "red" is a general term that covers all of them. Pigment names (or paint company names) such as Alizarin Crimson, Winsor Blue, etc., refer to specific kinds of color.

Value is the lightness or darkness of a color. Every color has a value range of *tints* (ascending toward white — using more water) and *shades* (descending toward black — combined with black). Make a value chart for each of six hues, ranging from almost white to almost black. Pure colors themselves (without any additions) vary greatly in value. Yellow is the lightest value, and purple is the darkest. Red and green are both in the middle value range.

Intensity is the relative purity or grayness of a color. It is sometimes referred to as *saturation* or *chroma.* For example, green as it comes directly from tubes or pans is intense. When it is mixed with another color (red, for example) it becomes less intense — less saturated and more grayed. If you mix red with a little neutral gray of equal value you will gray the red — make it less intense — but it will still be red. Add more gray to get less intense *tones* of red. If you mix equal values of red and gray and then add more water to thin the mixture, the color will be a lighter tone and a less intense red.

Temperature is the warmth or coolness of colors. Yellow, orange and red are warm colors that remind us of warm things: sunlight, wheat fields, fire. Green, blue and violet are cool colors that remind us of cool things: grass, water, ice, shadow. When warm and cool are mixed, the temperature might tend toward warm or cool, depending on which hue dominates. Warm and cool are relative terms, however, often depending on neighboring colors and the context in the painting.

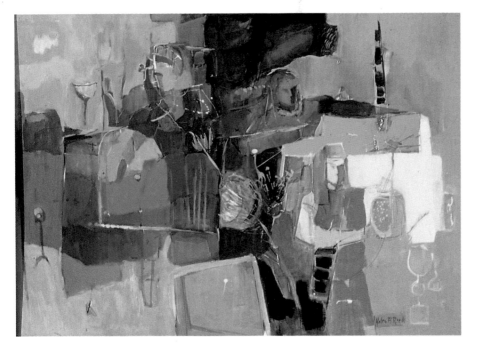

Can you identify hues, tints, tones, shades, neutrals, value contrasts and warm and cool colors in this mixed media painting? The neutral background seems to push the intense color shapes toward us. Helen Reed, *Rehearsal*, Watercolor, acrylic and ink, 22 x 30" (56 x 76 cm).

HUE

PRIMARY AND SECONDARY HUES

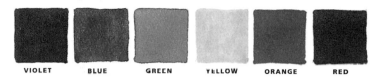

| VIOLET | BLUE | GREEN | YELLOW | ORANGE | RED |

Blue, yellow and red are the primary hues; violet, green and orange are the secondary hues.

VALUE

VALUES AND TINTS OF RED

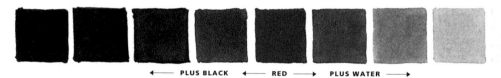

← PLUS BLACK ← RED → PLUS WATER →

The red hue is in the center. Adding black creates darker values (shades); adding water creates lighter values (tints).

VALUES OF PURE COLORS

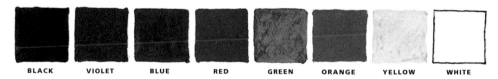

| BLACK | VIOLET | BLUE | RED | GREEN | ORANGE | YELLOW | WHITE |

Pure colors brushed on paper have values and can be sequenced from darkest (black) to lightest (white). Red and green have about the same middle value (compare them with middle values on the gray scale).

EIGHT-VALUE GRAY SCALE

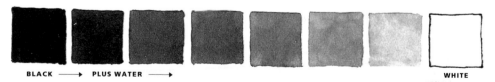

BLACK ⟶ PLUS WATER ⟶ WHITE

A value scale in black and white, made by starting with black watercolor and adding water to lighten the values. Compare light and dark color values with values in black and white.

INTENSITY

ADDING COMPLEMENTARY COLOR TO GRAY AND LESSEN INTENSITY

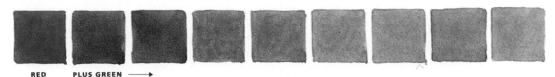

RED PLUS GREEN ⟶

Adding a complementary color will gray a color and lessen its intensity. Starting with red, a bit of green was added to the wash for each square. Values stay about the same but intensity lessens until the green begins to dominate and become more intense (saturated).

ADDING GRAYS AND WATER TO LESSEN INTENSITY

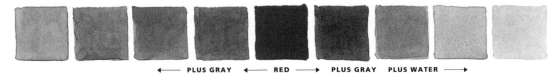

⟵ PLUS GRAY ⟵ RED ⟶ PLUS GRAY PLUS WATER ⟶

The red hue is in the center. To the immediate left and right, a gray (black and water) wash of about the same middle value as the red was added. Toward the left, the same gray was added for each square. Values stay about the same, but intensity of red is lessened. Toward the right, water was added, lightening the value and lessening the intensity. Middle tones are on left; light tones are on right.

TEMPERATURE: WARM AND COOL HUES

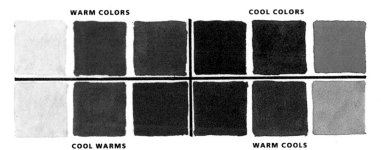

WARM COLORS COOL COLORS

COOL WARMS WARM COOLS

The top row shows yellow, orange and red as warm colors; violet, blue and green as cool colors. The bottom row illustrates a cool yellow, orange and red; a warm violet, blue and green. Some pigment colors allow us to have warms and cools of each hue.

SUMMARY OF COLOR PROPERTIES

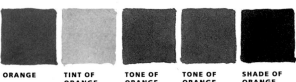

ORANGE TINT OF ORANGE AND WATER TONE OF ORANGE AND GRAY TONE OF ORANGE AND BLUE (COMPLEMENT) SHADE OF ORANGE AND BLACK

Reading from left: 1) pure *hue* of orange; 2) *tint* of orange (water added); 3) *tone* of orange (gray added); 4) *tone* of orange (its complement, blue, added); 5) *shade* of orange (black added).

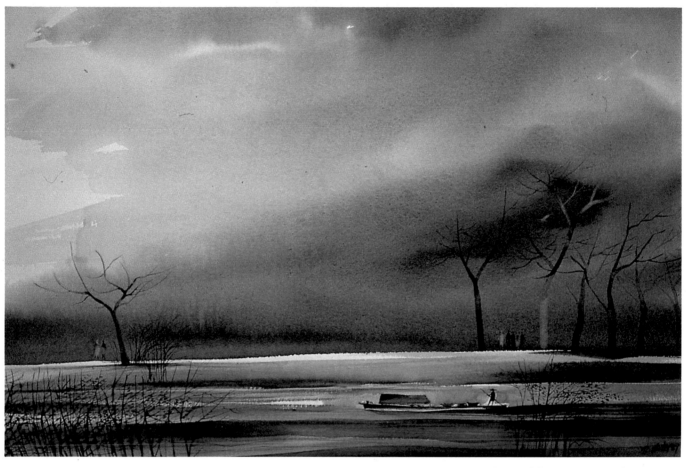

A somber mood is established with the use of cool colors and a wet-in-wet technique. Few simplified landscape elements are used; color gives the work its drama. Al Porter, *Chinese River*. 15 x 22" (38 x 56 cm).

The choice of color in this high-key landscape painting is personal, rather than realistic. What kind of feeling does the yellow dominance create? Glenn Bradshaw, *In a Summer Key*. Gouache, 24 x 36" (61 x 91 cm).

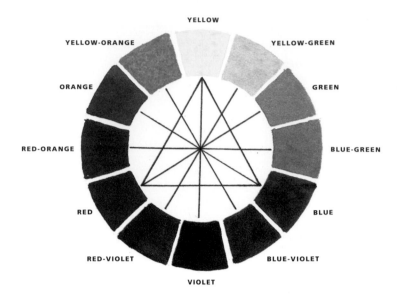

YELLOW
YELLOW-ORANGE
YELLOW-GREEN
ORANGE
GREEN
RED-ORANGE
BLUE-GREEN
RED
BLUE
RED-VIOLET
BLUE-VIOLET
VIOLET

The Color Wheel

Light from the sun appears to be white, but is actually composed of all the colors that we can observe. You have seen these spectrum colors in the refracted light in a rainbow: violet, blue, green, yellow, orange and red. If these spectrum colors are bent into a circle, they form a *color wheel*, a convenient arrangement to help us organize, study and understand color relationships. Pigment colors differ somewhat from those in light, but the following generalizations are basically similar.

The basic color wheel contains three primary colors, three secondary colors and six intermediate colors. In pigment (watercolor) hues, the *primary colors* are yellow, red and blue. From these primaries, most other colors can be mixed. If you mix the primaries red and yellow in the correct proportions, you will get orange. Red and blue make violet, blue and yellow make green. Orange, violet and green are secondary colors.

The mixture of a primary color (red) and a secondary color (orange) will produce red-orange,

an *intermediate color*. There are six intermediate hues: red-orange, yellow-orange, yellow-green, blue-green, blue-violet and red-violet.

If you mix any two secondary colors together (orange and green, for example) you get a brownish hue which is properly called a *tertiary color.* These mixtures can be rich in variety, depending on the proportions of the two secondaries mixed. Remember this when you need different and lively browns in your paintings.

Warm colors (yellow-green through red to red-violet) are on one side of the color wheel; *cool colors* (yellow-green through blue to red-violet) are on the other side. Yellow-green and red-violet can be considered either warm or cool, depending on context.

The color wheel also enables us to recognize *complementary colors.* These are any two hues shown directly opposite each other on the color wheel. Red and green, blue and orange, yellow-green and red-violet are each examples of pairs of complementary colors. If you add a bit of a color's complement (a bit of green to a red wash, for example) the color will be grayed and lose its intensity. One color of a complementary pair will always have that effect on the other. Complements have the most contrast possible in the spectrum and will visually dance when placed next to each other in their most intense saturation. Each will make the other seem more intense.

A *neutral hue* is one that is low in intensity. Grays are generally considered neutral in color, not showing evidence of any spectrum color. Gradually adding black, gray or a complement to a pure pigment will make it progressively less intense, until it finally becomes neutral. Neutrals can tend toward warm or cool, but if no spectrum color is dominant, we call it a neutral tone. (See charts on page 53.)

SOME COLOR RELATIONSHIPS EVIDENT IN THE COLOR WHEEL

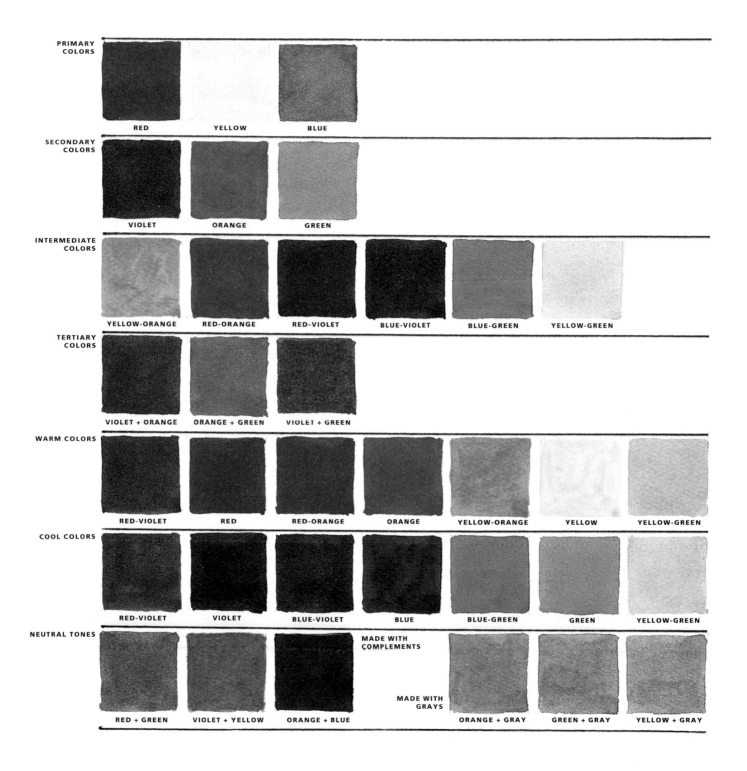

PRIMARY COLORS	RED	YELLOW	BLUE				
SECONDARY COLORS	VIOLET	ORANGE	GREEN				
INTERMEDIATE COLORS	YELLOW-ORANGE	RED-ORANGE	RED-VIOLET	BLUE-VIOLET	BLUE-GREEN	YELLOW-GREEN	
TERTIARY COLORS	VIOLET + ORANGE	ORANGE + GREEN	VIOLET + GREEN				
WARM COLORS	RED-VIOLET	RED	RED-ORANGE	ORANGE	YELLOW-ORANGE	YELLOW	YELLOW-GREEN
COOL COLORS	RED-VIOLET	VIOLET	BLUE-VIOLET	BLUE	BLUE-GREEN	GREEN	YELLOW-GREEN

NEUTRAL TONES

MADE WITH COMPLEMENTS

RED + GREEN	VIOLET + YELLOW	ORANGE + BLUE

MADE WITH GRAYS

ORANGE + GRAY	GREEN + GRAY	YELLOW + GRAY

Color Schemes and Relationships

Always select your colors with purpose. They should reflect planning and intent, and help communicate your ideas. It is often desirable to have one color dominate the work with several supporting colors to enhance it. But how can you choose compatible colors to create an effective color scheme? The color wheel will help you do this.

Over time, several basic color schemes have emerged that are interesting, organized and effective. The simplest of them is *monochromatic*, which means only one color is needed. Monochromatic paintings rely on value to make them work. Add black to a color to darken it; add water to lighten it. The range of values is infinite and paintings can be either subtle or dramatic, depending on the amount of contrast developed.

You have already read about complementary color schemes, which use colors opposite each other on the color wheel. As noted, complements enhance each other when adjacent, and neutralize each other when mixed. Such opposition can produce powerful contrasts. Red and green used together is an example.

The *double complementary scheme* is made up of two adjacent colors and the two adjacent colors directly opposite them. A wide range of combinations of these four colors is possible. Red, red-violet, green and yellow-green is one example.

The *split complement* is a triadic scheme consisting of one color plus the two hues on either side of its complement. Red, blue-green and yellow-green is an example.

The *analogous complementary scheme* uses four colors: two opposing complements and two on either side of one of them. Red, green, yellow-green and blue-green is an example.

Analogous colors can be any three or four adjacent colors on the wheel. They are closely related and enhance each other through close harmony and value contrasts created by mixing with black or adding water to the washes. A color

dominance is easy to sense in such an arrangement. Yellow, yellow-orange, orange and red-orange is an analogous color scheme.

Triads are any three colors that make a triangular arrangement on the color wheel. The sides of the triangle do not have to be equilateral, but two of the sides must be the same length. There are many possible triadic schemes (the split complementary scheme is one). For example: yellow, green and orange; yellow, blue-green and red-orange; yellow, blue and red; and yellow, blue-violet and red-violet.

In equilateral triads, you can select *primary triads* (using primary hues); *secondary triads* (using secondary hues); and *intermediate triads* (using three equally spaced intermediates).

In addition to these formal color schemes, there are a few others that you can work with. *Color families* can be used to create very unified paintings. There are three families: red, yellow and blue. For example, the red color family includes the seven hues on the color wheel that contain red: blue-violet, violet, red-violet, red, red-orange, orange and yellow-orange. The yellow family contains all the colors that have yellow in them; the blue family includes all colors with blue in them. If you use all the colors in a family, plus black to darken and water to lighten, you will have a single dominant hue and a great many variations, because each family contains both warm and cool colors, providing excellent contrasts.

You can create a greater variety of color schemes by simply eliminating any four analogous colors on the color wheel and using the remaining eight hues. Mixing can produce almost all needed hues, and working with self-imposed restrictions will help you improvise.

Opposite:
A number of basic color schemes have been developed from the twelve-hued color wheel. There can be twelve different sets of combinations in most of these schemes, and you should make charts including some or all of them as you explore color relationships and systems.

EXPLORING COLOR SCHEMES

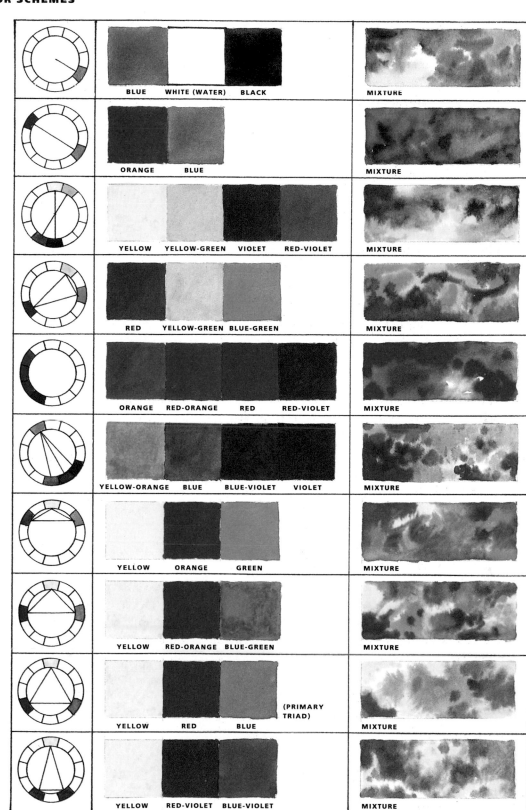

ONE OF TWELVE POSSIBLE
**MONOCHROMATIC
COLOR SCHEMES**

BLUE WHITE (WATER) BLACK MIXTURE

ONE OF TWELVE POSSIBLE
**COMPLEMENTARY
COLOR SCHEMES**

ORANGE BLUE MIXTURE

ONE OF SIX POSSIBLE
**DOUBLE
COMPLEMENTARY
COLOR SCHEMES**

YELLOW YELLOW-GREEN VIOLET RED-VIOLET MIXTURE

ONE OF TWELVE POSSIBLE
**SPLIT
COMPLEMENTARY
COLOR SCHEMES**

RED YELLOW-GREEN BLUE-GREEN MIXTURE

ONE OF TWELVE POSSIBLE
**ANALOGOUS
COLOR SCHEMES**

ORANGE RED-ORANGE RED RED-VIOLET MIXTURE

ONE OF TWELVE POSSIBLE
**ANALOGOUS
COMPLEMENTARY
COLOR SCHEMES**

YELLOW-ORANGE BLUE BLUE-VIOLET VIOLET MIXTURE

ONE OF TWELVE POSSIBLE
**TRIADIC
COLOR SCHEMES**
SKIPPING ONE HUE

YELLOW ORANGE GREEN MIXTURE

ONE OF TWELVE POSSIBLE
**TRIADIC
COLOR SCHEMES**
SKIPPING TWO HUES

YELLOW RED-ORANGE BLUE-GREEN MIXTURE

ONE OF FOUR POSSIBLE
**TRIADIC
COLOR SCHEMES**
EQUILATERAL TRIANGLE

YELLOW RED BLUE (PRIMARY TRIAD) MIXTURE

ONE OF TWELVE POSSIBLE
**TRIADIC
COLOR SCHEMES**
(SAME AS SPLIT
COMPLEMENTARY)

YELLOW RED-VIOLET BLUE-VIOLET MIXTURE

A great many color schemes are possible and it is good for you to experiment, to discover which combinations fit your ideas. After making sample combinations and mixtures, paint some small studies to see how these color relationships work. Remember that colors should reflect how you feel about your subjects, not just the way they look.

Color Mixing

Varieties of a Single Color

Each color in your palette can be mixed with every other color in the palette to create infinite hues, simply by varying the intensity of each of two colors. The amount of water you add will determine the intensity of the mixtures. If you add a touch of black, shades of each mixed hue will result.

You can begin to sense the unlimited colors available to you if you make some experimental studies. Since some artists have trouble making interesting greens in their landscape paintings, the accompanying charts illustrate the variety of greens available from a simple six-color palette, plus black. The number of possible greens increases if you mix your starting greens from combinations of yellow and blue instead of using the available pan or tube green. If these initial greens are more blue or more yellow at the start, mixing them with orange, red, violet and black will create still more kinds of green. The same multiplication of hues is possible with any given color.

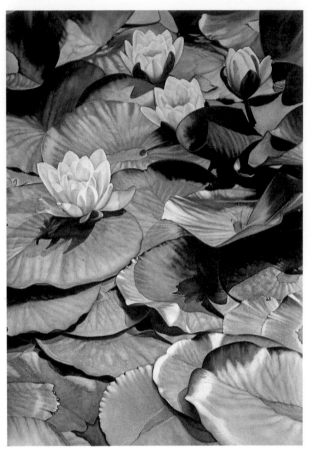

A wide variety of greens is used to describe these lily pads. Use the chart of greens to determine how the artist mixed colors to get this broad range. Linda L. Stevens, *Haiku #7*. 60 x 40" (152 x 102 cm).

Also, if you have several greens available in tube colors, you will have that many more possible hues to develop. Make some charts or sample sheets to show the varieties of a single color available to you. Then stop to realize that you can start with yellow, red, blue, orange or violet and create still more color mixtures with each hue. There is no need to be satisfied with a single color when so many possible mixtures are available.

A CHART OF GREENS

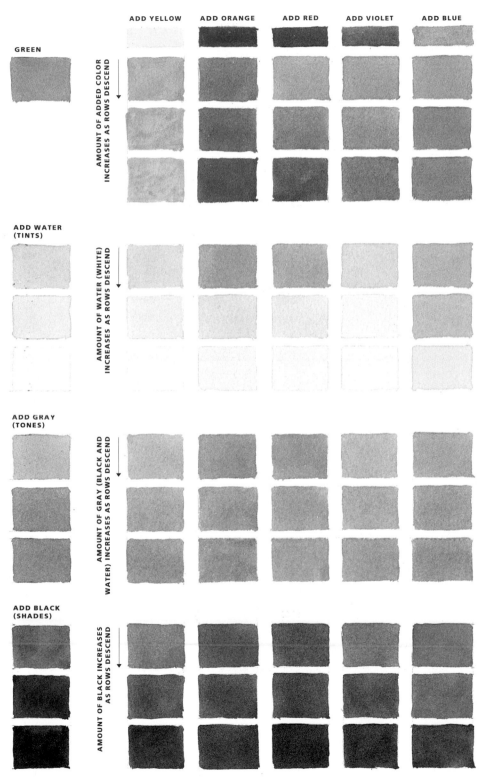

GREEN

ADD YELLOW ADD ORANGE ADD RED ADD VIOLET ADD BLUE

AMOUNT OF ADDED COLOR INCREASES AS ROWS DESCEND

ADD WATER (TINTS)

AMOUNT OF WATER (WHITE) INCREASES AS ROWS DESCEND

ADD GRAY (TONES)

AMOUNT OF GRAY (BLACK AND WATER) INCREASES AS ROWS DESCEND

ADD BLACK (SHADES)

AMOUNT OF BLACK INCREASES AS ROWS DESCEND

All these green mixtures began with the pan-color green at the upper left. Yellow, orange, red, violet and blue were added in the columns at the right of green. In the top bank of colors, more of the second color was added as the rows descend. There could be many more mixtures if six or more rows were used and gradations would be more gradual.

In the second bank of greens, the top mixture in each column was altered by adding water (therefore white) to make progressively lighter *tints*.

In the third bank of greens, the top mixture in the second bank was altered with the addition of a light gray. The same light gray was added again for the second row, and yet again for the third row. The values of greens do not change with the addition of gray, but the intensity of green is lessened in these *tones*.

In the fourth bank of greens, the top mixture in the second bank was altered by adding a bit of black. A bit more black was added to the second row, and more to the third, creating darker *shades* of the green mixtures.

If the water, grays and blacks were also added to the second and third rows of the top bank of mixtures, there would be a tremendous number of greens available. If the original green was mixed with intermediate colors (not just primary and secondary hues), the greens available would be doubled. You could also start with a different green and increase the possibilities even further.

MIXING MULTIPLE COLORS

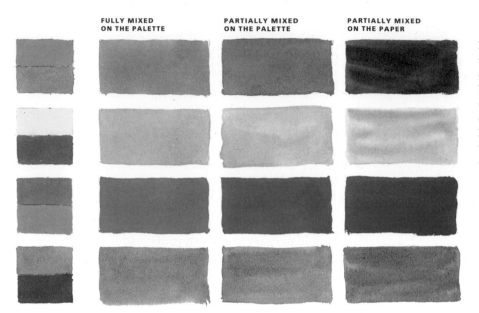

FULLY MIXED ON THE PALETTE **PARTIALLY MIXED ON THE PALETTE** **PARTIALLY MIXED ON THE PAPER**

In the first column of color mixtures, the two colors in the pair at left were completely mixed on the palette before brushing on the paper. In the second column, the colors were only partially mixed on the palette before applying to the paper. In the third column, the top color of the pair was brushed down first, and the bottom color was brushed into the damp top color.

GLAZING COLORS

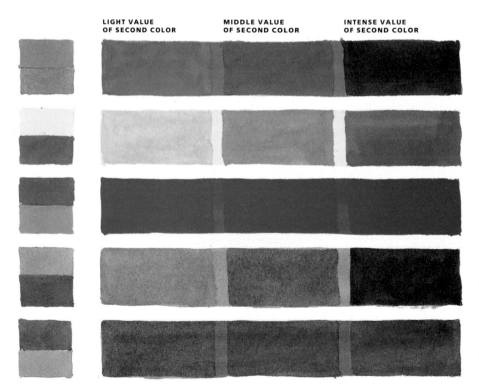

LIGHT VALUE OF SECOND COLOR **MIDDLE VALUE OF SECOND COLOR** **INTENSE VALUE OF SECOND COLOR**

This chart uses the same color combinations as above. Compare the results with the various direct mixing techniques. Usually it is better to put the lighter value color down first, because a light-valued, transparent color glazed over a darker-valued color will have little visual impact.

The top color in each set was put down first; then three values of the second color were laid over. Note that the last two sets are the same hues, but the first wash and overlays were reversed. Any set will appear somewhat different if you reverse the order of wash applications.

Note also how bright the pure color seems in the strips when next to altered or grayed colors. Cover the white space in these charts to further enhance the intensity of the pure hues. The farther away from each other the colors are on the color wheel, the more dramatic will be their glazing impact on each other.

Multiple Colors

With six hues (three primaries and three secondaries) and black in your basic palette, you'll probably be mixing hundreds of colors. One of the keys to using color successfully in your paintings, however, is to restrain yourself from mixing too much. Do not mix too many colors together, because grayish hues usually result.

Partially mixed colors provide some visually exciting results. If you mix two colors only partially, you will see three colors on the paper: the two starting colors plus the mixture itself.

When you mix colors on the palette, leave some space between the two pure colors, and then pull the brush across both and apply it directly to the paper. The result will be different than if you mix the two colors completely on the palette before going to the paper.

You can also mix colors right on your paper. Brush one color down and then brush the second color into it. Stop brushing before the two colors blend completely. The result will be an exciting blend of the two hues in which both original colors are evident, as well as the mixture.

You can also mix two colors by glazing one over the other, after the first has dried. This produces still another mixing effect. Results will vary, depending on the intensity of both colors. Try glazing light values (those with more water) over dark; dark over light; light over medium; and so on.

Making several charts will help you understand color mixing. Use the same two colors in various ways: well-mixed on the palette; partly mixed on the palette; partly mixed on damp paper; glazed on dry paper. Understanding these mixing techniques will give you more options and better skills to employ in your paintings.

Mixing the three primary colors produces a neutral gray. Therefore, mixing any complementary pair of primary and secondary colors should produce the same gray. Why is this true? Such color mixes may not provide a true neutral gray, however, if the colors are not perfect spectrum hues.

Interesting Grays and Neutrals

Grays are often considered neutral in color, but actually the richest grays tend toward a particular color, yet retain their neutral quality. Gray tube colors, or black mixed with water, are not very interesting or satisfactory. One way to enliven the neutrals is to mix a color with them, providing a bias toward that color. Another way to achieve lively neutral hues is to mix them yourself.

Complementary colors mixed in the proper proportions will produce neutral browns or grays with low chromatic intensity. If one color is a little stronger than the other, the "color identity" of the neutral will be in that direction. By experimenting with complementary mixes and studying the mixing chart, you can see what Vincent van Gogh was talking about when he spoke of violet-grays, orange-grays, red-grays, blue-grays, green-grays and yellow-grays in nature.

Complementary colors are opposite each other on the color wheel, made up of one primary color and one secondary color (red and green, for example). If you make your own green by mixing blue and yellow, and then mix the resulting green with red, you will see that neutrals are made by mixing the three primary colors. Any equilateral triad, when mixed carefully, will produce wonderful neutral hues.

COLORS ADDED TO GRAY

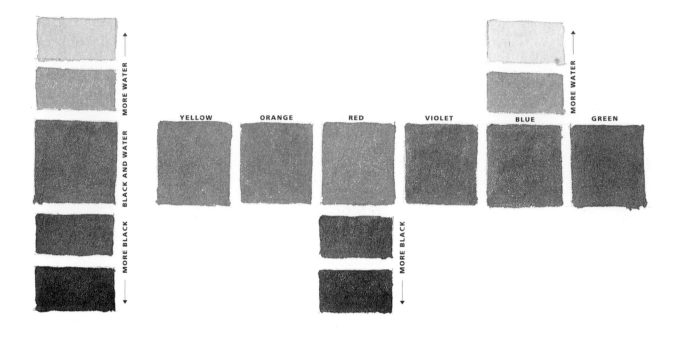

MORE WATER

BLACK AND WATER

MORE BLACK

YELLOW ORANGE RED VIOLET BLUE GREEN

MORE WATER

MORE BLACK

Colors added to gray At the left of the above chart are grays made by mixing pan-color black with water. Colors have been added to the middle-value gray in the horizontal band. These grays have a color bias toward the hue mixed with them. Above and below the band, water (up) and black (down) have been added. The values and varieties of colored grays are endless.

Mixing complementary colors of orange and blue in the palette tray — to obtain a neutral hue.

Color-biased browns and grays are not perfectly neutral, but when put in a painting they appear neutral, and readily enhance the more intense hues around them.

MIXING NEUTRALS FROM COMPLEMENTARY COLORS

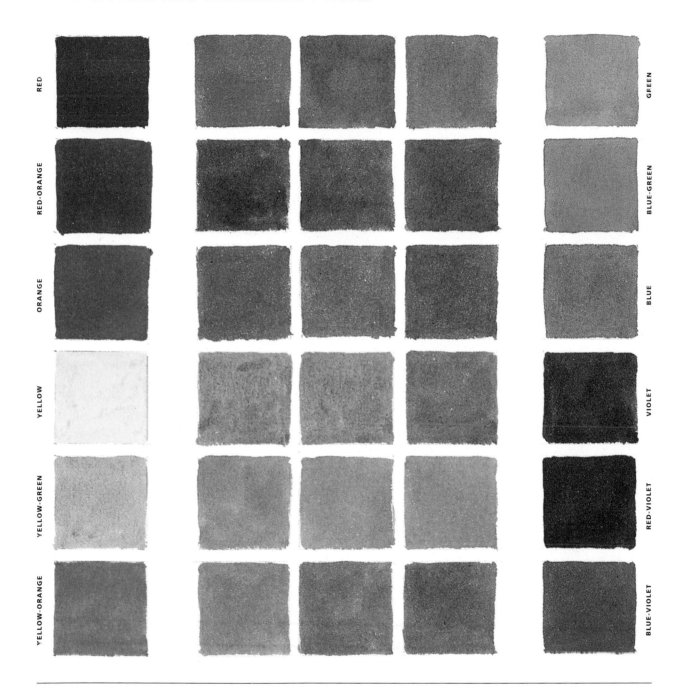

Mixing neutrals from complementary colors Colors on the left have been mixed with colors on the right to produce the neutrals in between. A little more of either pure color will create a color bias.

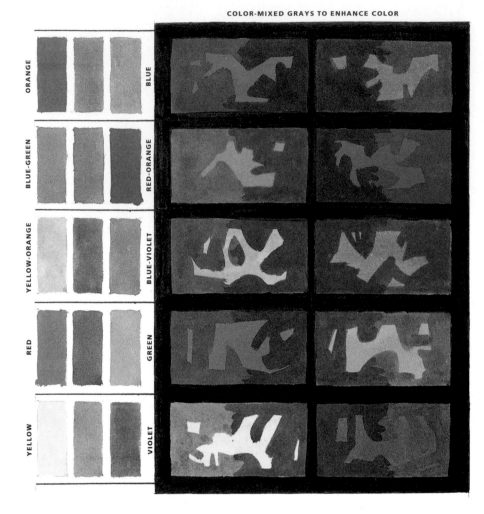

COLOR-MIXED GRAYS TO ENHANCE COLOR

In each horizontal row, two complements have been painted in the boxes at left and in the two horizontal boxes to the right. The neutral gray, formed by mixing the two complements, is shown between them, and was used as the neutral glaze over part of the two color boxes on the right. A darker neutral, mixed from the same colors, was glazed over part of the box to provide more value contrast. The pure colors glow because of *intensity contrast*. The black border helps you concentrate on the enhanced pure colors.

Pure complementary glazes will also make the colors glow, providing a different kind of intensity contrast.

Mixing black with the pure hue will make a glaze which, when placed over part of a pure color, will cause a glowing effect because of *value contrast*.

Placing a complementary hue directly next to and around a pure color will produce glowing effects because of maximum *color contrast*.

Using Neutrals to Make Colors Glow

Pure colors can be made to glow in a painting by surrounding them with mixed neutral hues. The contrast heightens the intensity of the pure color. In watercolor painting, this is an important concept to understand. Colors applied to paper cannot be made brighter, because adding more color simply reduces transparency and makes the color duller. Colors can be made to appear brighter, however, by graying or neutralizing their surroundings.

Study the chart and notice what kinds of contrasts will brighten pure color. White surroundings make the color appear dull, because the white paper is brighter than the color. Black, gray and mixed neutrals will enhance colors and make them appear more intense.

Glazes that neutralize a painted color (complementary hues and grays, for example) can also provide the contrast needed to make colors appear more intense. To make the hues in flowers appear more intense, for example, the greens surrounding them should be grayed and neutralized.

All colors in this little landscape sketch are cool — related to blue. Volume and space are created by value contrasts.

All colors in this sketch are warm — related to red.

Using Warm and Cool Colors

Hues on the color wheel can be grouped according to their temperature — warm or cool. Warm and cool become relative terms, however, when color relationships occur within a painting. An orange area in a very warm painting might seem cool, while the same orange in a blue and green painting will seem warm. Through mixing, warm colors (such as red) can be made cool; and usually cool blue can be made warm (see chart on page 42).

Tube colors vary in temperature. Ultramarine blue tends toward purple (and therefore red) and is much warmer than Manganese blue, which tends toward green. Tube reds and yellows can also vary in their temperature orientation. Mix red with a little of other colors, both warm and cool, and place the red mixtures next to each other. Notice the warm and cool tendencies of your red mixtures. They are still red, but vary in temperature. (See the chart of various greens on page 49.)

Both warm and cool colors are used in this sketch. If you squint your eyes, you'll see that cool colors seem to drop back and the warm ones come forward. Value, intensity and temperature contrasts create volume and space. Warm greens and dark values in the tree seem to push it forward.

1

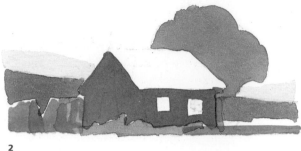

2

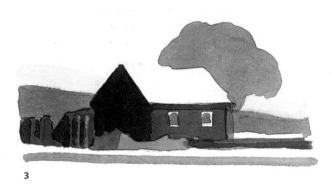

3

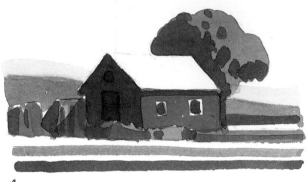

4

Color temperature can help you create a sense of depth in your painting. Warm colors are aggressive and seem to advance; cool colors are more calm and seem to recede. A red roof on a distant building must be "cooled down" or it will jump forward and not want to stay in the background.

You can make paintings with all warm colors, or with all cool colors, but most representational subjects will include some of each. Using both warm and cool colors will add temperature contrast, allow space to be felt, and can produce effective shadows that will suggest dimensionality in your work.

Glazes (of warm color over cool, or cool color over warm) will neutralize the first color put down (see chart on page 50). Mixing warms and cools will produce neutrals (see chart on page 53).

This little sketch illustrates the use of temperature in glazing. 1) The warm colors are put down. 2) The cool colors are added, but do not overlap the warms. 3) A cool blue (see the line below the sketch) was put over parts of the warms. Notice how the shadow side of the house drops back to suggest the third dimension of depth. 4) A warm purple (see the line added below the sketch) was placed over the cool greens to add form and express volume. The purple also made the door and window in the shadows. For the strongest statements about shadow and volume, use color glazes of opposite temperatures, not simply a darker value of the same color.

Contrast

Contrast helps us see what is what in a painting. Most watercolor artists create visual impact in their work by using value contrast (see the next section). But we have seen that contrasts can also be developed by using some of the differences between colors. Such differences include: *temperature* — contrasting warm and cool hues; *intensity* — contrasting pure and neutral hues; *complements* — contrasting opposites on the color wheel; *value* — contrasting darks and lights; and *hue.*

Creating Contrast

Pure colors have values of their own and create contrasts because of the light they bounce back to the eye. The hues in the chart are placed next to a gray value scale for corresponding dark to light sequencing. Color contrast is emphasized when intense hues are placed side by side. (The Fauves — Matisse, Vlaminck, Derain and Dufy — used color contrast to dramatic effect in the early twentieth century.) Primitive artists, as well as decorative designers and advertising specialists, often use pure color and contrasting hues because they provide lively, vivid visual images. If you want to experiment with color contrast, paint from a black and white photograph, substituting pure colors for the gray values on the chart.

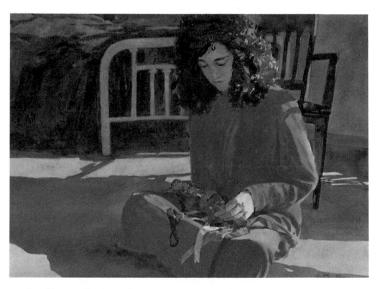

Red, yellow and orange dominate this very warm painting, with the pure colors placed against a neutral backdrop. Notice how the warm hues glow in the figure, the face and the ground. Controlled use of color contrast produces dramatic results. Martha Mans, *Scarlet Ribbons.* 20 x 28", (51 x 71 cm).

When pure, bold colors are used, it is often best to have one color dominate and use the others as smaller, contrasting hues.

Bright colors seem more intense when placed against black, but most artists prefer to place pure color against neutral or grayed areas. This lessens visual impact but produces more pleasing contrasts and combinations, and allows the pure hues to glow.

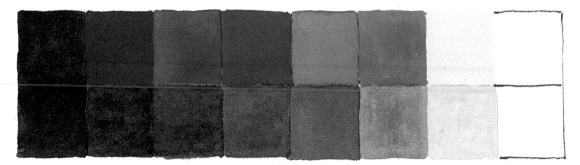

Pure colors have values of their own. Here, pure pan colors have been arranged to correspond with an eight-value gray scale. Variations in saturation of the paints will sometimes alter the sequential arrangement. Green and red are often considered similar in value.

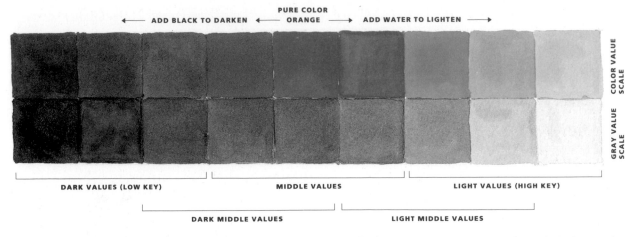

PURE COLOR
ORANGE

←——— ADD BLACK TO DARKEN ←——— ———→ ADD WATER TO LIGHTEN ———→

COLOR VALUE SCALE

GRAY VALUE SCALE

DARK VALUES (LOW KEY) MIDDLE VALUES LIGHT VALUES (HIGH KEY)

DARK MIDDLE VALUES LIGHT MIDDLE VALUES

The gray value scale alongside the orange scale provides a comparison of values. An entire painting can be made with one color plus black and water, because of the many values on the scale.

Value Contrast

Value contrast in painting refers to the dark and light of colors and painted areas, and is the most powerful visual effect that artists can use. A value scale reads from black to white, passing through a range of middle values. To see how value contrasts work, look at black and white photographs, or black and white photographs of full color paintings. To see values as you are studying a subject or your developing painting, squint to eliminate much of the color from reflected light.

You can give every color its own value scale (see chart) by mixing it with black to make it darker (shades) and water to make it lighter (tints). The most extreme contrast is black against white, as in Japanese sumi-E painting. In watercolor, such extremes are generally reserved for accents, deep shadows and bright light, while most surface areas are devoted to middle values. Of course, there are successful exceptions to this generality, as you will see.

Value contrasts help establish a color *key*. *High-key* color is in the white to middle value range; *low-key* color is in the middle to dark range. Full value contrast includes all values from black to white. A painting with a good range of value contrasts generates visual excitement through contrast. A painting of all middle values lacks strong contrasts and may tend to be lifeless.

Dark and light values can be used to influence eye movement through a painting toward a focal point. Our eyes read movement through areas of similar value — from light area to light area to light area, for example. Movement through similar values (regardless of color) is called *passage* or *linkage.*

Value contrasts can be used to emphasize shapes and define objects. If you place dark values behind light objects, the light objects will pop forward and be easily identified. The reverse is also true. If a dark shape surrounds a dark object, however, it will not be easily seen. Middle values will contrast with darks or lights.

Value contrast also defines form, helping us recognize three-dimensional representation on a flat surface. By shading an object or figure with darker values, we can sense the source of light, the form of the object and the shadow it casts. The transition from light to shadow will be smooth and gradual on rounded objects, sudden and crisp on angular forms.

This is a very high key painting in which the objects are made visible by shadows and subtly contrasting values. The forms and dimensionality of the cloth and papers are described not by line but by the values of the shadows. Kent Addison, *Still Life #1029,* 1982. 22 x 30" (56 x 76 cm).

The sensation of water crashing against rock is dramatically abstracted with contrasting values. Warms and cools are also contrasted, but the black and white areas produce the most visual impact. Middle values form a buffer between the two extremes of the value scale. Marilyn Hughey Phillis, *Sea Wall.* 40 x 30" (102 x 76 cm).

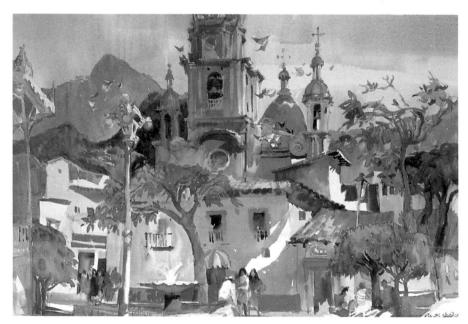

The complete value scale as well as a variety of colors and intensities are used in this painting. Lights and darks are important, but middle values are used to tie the parts together. Darks are placed behind lights, and lights behind darks for emphasis and description of shapes. Look for passage of light values and middle values, and for contrasts of color intensity. Robert E. Wood, *Puerto Vallarta.* 29 x 41" (74 x 104 cm).

Greatly thinned (light-valued) acrylics were allowed to run over the surface to create soft overall hues. Other light values were glazed over them to produce a slight value contrast to accompany the temperature contrast. Crisp edges contrast with vast, soft areas. Nanci Blair Closson, *Window to the Sky*. Acrylic watercolor stain, 66 x 50" (168 x 127 cm).

In watercolor painting, color values can be lightened by adding water while mixing. Once the paint is on paper, however, it cannot be lightened by adding more color. A wet color can be lightened by lifting with a dry brush or by blotting. A dry color can be lightened by lifting with a damp sponge or scrubbing with a damp brush. White paint may also be used to lighten a color, but transparent watercolor techniques do not usually rely on it.

Colors can be darkened in mixing by adding black or another dark hue or dark neutral. Once colors have dried, glazes can be laid over them to make them darker. Experiment on scratch paper so you are familiar with several ways to darken colors and thereby increase value contrast.

Using Very Little Contrast

As soon as we make a generalization such as "All paintings must have considerably strong contrast to be readable," we can think of several exceptions. Some artists prefer to work with minimal contrasts of value, color or intensity, yet their work is visually exciting. Rather than depending on powerful contrasts, they make subtlety a dominant factor in their approach to picture making.

High-key paintings rely on values at approximately the top half of the value scale, where most of the colors are of light value. Such paintings exhibit harmony and great unity, because of close values. With care and experience, artists can create close-valued, high-key paintings that are calm, gentle and serene. But watch out: high-key paintings can also appear boring.

Low-key paintings are made of dark-valued, somber hues. The moods of such works are generally sad and heavy. Storms, night scenes and deeply moody feelings are best expressed with such low-key dominance. The lightest values included are generally in the middle range of the value scale.

Middle-key paintings make use of the middle of the value scale, with neither extreme lights nor extreme darks being used. Like high- and low-key paintings, they are visually unified and harmonious, but can be graphically unexciting unless the artist composes and executes them carefully.

In any high-, low- or middle-keyed painting, other elements — texture, mood, color intensity, movement, contrast, pattern — can be emphasized

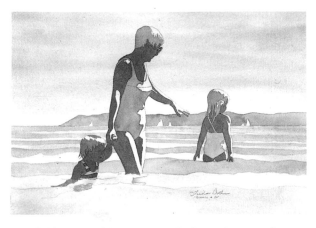

Careful layout and drawing precede the application of delicately graded, high-key washes. Light-valued color combinations show little value contrast, but subtle temperature contrast. Linda Doll, *Sunshine #20*. 14 x 20" (36 x 51 cm).

The earth's dramatic textures are the subject of this low-key, abstracted landscape. The painting has a blue dominance with pinkish temperature contrasts. Texture is emphasized over color and value contrast. Pauline Doblado, *Strata VII*. Watercolor and collage, 22 x 28" (56 x 71 cm).

and become dominant. These elements can help to create graphically exciting paintings.

Make several small high-, low- or middle-key paintings or designs. Experiment with different color combinations; try monochromatic or limited palette combinations; emphasize movement, gradations, warmth or texture. Remember that light values of watercolor are made by adding water, while dark values are made by adding black; and that graying and mixing hues can provide the color variations you need. Working with limited value contrasts will help you understand and appreciate the use of the full value scale in establishing focal points, developing movement and making graphically dynamic paintings.

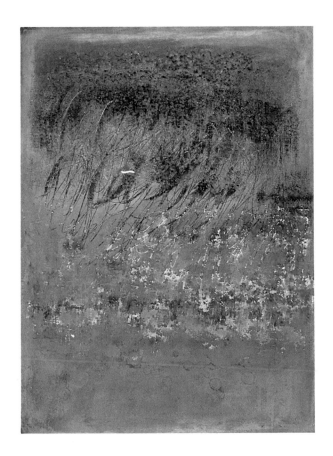

Middle values and neutralized colors are used without value extremes or intense hues in this nonobjective painting. Texture and temperature contrasts instead are used to provide graphic excitement. Louise Cadillac, *Interior Series 13*. Watercolor and acrylic, 40 x 30" (102 x 76 cm).

A LIMITED PALETTE

All the colors on this chart were made from blue and orange, with black and water added. More intense mixtures of the hues would result in richer colors. Orange and blue and their neutral mixtures are in the middle horizontal row. Tints of each are above; shades of each are below. More steps could be added at both dark and light ends of the chart.

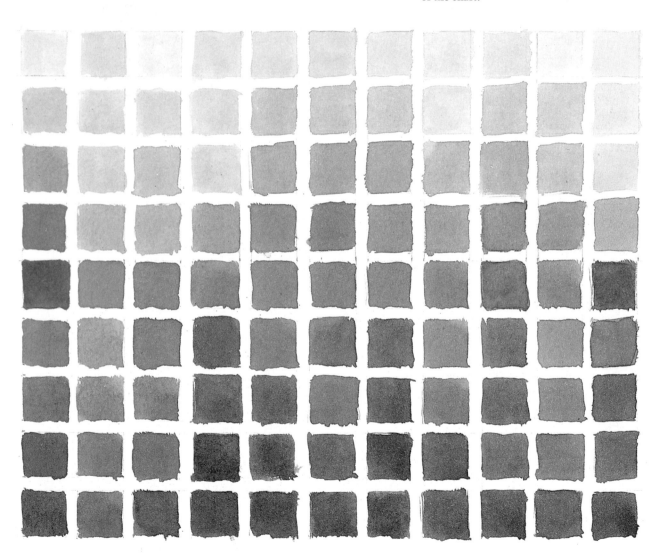

A Limited Palette

Artists generally use most of the hues in the color wheel when making their paintings, even though one or two may be dominant. Excellent paintings can also result, however, from a *limited palette* of only two or three colors. Many of the two- or three-color combinations already discussed (see Color Schemes and Relationships) can be explored as limited palettes. Try using two colors, such as orange and blue, adding only water and black to them and their combinations.

Make washes of orange and of blue on opposite sides of your mixing area. Each can be used in its pure state (plus water or black) or can be mixed together in various combinations. The chart shows you only some of the possibilities of these two hues in mixtures, tones and tints.

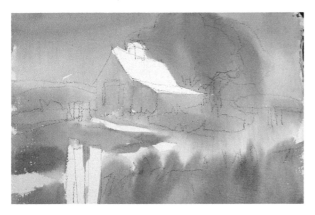

After the barn and its surroundings were drawn, the paper was wet with a brush and clear water, except for the white areas. Light values of blue and orange were combined and brushed into the wet surface.

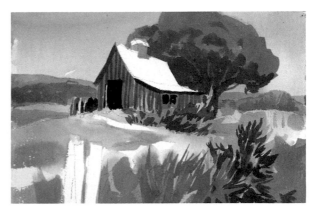

Orange (in the tree) and blue-orange mixtures of several middle values were then brushed down, leaving the whites and other light-valued areas for contrast. Orange-blue mixtures were added as glazes. Black was added to the mixture to paint the dark barn door and windows. Branches were scratched into the dark of the tree.

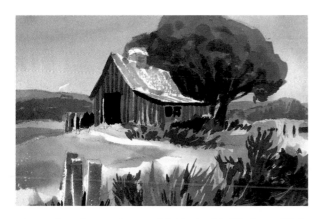

More color mixtures (some with black added) help establish form and textures.

A pure blue glaze was brushed over the shadows of the barn and into the shadows next to it. Orange glazes were added over some blue and neutral areas. Black was mixed with orange-blue combinations to make the darkest darks. Textures and glazes were added for the final touches. A full range of contrasts is evident, although only two colors and black were used.

With a limited palette of two colors plus black and water, a complete range of contrasts is still possible:

- Temperature contrast — warm and cool colors
- Contrast of intensity — from pure to neutralized mixtures
- Value contrast — from very light to very dark

When you are beginning to learn about a medium, it is often a good idea to begin painting with only a few colors to explore the possible contrasts noted above. Colors can be added one at a time until your working vocabulary is full. Paint simple landscapes or still lifes to develop your awareness of limited color and how to use it.

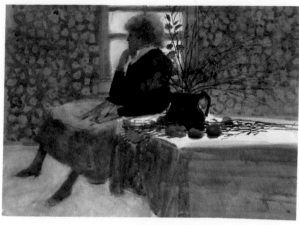

A carefully constructed design underlies the subtle mix of muted hues in this painting. Marbury Hill Brown, *Early Morning.* **21 x 26" (59 x 66 cm).**

Using Color Expressively

Artists *respond* to color in the environment, rather than attempting to duplicate it. All that you have learned about hue, value, intensity and mixing colors will help you understand color and use it expressively.

Even if you are painting representationally, you usually make personal decisions about color. Trees are not always green; skies are not always blue. The color choices of most artists depend on their desire either to imitate nature or to express themselves.

If a single color dominates a painting, we might say it is a yellowish painting, or a bluish painting (see page 43). Color dominance is a basic technique for providing visual unity in a painting.

Vivid colors tend to be exciting; pale colors usually indicate calm. Color can be riotous, intense and penetrating. German Expressionists used vivid hues to portray their frenetic, disturbed culture. A bold use of color often suggests power and strength. Vivid color contrasts are visually jarring, and can complement certain subjects.

Color helps establish moods. Bright colors, for example, might suggest happiness; dull colors may indicate sadness. What colors might you use to paint a joyful circus or party? What about an autumn morning? A heavy heart? Freedom? These are personal feelings and the colors used to express them should be equally personal. You should *feel* the colors as well as see them. If a brown sky will help you express the desert better than a blue one, paint it brown!

To some artists, colors have symbolic meaning. Raoul Dufy once said that to him, Mozart's music was bright red! In primitive societies, colors often carry symbolic weight, and have deep meaning. Think about your own reactions to certain colors. Does black say "death" to you? Is red a joyous or a painful color? Do you find yellow depressing? These kinds of color associations could — and should — affect how you choose paint colors, and how your final paintings look.

Every artist responds to and makes use of color in personal ways to express ideas. The choice between intense or muted color, realistic or expressive color, warm or cool color, depends on your own response to your painting concept and subject.

Basic Compositional Elements

The Elements of Design

In order to express yourself in your painting, you need a vocabulary — visual elements to help you tell your story. Painters use these elements to construct paintings, just as authors use words to build paragraphs. They help you see design all around you, and express yourself on paper. These artistic building blocks are called the *elements of design* or *elements of art.* All painters, whether beginners or professionals, use the same elements, generally in combination with each other rather than alone. They are very briefly summarized here. If you wish to dig deeper into design and composition, study some of the books listed in the bibliography.

Color

Color is the most personal and expressive of the art elements, because it appeals to human emotions. It is the most important element in making watercolor paintings. Chapter 4 deals with it in great depth.

Value

Value — the relative darkness or lightness of a color — is also vital to watercolor. Value makes paintings understandable and readable, because your eye reads contrasts between dark and light. You must learn to see values in the world around you before you can translate them to your paintings. See Chapter 4 for more information on value.

Shape

Your eye is used to looking at three-dimensional forms, but you paint shapes on a two-dimensional surface. To *see* shapes around you, close one eye and squint the other, and you will transform your world into flattened, simplified shapes. Shapes can be geometric or organic, large or small, and have crisp or soft edges. Painters are shape makers, and the better painters make more interesting shapes.

To make shapes interesting:
- Make them longer in one dimension than the other
- Stretch them
- Slant them so they do not parallel the paper's border
- Make them interlocking, like jigsaw puzzle shapes
- Look at shapes as silhouettes
- Be sure that negative shapes are as interesting as positive shapes
- Use shapes of various sizes

Shapes are just as important in representational paintings as they are in abstract ones, and watercolor painters strive to make fascinating shape combinations.

Color This is basically a warm painting with contrasting cool colors in foliage, shadows and sky. Some foliage is warmed or neutralized. Colors are generally muted earth colors; the flowering bougainvillaea provides contrasting, intense color. The magenta is mixed with several of the greens, which range from yellow-green through violet-green to blackish green.

Value A simplified value pattern of black, gray and white. White and high-key color values in the painting are left white. Middle values are made gray. Dark and low-key color values are black. Notice how whites, grays and blacks are linked together in places. If you squint at the full-color painting, you should see this simplified value pattern.

Shape The painting is made up of shapes, shown here as simplified, outlined areas. The shapes are: stretched, organic, geometric, jagged, interlocking, horizontal, vertical, diagonal. The negative shapes (sky and ground) have direction and interest, although the foreground shape could be made more interesting. If each of these shapes were painted flatly and with different colors than in nature, you would have a flat, abstracted image.

Line Implied lines outline shapes in a painting, so the shape sketch can also become a line study. Actual lines in the painting include several hard edges in the architecture, and the calligraphic lines in the foliage.

Texture **Over half the surface of the painting contains simulated textures. Texture is one of the dominant elements of this subject; it symbolizes the ancient quality of the structure and the variety of vegetation. Untextured areas afford rest for the eyes and contrast for the texture.**

Space **The painting is of shallow space, not infinite space carrying to the horizon. Space is explained in three ways in this painting: 1) through *linear perspective* — architectural lines leading to various vanishing points; 2) through *shadows* which emphasize volume and indicate form and depth; 3) through *overlapping shapes*, whereby we sense depth.**

All the art elements are combined in this painting, as they are in most. One or two elements may be dominant (color and texture, for example) but all the others are identifiable, and work together to produce a unified painting. Gerald F. Brommer, *Carmel Mission.* 22 x 30" (56 x 76 cm).

Line

Lines in paintings have two basic purposes — to outline shapes and to be calligraphic. Outlines of shapes are often edges of color or value, and the line is implied, not actually painted. Calligraphic line, on the other hand, has a life of its own; it is not an edge of anything. It describes textures, creates paths of movement, or is just itself, dancing across a nonobjective surface. It can be light and happy or cumbersome and dark. It can be integrated into the painting or can stand alone.

Most artists begin their paintings by drawing lines that represent future painted shapes. Calligraphic lines are added later, to create texture, structure and connections, to strengthen a composition or lead the eye from place to place.

When line is used in watercolor, it must appear to be an integral part of the work, not something added to the painting as an afterthought. Paintings with a transparent look should use transparent lines. If the work is strong in contrast, the lines can also be more bold. Under all circumstances, the use of line should be controlled. Too much linear work clutters the surface and produces a busy effect. Use line judiciously; keep it interesting by varying its size, weight, color and character.

Texture

Texture can be felt when it is touched. Surfaces can feel rough, smooth, wet, glassy, and so on. Textures can be actual (a rough fence) or implied (a photograph or painting of a rough fence). Watercolor painters usually work on slightly textured paper and must imply most of the textures they use. Experiment to see how many textural effects you can create.

Texture is often used to contrast with smoothly painted surfaces. When painting textured objects, you may wish to experiment on scratch paper to see how best to represent them in your painting. See Dry Brush Painting and Experimental Techniques, Chapter 3, for texture-making ideas.

Space

Space in paintings can be flat or deep, depending on the concept and style of the artist. Pushing shapes back in space creates a sense of depth. This can be done by overlapping objects or by incorporating one or more forms of perspective. *Linear perspective* makes use of lines that lead to vanishing points, and is a formal approach to painting space. *Aerial perspective* involves reducing color or value intensity as objects recede in space. *Size perspective* requires that similarly sized elements (trees, poles, people, etc.) diminish in size as they recede in space. By applying one or more of these techniques you can produce a strong sense of depth. If you wish to paint flatly, make sure none of these is used.

The Design Principles

The art elements just discussed are a painter's working vocabulary. These visual elements must be organized to make effective paintings; this process is called *design* (it can also be called composition or structure). The design principles help artists arrange the art elements; they are the grammar of the visual arts. An understanding of the design principles will afford you a method of analyzing your paintings, allowing you to become a critic of your own work.

Like the art elements, the principles of design are not used alone, but only in association with the other principles. If they are all used properly, the painting will probably be well structured and unified. The design principles are outlined briefly here, and will be mentioned throughout the book. More information on design and composition is available in some of the books listed in the bibliography.

Unity
If all the parts of your painting hold together, and seem to be cohesive, it is unified. Unity is a vital

The painting is visually unified, as the following analysis will show. Style, technique, light, spirit, and message are compatible, and unity is the result.

concern of the artist and the most important principle of design, because it involves the wholeness or completeness of the work. When you analyze your own painting, judge the unity of the surface by checking on contrast, balance, movement, emphasis, repetition and gradation.

CRITIQUE To analyze your own painting, ask questions about unity. Do colors work well together? Is there a dominant color? Is style consistent throughout the work? Do you sense a balancing of various elements? Does your eye move along similar values from part to part? Do your shapes have variety? Are they interesting? Have you established a full scale of values? Does it all seem to work together?

Contrast
Almost every painting has contrasts; they are essential to our "reading" of paintings. You have already learned about color and value contrasts in Chapter 4. But there are many other kinds of contrasts, too. Here are some descriptions:
- *Color contrast:* warm and cool; intense and grayed; color value contrast; contrast of hues.
- *Value contrast:* from dark to middle to light; dark against light; light against dark; middle value with accents of dark and/or light; and so on.

Contrast analysis This diagram illustrates shape contrast (variety of shapes); size contrast (from large shapes to small); line contrast (from heavy to light, curved to straight, inferred and actual); and directional contrast (vertical, horizontal and diagonal directions).

Balance analysis Balance is a "felt" principle. Imbalance would feel uncomfortable. The diagram shows that the painting is balanced asymmetrically. Values are balanced. Inactive (flat) and active (textured) areas are balanced. Directional movement is balanced.

- *Line contrast:* straight (geometric) and curved (organic); thin and thick; dark and light; continuous and interrupted; long and short; and so on.
- *Shape contrast:* angular (geometric) and free-form (organic); large and small; freestanding and interlocking; compact and stretched; vertical, horizontal and diagonal.
- *Size contrast:* one large size and several smaller sizes; large, medium and small sizes.
- *Textural contrast:* coarse and fine-grained; sticky and smooth; heavily-textured and lightly-textured areas.
- *Directional contrast:* horizontal, vertical or diagonal dominance with other directions supporting the main thrust.

CRITIQUE To analyze your painting, ask questions about contrast, such as: Is there a large dominant shape? Are supporting shapes of a good variety of size and shape? Are there contrasts in color temperature? Intensity? Hue? Is the value scale complete? Are there near whites and blacks? Are middle values interesting in variety? Can you "read" your painting from twenty feet or more? Are there contrasts in texture, direction and line?

Balance

There are no "balance rules" to go by, but your eye and body will help you sense balance in a painting. If one side is too heavy, too dark, too light, too textured, you must trust your senses to achieve balance. Imbalance is uncomfortable, and you will feel it. You need not balance with absolute equality of size, value or shape. Instead, balance an intense shape with a heavy, strong line, or a large grayed area with a small, intense color shape.

Symmetrical balance means two sides in almost perfect equality, which may be static and uninteresting. Asymmetrical balance is organic, a "felt balance" that does not rely on a mirror effect, and makes a more interesting composition.

CRITIQUE To analyze your own painting, ask questions about balance, such as: Does the painting feel balanced? Or does one side feel heavier than the other? Are similar colors represented in various parts of the surface? Are temperatures balanced? Warms and cools on each side? Are large shapes balanced with small, intensely colored shapes? Are values balanced to some degree? All darks should not be on one side. Are large inactive areas balanced with small areas of intense visual activity (texture or contrast)?

Movement analysis Passage and linkage movements are shown by short, fat lines. Long movement journeys on light or dark values are shown with elongated arrows. Line movements run along edges and on actual lines. Transitional movements are shown with fat-to-thin arrows. The direction of general movement leads toward the focal area, indicated by large interlocking circles.

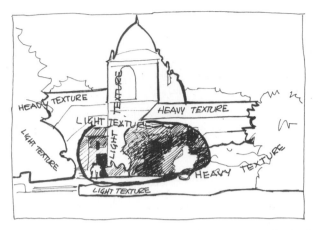

Emphasis analysis In this painting, the content emphasized is mission architecture, its warmth and age, and sunlight and shadows. Emphasis of art elements is placed on *color* (warm hues) and *texture* (in building and foliage). The geometric *shapes* of the architecture (heavy outline) are emphasized by placing them amid organic foliage shapes. Glazes are used as shadows to help emphasize the three-dimensional *form* of the building and the plants. The *focal area* (shaded) is given emphasis by the bougainvillaea, the light part of the building and the people.

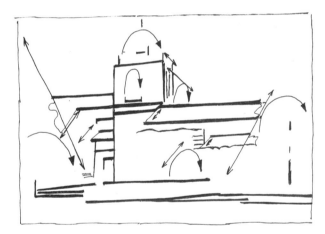

Repetition (pattern) analysis Roof shapes are repeated and their angles are repeated in shadows. The arching shape of the dome is repeated. The prickly foliage shapes are repeated in several plants. Horizontal and vertical lines are repeated, and diagonal lines are repeated and placed in opposition. Colors and textures are repeated — the magenta is mixed with greens and purples, and is in the roof colors. Values are repeated and balanced. The repetition of architectural lines creates rhythm, as do horizontal shapes on the right side. Repeated dark-valued windows, doorways and openings also create rhythm.

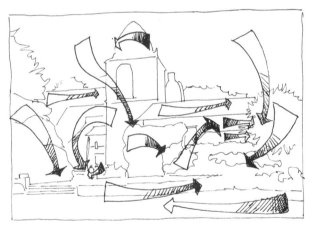

Gradation analysis Gradations are concerned with *transitions* of some kind — usually light to dark or dark to light values. The sky is graded subtly, and might benefit from an overall gradation. Colors and values are graded over the entire surface. Study the fat-to-thin shaded arrows in the diagram, then refer to the color photograph.

Movement

Movement describes the visual journey from one part of the painting to another. Our eyes move over connecting areas or shapes of some similarity, or over transitional areas. Such visual connections are called passage or linkage, and include:

- From one light-valued shape to another; or dark to dark; or middle to middle value areas (Two or three connected areas of the same value might be thought of as a single complex shape)
- From one color to a similar color (temperature linkage)
- Transitions from warm to cool or cool to warm
- Transitions from dark to light or light to dark
- Over connected lines or curves

Repeated movements in a painting, like repeated accents in music or poetry, can produce rhythms. Rhythmic repetitions can also produce visual movement, as along a succession of posts, trees, rocks or people.

CRITIQUE To analyze your painting, ask questions about movement, such as: Can my eye move from the edge of the painting to the focal area, over areas of similar value? Or over transitions of some kind? Are light (or dark) values connected to form passage or linkage? Positive and negative shapes should link in places. Can I move from corners into the painting? (Do not isolate corners.) Can gradation of value (with darker values at the edges of the painting) help keep movement inside the frame? If very dark or light areas are isolated, have I linked them to other areas of similar value? (not necessarily the exact same values).

Emphasis

Emphasis refers to three aspects of painting: 1) emphasis of content (what is being portrayed); 2) emphasis of art elements; and 3) emphasis on a focal area. In design and composition, the second and third emphases are most important.

Emphasis can be produced by making one element dominant — color, shape or line, for example. One particular element often dominates an artist's work and becomes part of his or her style of painting. Some emphasize texture or color more than line or shape. We use all of them, of course, and often change our use of them as we grow as artists.

Movement in painting is often directed to a *focal area*, a place of emphasis, where extreme contrasts can produce visual strength. Strong contrast of value, temperature, texture, size, etc., can all help produce focal areas, which may be small or large. Focal areas generally help organize your painting, providing opportunities to unite the surface through movement.

CRITIQUE To analyze your own painting, ask questions about emphasis, such as: Is there a dominant color? If not, how can I achieve dominance? Dominance implies emphasis. Is there a dominant shape? Supporting shapes? Is there a focal area? How is it emphasized? Can textural emphasis help the painting? Would glazes over one area help emphasize another area? Is light to be emphasized or lessened in importance?

Repetition (Pattern)

Repeating certain elements or things in a painting creates pattern. Repeated trees or roofs, for example, can make an irregular pattern. Repetition need not mean duplication; approximate shape or color repetition can create pattern. Such echoing of motifs will help establish unity and may even create movement. This is an example of how the principles of design often work together.

CRITIQUE To analyze your own painting, ask questions about repetition and pattern such as: Are shapes repeated in various ways? Are lines repeated in several ways and places? Do repetitions create rhythm and pattern? Are colors and textures repeated? Are shapes echoed?

Gradation

Gradations are smooth transitions of color, intensity, value or texture. In Chapter 3 you

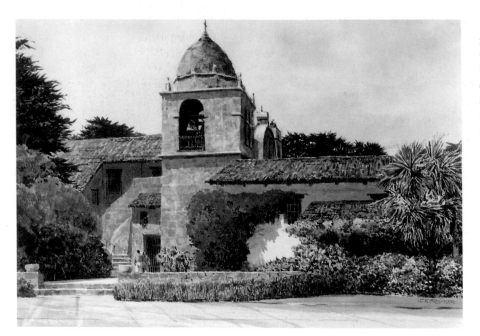

Variety analysis Although there is a noticeable dominance of color, shape and texture, there is still great variety within this painting. Look for variety of color (warms and cools), variety within color areas (many greens, for example), variety of texture, edges (feathered, soft and crisp), shapes, values, lines and sizes (largest sky shape to small people shapes).

learned about washes which can be graded by value, color or intensity. Large flat areas can be made more interesting by gradation of value or intensity. Skies are generally not flat, but have atmospheric gradation — darker at the top, lighter at the bottom. Storms or fog can create different sky gradations. The colors in water should be graded, not allowed to remain flat. Flatness can be dull, or can stand out if the rest of the painting is active. Gradation can produce subtle interest on a surface and make it more compatible with the rest of the painting, helping establish unity.

Line can be graded from thin to fat; textures from extreme to plain; shapes from roundish to squarish; etc. Remember that your eye also moves along gradations.

CRITIQUE To analyze your own painting, ask questions about gradation, such as: Is the sky or background graded in some way? (vertically, horizontally?) Are large flat areas interesting? Do they belong in the painting? Will gradation help? Can warm areas include cool gradations? If shapes are too regular, can gradation from wide to thin help? Are lines graded enough to be interesting?

Variety

As you scan the analytical questions about gradation, you will note that they seem to emphasize *variety*. Variety keeps paintings from appearing boring. However, there must be a balance between unity and variety. Too much variety induces chaos (the opposite of unity). Just the right amount adds life and excitement but does not destroy unity. Unity is essential to your work; variety is the spice that adds zest to your painting.

CRITIQUE To analyze your painting, ask questions about variety, such as: Is a single color, texture, shape, value or line dominating the work too much? Is variety constrained enough to allow unity to dominate? Is the amount of variety distracting attention away from the intended focal point? Is the composition static because too many elements are too similar to one another?

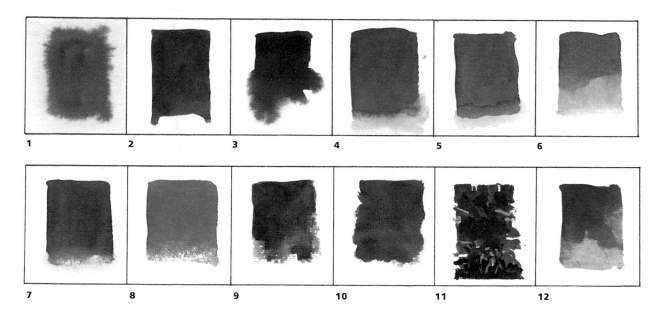

1 Color and shape on a damp surface (wet-in-wet).
2 Color and shape on a dry surface (hard edge).
3 Dry paper; add color shape on dry and dampened surface.
4 Color shape on dry paper; wet the edge immediately.
5 Color shape is dry. Rewet with water-color brush.
6 Color shape on dry paper; edge lifted with tissue stroke while wet.
7 Color shape dry. Rewet and scrub with bristle brush.
8 Color shape dry. Lift with eraser.
9 Dry brush, textured edge.
10 Feathered edge; pushing brush toward the edge.
11 Painted, interrupted edge; broken and painted over.
12 Color shape on dry paper; blotted immediately with tissue.

Edges, Passage and Movement

Edges of Shapes

In painting a watercolor, artists often begin by putting down the major shapes — usually saving the white shapes, adding the light and middle value shapes, and finally applying the dark shapes. These shapes have edges, which are often read as lines separating the color shapes. In the search for variety in painting, it is necessary at times to use several kinds of edges.

Paintings can be made with all soft edges (wet-in-wet) or all crisp edges (painted on dry paper). However, watercolors are usually more interesting when they contain both soft and hard edges, with one of them dominating. Soft edges give relief to a hard-edge painting; hard edges provide contrast in a soft-edge watercolor.

Soft edges can be made on dry paper by damp-ening an area with a soft brush and running color into the damp space. After you have put down a shape on dry paper, you can make a soft edge by immediately wetting one edge with a slightly wet brush and clear water. After an edge has dried, you

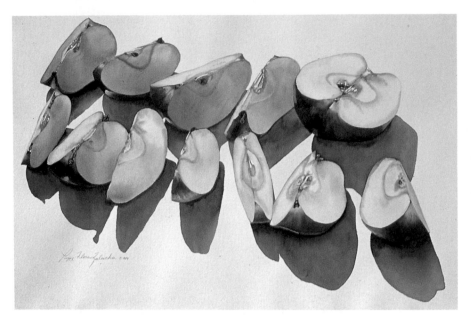

The shadows and apple shapes all have hard edges, but notice the colorful graded wash areas within the shapes. Study the passage of light to light, dark to dark, and middle value to middle value. Passage from negative space (background) to the positive shapes (the apples) has made the edges and parts of some apple slices almost disappear. Peggy Flora Zalucha, *One Dozen Slices #2.* 18 x 30" (46 x 76 cm).

can soften it by scrubbing it with a damp watercolor brush or a small, stiff bristle brush dampened with clear water. You can also use an abrasive eraser to soften a dry edge.

Edges can be broken to add interest. Dragging a brush and color along an edge will create a textured edge — an irregular line between rocks and moving water, for example. An edge can also be feathered by scumbling with a rather dry brush. Edges can also be broken by crossing them with lines or other shapes.

Passage or Linkage
Movement in a painting is often accomplished through passage or linkage — the connection or merging of equal-valued shapes. In some cases, edges between these merged shapes seem to disappear, allowing the eye to move easily from one to the other.

Soft edges can also provide passage, allowing a merging transition from one shape to another.

Study paintings throughout the book to discover the use of passage. Squint your eyes to find linked areas of the same or nearly the same values. Without passage a painting can seem like a checkerboard, with light shapes against dark and dark shapes against light, and no connections of equal value.

Generating Dynamic Compositions

From the beginning concept to the final touches, the development of your painting involves design — where to place dominant shapes, where to locate the center of interest, which values to use, how to relate colors and so on. Much of what you do is intuitive, governed by your visual experiences and your feel for your subject. But painting also involves decision-making, and how you make decisions reveals your personal sense of design.

The Design Process
FORMAT Your first major decision in making a watercolor is to choose the size, shape and proportions of paper that will work best with your subject. Should the painting be horizontal, vertical or square? Regular proportions or stretched? Large or small? How wide or how high?

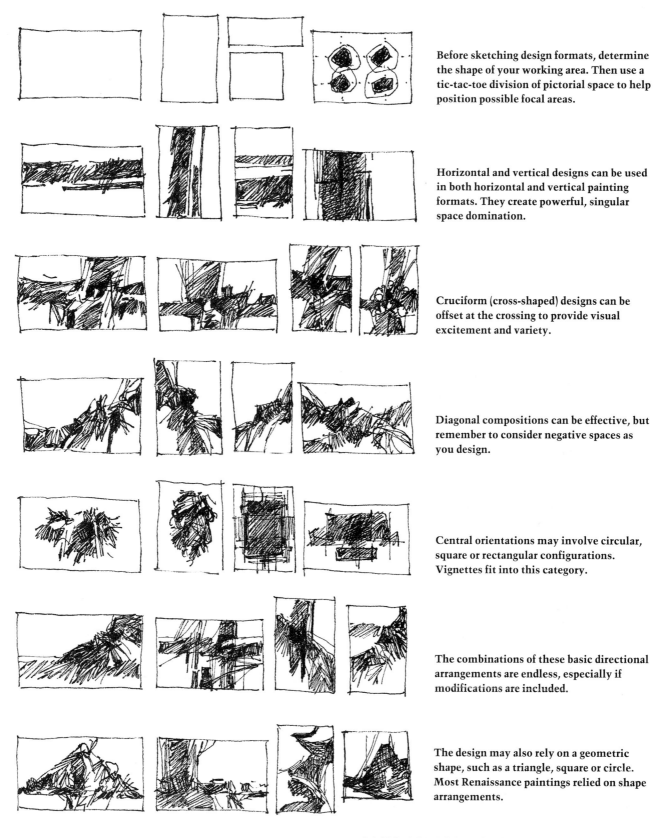

Before sketching design formats, determine the shape of your working area. Then use a tic-tac-toe division of pictorial space to help position possible focal areas.

Horizontal and vertical designs can be used in both horizontal and vertical painting formats. They create powerful, singular space domination.

Cruciform (cross-shaped) designs can be offset at the crossing to provide visual excitement and variety.

Diagonal compositions can be effective, but remember to consider negative spaces as you design.

Central orientations may involve circular, square or rectangular configurations. Vignettes fit into this category.

The combinations of these basic directional arrangements are endless, especially if modifications are included.

The design may also rely on a geometric shape, such as a triangle, square or circle. Most Renaissance paintings relied on shape arrangements.

Directional brushstrokes When all brushstrokes are laid down in the same direction, flatness is emphasized and form is minimized. If naturalistic subjects are treated this way, an exciting tension between reality and abstraction will exist. Seurat's pointillism and Cezanne's squarish strokes create a similar tension, flattening their three-dimensional subjects.

Tilting the foreground Instead of using a gradual transition into deep space, you can tilt the foreground, moving everything forward and condensing actual space. Things at your feet are seen vertically (from above) while distant objects are seen horizontally (straight on).

Wedging When large shapes are wedged together, our eyes move gradually into the distance, skating from side to side across the wedges. These wedges, which need not be actual land formations, can be defined by varying values.

Zigzag movement To allow space for a zigzag to develop, you should use a high horizon. Here the movement is defined by the lighter values, but it could also be defined by objects or dark or middle values.

Low Horizon A low horizon, like a high one, creates an unequal division of space, producing dynamic visual tension.

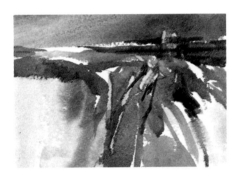

High horizon Placing the horizon line in the top quarter of the sheet forces movement dramatically upward and visually creates a sense of compression. It allows you to develop the foreground and provides space for establishing visual movement.

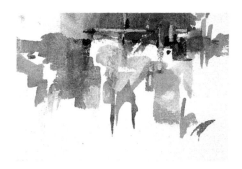

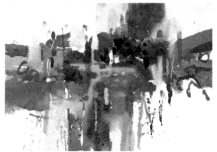

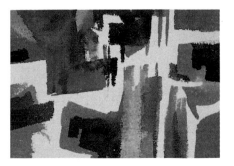

Vignetting In a complete vignette, the subject is surrounded by white paper. Partial vignettes, like this one, also generate excitement. Keep the corner configurations interesting and different from each other. Provide transitional areas to move from negative to positive space.

Cruciform Both horizontal and vertical directions are used, with the focal area located in the crossing section. Light from negative space must be able to move into the form, providing passage to the focal area. Movement on darker values is natural because of the arrangement.

Interlocking shapes Value contrasts can define interlocking shapes, which fit together like pieces of a jigsaw puzzle to unite the surface. Interlocking avoids monotonous shapes and straight edges.

FOCAL AREA Once the shape is determined, you should probably locate the center of interest, the focal area where the movement generated in the painting will culminate. American artist Robert Henri said, "The eye should not be led where there is nothing to see." Most paintings have focal points.

Euclid, a sage of ancient Greece, proposed the golden mean as the perfect proportional placement for the elements in a painting. His divisions of space were based on exact measurements, but a generalization of his arrangement can be made by placing a tic-tac-toe configuration inside your established borders (see chart on page 75). The four places where these lines intersect are prime places for focal points. This rule of thumb eliminates clumsy locations such as the corners or dead center, which can cause many problems when structuring your paintings.

SPATIAL ARRANGEMENT A few basic design layouts are sketched here to acquaint you with some compositional possibilities. These might appear simplistic, but they are based on observations of nature and of existing paintings, and provide basic means of visual organization. Remember, however, that many successful paintings ignore all formal directional orientation and emphasize overall patterns instead.

Make your own thumbnail sketches to simplify pictorial material into basic design formats: vertical, horizontal, square. Then apply some of these design arrangements, or combinations of them: horizontal, cruciform (cross shaped), diagonal, central. Such sketches should help you understand the underlying structure of paintings.

Another way to become familiar with organizational concepts is to make a series of small watercolor studies that emphasize only the major shapes and movements in paintings. Use these small studies (each one 5 x 7" in size) as a starting point when you begin designing your own paintings.

Altering the Painted Image

It has often been said that the watercolor medium is difficult because you cannot alter the painting in progress or when finished. This is not totally true, however. While it is easier to cover up mistakes or make changes when working with opaque media, changes are possible when working with transparent watercolor.

You might wish to change the path of visual movement in the foreground, shift the center of interest, change the color in a large part of the surface, eliminate parts of the background or change some size relationships. Such changes are not easily accomplished with transparent watercolor, but the painted image *can* be altered in several ways.

Before those methods are described, it is important that you understand the need for using good materials. Paper is the vital ingredient. Most of the better papers have a well-sized surface, a gelatin coating which allows lifting to take place because the paint lies on the surface. Color sinks into the surface of more porous papers, however, making it difficult to lift.

Experiment with papers to see how they react to lifting techniques. Some artists apply an extra layer of sizing (a diluted acrylic medium, for example) to their paper prior to painting to make it easier to lift or adjust colors.

Most painted colors can be lifted from a dried surface. Some tube colors are considered "staining colors", however. These are usually very transparent and filter quickly down into the paper's fibers, making them extremely difficult to lift completely.

Lifting Color

Before making changes on a dry, painted surface, it is advisable to lift some of the color from the paper. This can be done in several ways, depending on whether you need to rework large or small parts of the surface.

If the entire surface needs to be changed, you can submerge the painted sheet (if it is good paper) in a tub or large pan, and sponge off the surface. Some artists use a shower for this process, or a garden hose. Not all color will be removed, but often enough washes off so that a new surface can be painted.

A damp sponge can be used on selected parts of a dried surface. If a large area needs to be lifted, use a large sponge and a scrubbing motion. Scrub firmly, but do not overscrub the surface. Wipe the sheet immediately with an absorbent tissue to pick up some color and to dry the surface.

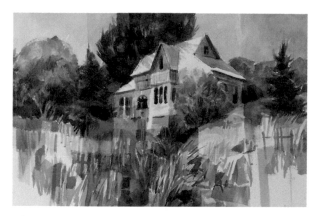

This demonstration shows several ways that watercolor pigments can be lifted and colors changed. The painting is about half finished, but needs some changes.

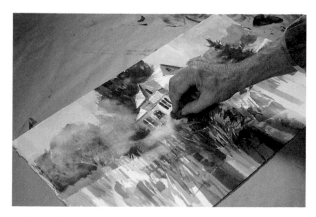

Color and value changes are needed in several places. Selected areas are wet with a sponge and color is lifted with absorbent tissues. Light is brought from the background into the positive shape of this cruciform design layout.

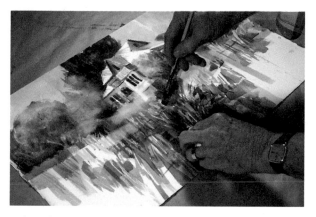

Selected areas are lightened by scrubbing with a damp bristle brush, then lifting with a tissue. These liftings help develop a light path through the dark foreground and pick up highlights on the hill and on fence posts.

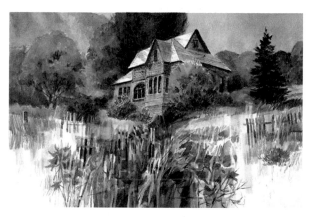

With positive and negative shapes interlocking, the finished painting is now better integrated. Eye movement over light and dark linkage is more interesting. Color is more typical of the desired autumn feeling.

If a smaller, controlled area needs to be lifted, put down pieces of drafting tape to mask out the areas you do not want to lift. Scrub firmly and quickly with a dampened sponge to lift the color.

A wet watercolor brush can be stroked or pushed over dry, painted areas to soften the paint, which can then be lifted with a squeezed-wet brush or with absorbent tissue. Tissue-lifting may not be necessary if the re-wet and pushed color is satisfactory.

A wet bristle brush can be scrubbed over a dry surface to soften and move color, which can then be lifted with a tissue or squeezed-out brush. The bristle brush will tear up the surface of the paper if scrubbed too much, so be quick and firm in your strokes. Some papers will be chewed up by such scrubbing; this process cannot be used on them. Some artists cut stencils of mylar or acetate and brush away from the edge of the stencil for a controlled lifting. A wet stencil brush can also be used for this lifting process.

A piece of sandpaper, stroked gently over the surface, will lift color from a dry surface. It works better on some papers than on others. Because the sandpaper is abrasive, it will scar the surface and overpainting may not be successful.

Color can be lifted in spots with an abrasive eraser or an electric eraser. Eraser shields can be used to protect those areas you do not want to lift. With any eraser, the surface is scarred, and over-painting with transparent color is not advisable.

Scratching Out Color

Scratching can produce changes in the surface by lifting and shifting color and adding texture. A dry surface can be re-wet with clear water or a color glaze. When this has set for a few seconds, it will have penetrated the color surface and dampened the paint. Using a chisel-shaped brush handle, a clipped credit card, a screwdriver or other tool, the newly-wet surface can be scratched to lift and push color aside. This should be done firmly and with as few strokes as possible, to prevent damaging the paper's surface.

Scratching can also be done on a dry surface with a knife or razor blade to remove color and allow white paper to show through. This can be very effective in textured areas or to make white lines, but since the surface has been abraded by the sharp tool, any color applied over the scratch will turn very dark. Remember also that razor-scratched lines are so different in character from the painted surface that they can destroy or interrupt the unity of the painting.

TWELVE TECHNIQUES FOR LIFTING COLOR

In each case the block of color wash was dry, color was lifted or scratched off in some way, and another color glaze was painted over the right half of the test block. The results show that color can be lifted and the painted surface can be altered; and that after lifting, a new color can be added, allowing a color change to take place. The following lifting and scratching techniques were used in these blocks:

1 Lifting color in a general area with a damp sponge.
2 Lifting color with a damp sponge, using a drafting tape stencil.
3 Wetting the dried block with a watercolor brush, and lifting with tissue.
4 Lifting with a damp bristle brush; blotting with tissue.
5 Using a damp bristle brush and acetate stencil; blotting color off.
6 Removing color with fine-grain sandpaper.
7 Using an abrasive eraser.
8 Using an eraser with an erasing shield (stencil).
9 Rewetting the painted surface, and moving paint with a chisel-ended brush and a credit card slice.
10 Scratching with a razor blade on a dry surface.
11 Rewetting the surface with clear water, and pushing with a watercolor brush to move paint; lifting with tissue.
12 Rewetting and pushing paint with a bristle brush, lifting off with tissue.

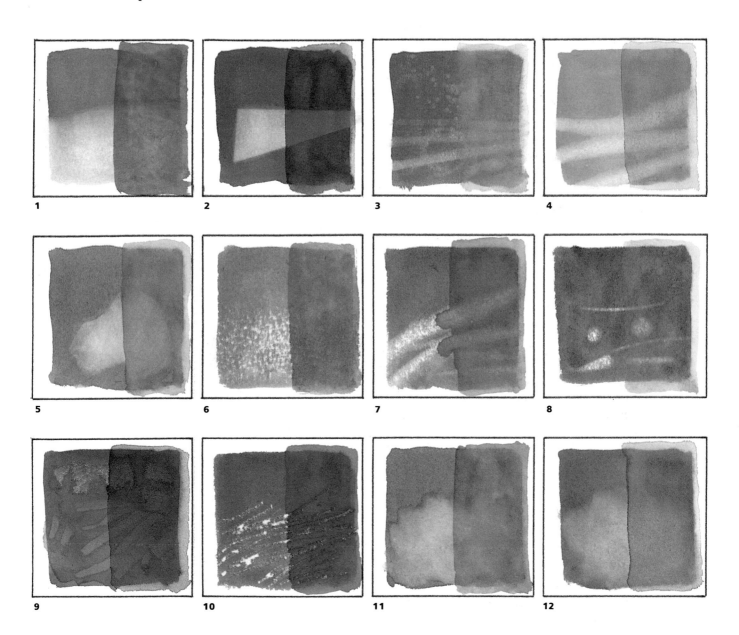

1

2

3

4

5

6

7

8

9

10

11

12

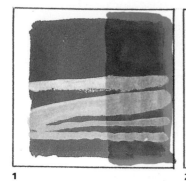

1 2 3 4

OVERPAINTING

Colors and values can be changed by over-painting with other watermedia. To see if a new color can be added over this newly applied color, a light color glaze was brushed gently over the right side of each test block. The media used are:

1 White designer's gouache. The color of the initial wash redissolves into the white, making a light blue.
2 White acrylic. The underlying color seeps into the white. Several more layers would bring it back to pure white.
3 White designer's gouache mixed with transparent watercolor. This allows a lighter color value to be laid on a darker background.
4 Yellow pastel applied in line and smudge, to add a contrasting and lighter value. A fixative was used before the glaze was applied.

Adding to the Surface

Alterations in watercolor paintings can also be made by adding instead of lifting. White paint (gouache or tempera) can be used to lighten areas which can then be carefully repainted. Brush color gently over the whites, or else a chalky color mix will develop. Diluted acrylic gesso can be used over large areas for the same purpose; this has a harder finish, so overpainting is much easier. Watercolor can be mixed with white gouache to make tints that might be painted over a watercolor surface. Again, take care to maintain the unity of the surface. If such additions are used in one place, they should also be added to other parts of the surface to retain consistency and unity.

Water-based pastels can be used to lighten, deepen or intensify colors by working them over a painted surface. Practice to find ways to achieve a unified surface.

The charts on this and the preceding page illustrate several ways to lift, lift and change, and add color to alter the painted image. Work on the backs of old paintings or on scraps of watercolor paper to practice some of these techniques.

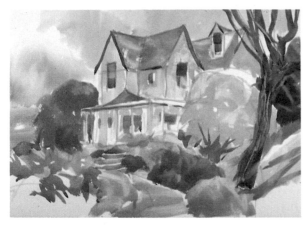

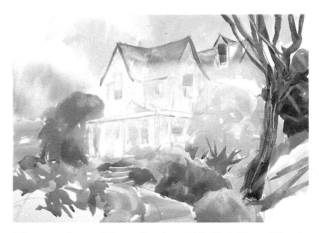

This watercolor of an abandoned house illustrates the first step in the painting process: applying light values of color freely and quickly. The developing image, however, does not give the desired feeling of a house on a hillside, so changes will have to be made.

The central part of the surface is scrubbed briskly and firmly with a damp sponge, then blotted with absorbent tissue and allowed to dry. Note that some of the colors remain as stained areas and pale lines and shapes.

A new drawing is made over the scrubbed surface, using watercolor and a pointed brush instead of a pencil. The roof lines of the house are the same, but the house itself becomes smaller and is pushed farther up, allowing the foreground to be more fully developed.

Watercolor is brushed onto the redesigned surface, much as in the initial painting steps, although values are a bit darker and hues a bit more powerful. The painting is not yet finished, but you can see the great difference between it and the initial image.

This painting was thought to be finished, but study revealed that it has two major focal areas: the house and the foreground tree. One should be reduced in importance.

To help visualize a drastic change, white bond paper is laid over the bottom part of the painting. Watercolor washes and marker lines are added to kill the intense white, and to help suggest the "feel" of the proposed revision.

A variety of rice paper pieces are collaged over the lower half of the painting. Textured papers are added to suggest rocks and tropical foliage, then allowed to dry completely. Notice how they cover the foreground of the painting.

A ¾" (2 cm) flat watercolor brush, used dry, begins the color building process. No drawing is done (although that is another option) and color is applied directly. One of the trees is darkened to push it back in space.

Colors are added over papers and built up over previous color washes. Movement, balance and emphasis are considered as foliage and rocks begin to emerge. Calligraphic lines in the top part of the painting are repeated below.

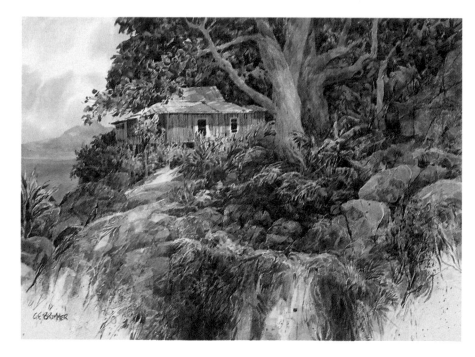

The finished painting is drastically changed. The house is now the sole focal area. Movement through the painting is more interesting (from lower right to upper left). The foliage and rocks help the viewer see the cottage. The out-of-focus foreground leads the eye easily to the in-focus house. There are also transitions from negative to positive space; from more abstract areas to more representational; from cool to warm. Colors, textures and values are repeated on top and bottom to help unify the surface.

Adding Collage

Major changes can be made by collaging rice papers or other absorbent papers over small or large parts of a completed painting. This process works best if the painting is done on heavy paper, or on lighter papers mounted on heavy board such as illustration board.

A variety of rice papers can be glued to the painted watercolor surface with slightly diluted white glue or diluted acrylic medium (half water, half matte medium). When this surface is *completely dry*, watercolor washes can be applied (see the demonstration). When brushing watercolor on the collaged surface, the brush must be quite dry — you may even have to blot off some of the color with tissue or a paint rag. This dry brush should then be stroked very lightly on the surface to allow textures to show. Experiment on the backs of old paintings to learn how to apply color most effectively. Try wet brush, dry brush, flat brush, and pointed brush with various strokes, even a worn out brush in a scrubbing motion.

Follow the steps in the demonstration sequence so you understand the sequential procedure. (See also Collage in Chapter 7.) Books on collage are listed in the bibliography.

Cropping

If your painting seems finished, and yet you are not satisfied with its look or feel, cropping might be part of the solution. Cropping is the process of trimming the painting to its best proportions, or eliminating an area or a section that does not feel comfortable with the total work. Trial cropping should be done by using two L-shaped pieces of matboard. These can be manipulated to provide an opening of any size and shape. Once you make your decision, a mat can be cut to the desired shape and placed over the painting.

Cropping can improve a composition that is out of balance or has objectionable elements. The horizon can be made higher or lower; too large a

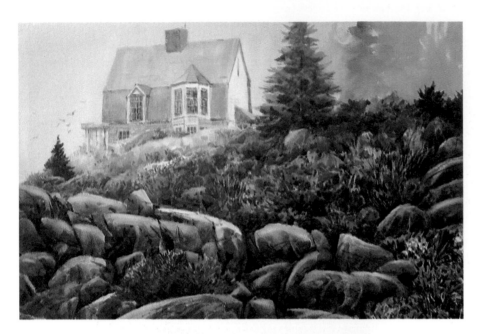

This painting of a coast guard house in Maine emphasizes the structure and its relationship to a rocky promontory.

Opposite:
The painting can be subdivided into many effective images, each with a somewhat different emphasis. Cropping allows a desired focal area and visual emphasis to be analyzed and selected.

Use two L-shaped pieces of mat board to explore cropping possibilities.

void (sky or foreground) can be lessened; the location of the focal area can be moved. Experiment to see how this can be done , and how effective the results can be.

Cropping can also help clarify what your painting is saying. Mood can be enhanced; emphases on certain areas can be changed; your feeling of purpose can be strengthened; your focal area can be made sure.

Cropping can also improve your technical presentation by eliminating poorly painted areas and emphasizing the best parts of the painting.

Parts that are too congested can be cut down or away; weakly painted areas can be blocked out; foregrounds or backgrounds that do not contribute positively can be reduced in area and importance.

Some artists never crop their paintings. Others crop all the time, and never produce two paintings of the same size. Cropping to them is part of the painting process. If you try cropping and find you like the result better than the full painting, you are simply showing your ability to recognize the better image, and to make artistic choices and decisions.

Repainting

If all methods of altering your painting fail, but you still like the subject and concept, the next solution is to repaint it. Identify your problems and eliminate them in your sketching for the second painting. Think of it as a sequel. Do not imitate the first work, but make necessary changes and paint freely. The second and third attempts at a now familiar subject seem to flow easily and directly. Perhaps your concept will change a bit, but that is fine. The idea is to paint energetically and easily to express your thoughts and ideas.

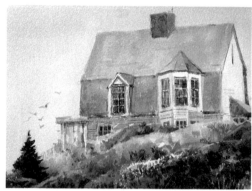

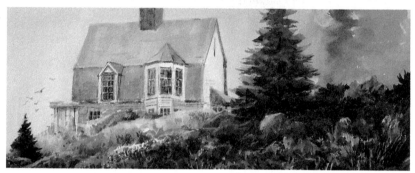

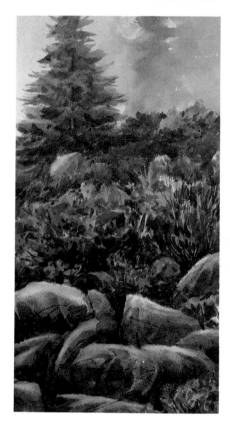

Exploratory Combinations

In an era of graphic experimentation and emphasis on unique visual effects, watercolor enjoys extensive popularity and creative application. Because of its transparency and water content, it can easily be mixed with other water-based media such as acrylic, tempera, casein, ink, dye, and gouache. It also mixes and works well with many dry media such as charcoal, colored pencil, graphite and pastel.

Its aqueous quality causes it to be resisted by oil, grease and wax-containing media; fascinating and complex surfaces can be produced with such combinations. In addition, watercolor can be applied to several kinds of surfaces: smooth, rough and textured watercolor papers, rice papers, collaged surfaces and even to some fabrics and canvas. Paper surfaces can be altered to create still further combinations of watermedia and ground.

Transparent watercolor has been combined with other media throughout its history. It was often mixed with various kinds of ink or with a white, opaque, tempera-like medium called *body color*, which was used for highlights and opaque overpainting. Today we use white designer's gouache for the same purposes. Graphite and tempera have also been used with watercolor.

Whether you mix media because it helps you express ideas or simply because you enjoy experimentation, remember that mixing media does not diminish the importance or integrity of the watercolor medium, but rather expands and extends its possibilities. Perhaps some of the explorations here will appeal to your sense of visual adventure.

Combining Transparent and Opaque Watercolors

Exciting colors and contrasts can be created by mixing transparent and opaque watercolors in the same paintings. Entire books have been written about combining watercolor with casein, gouache and acrylic. (See the bibliography.)

Combining opaque white (tempera or designer's gouache) with transparent watercolor results in an amazing array of different colors. You can experience this by dipping your brush in your watercolor source, and mixing the paint on a plastic surface with a bit of white tempera or gouache, then stroking it on paper. A pastel tint usually results, but deeper values can be obtained by careful mixing.

Transparent and opaque passages can be used in the same painting to create contrast, but care must be taken to keep them visually compatible. White opaque color might be spattered on a watercolor to simulate snow or the spray of crashing surf.

Acrylic gesso can be used to make a textured ground on which transparent watercolor will flow

Lyonel Feininger, an American artist originally from Germany, made countless sketches and paintings of marine subjects. Here he combined watercolor and ink over a pencil drawing on tan paper. The painting is high-keyed, and takes advantage of the transparency of watercolor washes. The ink lines fracture the surface into geometric shapes. Lyonel Feininger, *The River*, 1940. Watercolor, ink and pencil, 10 x 17" (25 x 43 cm). Worcester Art Museum, Massachusetts.

Paul Klee, *Refuge*, 1930. Oil, opaque and transparent watercolor on plaster-coated gauze, on paper-faced board, 21⅜ x 13⅞" (54 x 35 cm). The Norton Simon Museum, Pasadena. Galka-Scheyer Blue Four Collection.

Organic shapes painted with transparent and opaque watercolors have been combined with inks to create whimsical forms. Arshile Gorky, *Work on Paper*. Mixed watermedia, 20 x 24" (51 x 61 cm). Collection of Frederick Weisman Company.

and settle. Gesso (a white, chalky substance) can also be brushed over or mixed with watercolor pigments.

Combinations of watercolor and gouache can be used with rice paper collages, both to stain papers before collaging and as a medium to paint over the collaged surface.

Opaque black gouache can be used as a background color for paintings, particularly still lifes. Naturally, transparent watercolor cannot be painted over black, but if the black is carefully placed after the watercolor has dried, it will appear as a flat, velvety background for the luminous watercolor passages.

As with all exploratory combinations, it is a good idea to work for several days on scrap paper before jumping into a major painting. Some opaques will redissolve when watercolor is brushed over them, producing a chalky mixture. This may or may not be an asset. Try many combinations, observe what takes place while wet and after drying, and then apply your new-found knowledge and experience to your painting techniques.

Collage

Gluing papers of various textures or colors to the painting surface can provide some exotic grounds on which to apply watercolor. The collaged papers themselves can also become important parts of the developing painting, especially if texture is vital.

Any paper can be used, but soft, absorbent ones work better because they will not wrinkle when glued down. Oriental rice papers are superb, but expensive. Try using soft drawing papers, paper towels, tissues and other textured sheets. The ground or support for collaging should be heavier in weight than the papers you will collage. Heavy watercolor paper and various white boards are best. Although some boards will not accept watercolor washes, the collaged surface might.

Papers can be glued down with any of the PVA white glues, diluted with water. Wallpaper paste and other water-based adhesives will also work. Papers can be put down before painting starts, after an initial color layer is applied, or at any time during the building process.

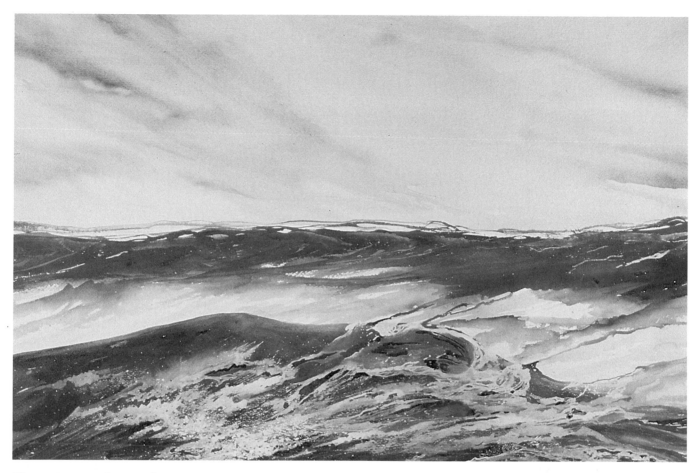

The transparency of watercolor contrasts with the opaqueness of gouache in the foreground of this ocean painting. The light-valued sky is in watercolor, and retains its luminosity. Mary Alice Braukman, *Summer Seas, Summer Skies*. Watercolor and gouache, 22 x 30" (56 x 76 cm).

Rice paper is well suited to representing the natural textures of rocks and tumbling water. Sarabob Londeree, *Ambiguous Cascade*. Watercolor and collage, 28 x 36" (71 x 91 cm).

Carole Barnes, *This Good Earth.*
Watercolor, acrylic and collage, 21 x 28"
(53 x 71 cm).

Hal Larsen, *View to the
Past.* Mixed watermedia
and collage, 30 x 40"
(76 x 102 cm).

Papers can be torn or cut, and glued flat to the surface. Lighter papers can be crumpled and wrinkled to build very heavy textures. Colored papers and shiny magazine papers can also be used, but they do not accept watercolor easily, and transparent watercolor washes will not cover intensely colored papers. You can, of course, add opaque watercolors or acrylics to cover whatever is underpainted or collaged.

The rice paper and watercolor process is demonstrated in Chapter 6 to alter a finished painting. The sequence is the same when building a painting from scratch, except the underpainting is not as detailed. 1) Put down some color and let dry; 2) add collaged papers and let dry; 3) apply color with a *very dry* brush; 4) add details and colors to finish; 5) add more collage when it is needed.

Experiment on the backs of old paintings, or over previously painted surfaces to experience the procedure and gain confidence in the technique. *Do not* use collage where it will cause you problems in finishing the work. *Do* try to use it where texture or other effects cannot be developed any other way. Or try it for the sheer joy of experimentation.

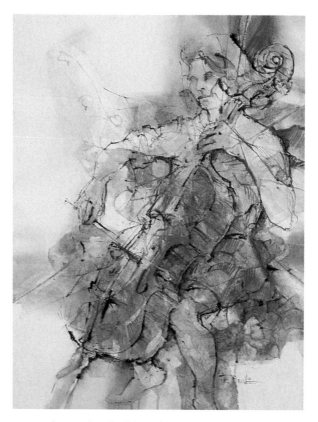

Watercolor was brushed down first in active, gestural washes. When it dried, ink lines of many thicknesses were added. Lawrence Brullo, *Cellist.* **Watercolor and ink, 22 x 30"** **(56 x 76 cm).**

Ink and Markers

Using watercolor with ink lines may not produce exciting textures or effects, but the combination can certainly change the feel of your work. Ink lines are generally used as edges, to cage colors in definite shapes; they can also run free. Inks can be applied with sticks, pens and brushes. Markers are self-contained tools available in a wide variety of shapes, nibs and colors.

Ink can be used to make a full-scale drawing before any color is put down. Watercolor can then be added over the lines, unifying the two elements. Lines may be left visible outside the core of the painting, acting as a transition from white paper through drawn lines to fully painted areas.

Ink lines can also be drawn over freely-applied watercolor washes. In such instances, the drawing will probably appear more important than the painting.

India ink is waterproof; added watercolor will not make it bleed. Some inks will run when water is added, and should be applied only over dry watercolor. Drawing into wet areas, however, can produce some wonderfully different kinds of lines. Try it.

Most markers will bleed when watercolor is added, so they should generally be used *over* the dry watercolor surface. The varying width of marker lines can be attractive in itself, and can also work well in developing interesting outlines for objects painted in watercolor.

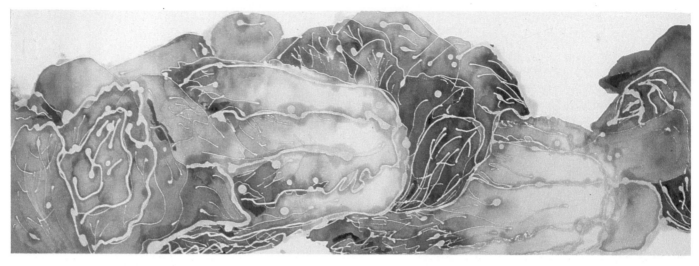

After drawing lines lightly with a pencil, a student artist used a batik tool to apply wax to paper. Watercolor washes were then run over the surface. Watercolor and wax, 9 x 24" (23 x 61 cm).

Neon lights and billboards are colorfully rendered by an art student using the wax resist technique. Heavy crayon was put down first, followed by medium or dark-valued watercolor washes. Watercolor and wax crayon, 18 x 24" (46 x 61 cm).

Wax and Crayons

Wax crayons resist watercolor. This phenomenon can be used to advantage in creating fantastic textural surfaces, or more subtly in portraits or landscapes.

Draw first with crayon and flow watercolor washes over the drawing, adding colors of darker value or contrasting hues. You can also add crayon lines over dry watercolor washes, and then brush contrasting washes over them. Mix up the process; draw into a wet surface. Use white candles to make a line drawing on white paper and watch what happens when the wet watercolor flows over it. Apply hot wax with a batik drawing tool and overpaint with watercolor. Be sure to use watery washes for the overpainting or the wax will not resist the overlays.

Paint and draw, scratch or scrape the crayon surface. Add ink lines, blot, scrape and paint. Experiment on small swatches of different papers to see how much variety you can achieve.

Some of the swirling lines produced with art masking liquid become edges while others are painted over. This treatment makes the lines seem to move in and out of the painted surface. Maxine Masterfield, *She Hides.* Watercolor and inks, 22 x 30" (56 x 76 cm).

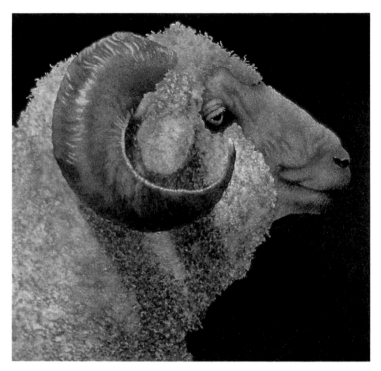

Will Bullas makes most of his watercolors without a painting brush. After carefully drawing his subject, he may lay down some light watercolor washes. But the real painting is done with toothbrushes, spattering color onto the surface. For each color applications he uses liquid latex to block out areas that should not be painted. After spattering all the color in an area, he peels off the latex and applies more over other areas that should not get the next color. He repeats this intricate process until all necessary areas are covered. He then spatters in details, using a set of plastic stencils to shield the areas to be protected. The finished work is made entirely of tiny spattered dots. Will Bullas, *A Sheep on the Job.* 30 x 30" (76 x 76 cm).

Stop Outs

Blocking out lines or areas that should not receive color can be accomplished with stop outs such as liquid friskets, rubber cement or liquid latex. These materials, which go by many brand names, resist watercolor overlays and can be removed again simply by rubbing with a finger, eraser or rubber cement pickup. These art masking fluids are also water-soluble if brushes are washed immediately after use. They work well on better papers, but can lift the surface of softer papers.

Art masking fluids are easy to control; fine lines can be put down with a small brush. Rubber cement and liquid latex are less predictable and more difficult to use precisely. **Note: These fluids should only be used in areas with active ventilation. Always read directions before using.**

Put down marks, strips or dribbles of stop out. When they dry, paint over them. When the color has dried, rub off the stop out. Apply again over dry watercolor; flow on more wash; rub off. Repeat the process until the desired surface texture, pattern or color is achieved.

White lines against dark backgrounds, ropes stretching over water, waves, birds, or abstract patterns can be masked off and appear white against the painted surface. Colors can be added to these white shapes or lines, or they can be left alone. A little practice will be beneficial before trying the process in a full scale painting.

Used with discrimination, stop outs can benefit some kinds of work. But be careful — the stop out technique should not become a crutch, or dominate the painting. It should always fit the overall concept of the work.

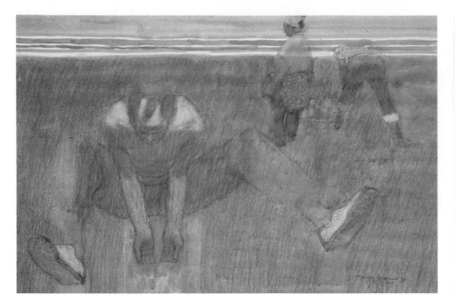

This work is more drawing than painting, but watercolor adds sparkle and life. Bringing a little color down into some of the heavily pencilled areas helps establish visual unity. Marbury Hill Brown, *Beach Combers*. Watercolor and pencil, 22 x 30" (56 x 76 cm).

Patterned designs can allow you to experiment with many media. Here the artist has added textures and lines over an abstract watercolor painting. Ray Schmit, *Fascia*. Watercolor, charcoal, pastel and markers, 27 x 21" (69 x 53 cm).

Drawing Media

Most artists use their drawing skills and drawing media to sketch or otherwise prepare for painting in watercolor. But drawing media such as pencils, charcoal, pastels, inks and crayons of various kinds can be integrated into paintings and become vital and visible parts of the work.

Graphite (lead) and colored pencils can be used over and under watercolor washes. These media make lines, of course, but can also be used for shading and to express volume or pattern. Try adding color, value or line to old paintings with pencils. Also try adding watercolor over an old pencil or charcoal drawing. Then see if the results encourage you to work in new directions.

Pastels and charcoal can be applied over watercolors to provide texture and a completely different feeling in your work. Some pastels artists work on a watercolor base; pastels can also be used for accents and color boosts.

Unique Painting Surfaces

Most watercolorists are happy to work on watercolor papers, which they have chosen after much experimenting. Others, however, enjoy the challenge of creating different working surfaces. Try building up the painting surface with collaged materials such as cut or torn papers and boards. The building-up process can be subtle if thin papers are collaged, relief-like if boards or heavy papers are used.

Normal watercolor papers have been sealed with gelatin sizing to provide an ideal absorbency for the normal application of watercolor washes. If you sponge or soak the paper, you will remove some sizing, thereby allowing colors to penetrate the surface — a technique used in many wet-in-wet applications.

It is possible, on the other hand, to apply additional sizing to seal the surface more completely. You can use diluted acrylic matte medium (a fifty/fifty mixture with water), colorless corn-

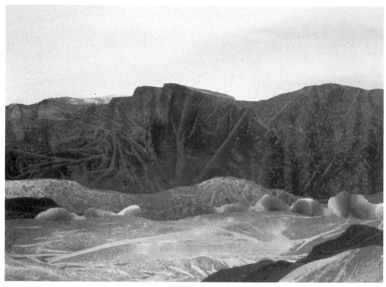

Illustration boards, watercolor boards and heavy papers have been cut and constructed to establish the architectural elements in this work. When such depth is built up, shadows will change as the light source changes. Guenther Riess, *Orange Square Crushed*. **Watercolor and acrylic construction, 32 x 26 x 3" (81 x 66 x 8 cm).**

June Johnston flows deep-valued watercolor washes onto hot pressed, smooth-surface sheets, and often lays wrinkled plastic wrap on top. After the entire package dries, she tears or cuts the papers into shapes that fit her landscape concepts. The torn papers are arranged and then glued in place. Sometimes she adds color. June F. Johnston, *Laguna*. **30 x 34½" (76 x 88 cm).**

starch, methylcellulose, or a prepared gelatin sizing. When such prepared surfaces are dry, the applied watercolor washes will not penetrate the surface, but will remain on the surface until they dry. This process produces characteristic settling patterns, especially when sedimentary pigments are used. Both wet and dry pigments can easily be lifted from this impenetrable surface by wiping, re-wetting and lifting, or by stroking with a wet brush and lifting with a tissue.

Acrylic mediums and white acrylic gesso can be used to prepare and texture a paper's surface. When watercolor washes and thinned acrylic washes are brushed over such surfaces, the developed textures will be emphasized because some resisting will occur. Wiping, scratching, sanding, scrubbing and other unconventional techniques will produce wonderfully complex surfaces. Explore on small papers to discover what kinds of surfaces you can develop.

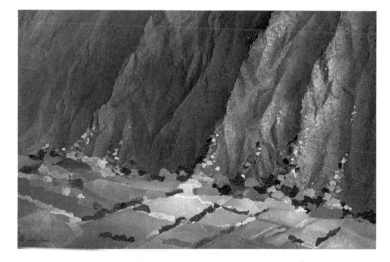

Before she starts on her painting, Ande Lau Chen colors several kinds of rice papers with watercolor by airbrushing or painting to get the desired textures, colors and effects. She then tears the stained papers to the desired shapes and glues them to a heavy watercolor sheet. When all of this is dry, she adds final touches with watercolor or acrylic paints. Ande Lau Chen, *Waipio*. **Watercolor and collage, 30 x 40" (76 x 102 cm).**

Developing Drawing Skills

Almost everything in painting begins with drawing. Drawing enables you to gather information directly, see your subjects more clearly and analytically, select visual elements creatively, organize spaces effectively and plan compositions intelligently. Drawing is a multipurpose activity, and in watercolor painting it is vital to several important aspects of the painting process.

Studying watercolor techniques — how to handle the medium, mix the colors, use brushes, create fascinating surfaces — trains the hand. Mastery of design elements and principles trains the mind, giving it the ability to organize, analyze, critique and solve visual design problems. Drawing deals primarily with training the eye, giving it the ability to see critically and respond selectively and directly to your subjects. Drawing can also help you organize space and select pertinent subjects.

In Chapter 10, you will learn about mood, content and personal expression — the development of your ability to involve the spirit in your painting.

These four aspects (use of hand, eye, mind and spirit) form a complete approach to the production of any art. You need all of them to express yourself fully, and it often takes many years to develop command of them all. In most cases, drawing is a vital activity in each area. The more you improve your drawing ability, the easier it is to express yourself successfully.

Sketching

As you will see in Chapter 9, there are many ways to gather visual resource material, but the most immediate and direct is by drawing. Many artists gather visual information in sketchbooks — a place to doodle, make sketches and drawings, try out ideas and record visual impressions. It is a place to keep supplemental verbal notes as well.

Sketching helps you see and understand your painting subjects. Any scene or object will be more familiar to you after you have looked at it carefully and drawn it.

Although sketches can range from a glimpse of a scene to a detailed study, sketching should be just what the word implies: quickly recorded responses to your subjects. Use your sketches to gather visual information, select elements to include and make trial arrangements. Do not necessarily make finished drawings. Try leaving the details and finishing for the painting process, or your work may lack spontaneity.

Consider your sketchbook a visual diary. You may not make paintings from every sketch, but making the sketches is the best way to learn to see your subjects.

Opposite:
Location drawings from the author's sketchbooks. The drawings are done with a variety of media, but all were made for the purpose of gathering visual information.

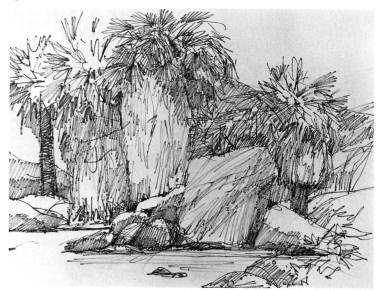

Sketchbooks come in many sizes, shapes and colors, but the only important consideration is the paper inside. Choose sketchbook paper that fits the medium you'll use to sketch.

Palm Trees, California. Felt-tipped marker, partially dry. Value and textures added to contour drawing, 12 x 18" (30 x 46 cm).

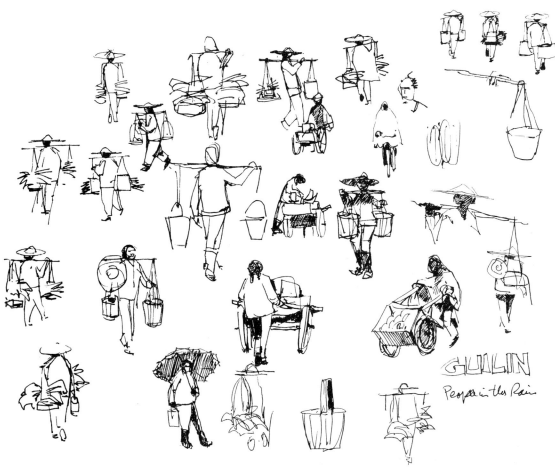

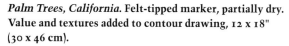

People in the Rain; Guilin, China. Contour and some value in medium-line metal ball marker, 11 x 8½" (28 x 22 cm).

Select four or five elements from your subject environment, isolate them and draw them in a simplified, linear style. Then explore a number of possible arrangements of those parts, before beginning your painting. Here, notice how the large trees are moved around in the small sketches.

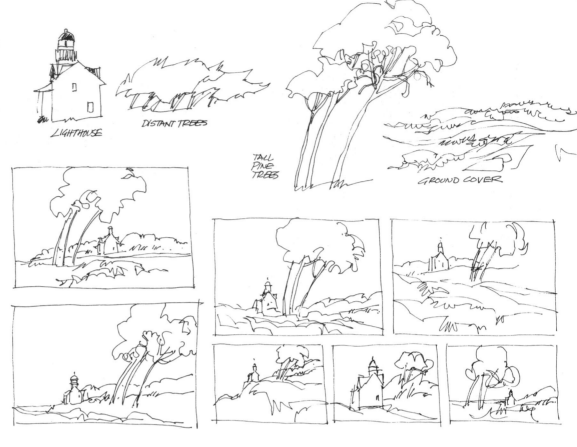

LIGHTHOUSE

DISTANT TREES

TALL PINE TREES

GROUND COVER

Try several design concepts. Here, three have been selected, and then each is explored with several value arrangements, to help establish linkage, movement, balance and value systems for the painting. Such sketches can be used for reference and to help solve visual problems while you paint.

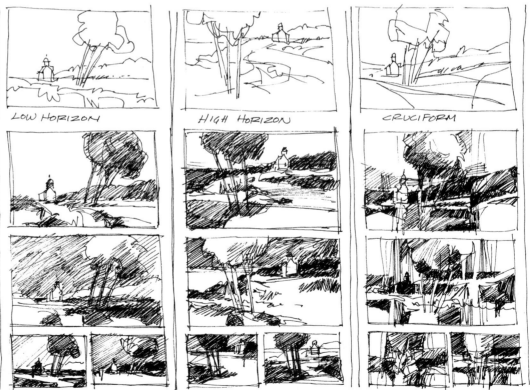

LOW HORIZON

HIGH HORIZON

CRUCIFORM

Several gray markers of different values are used here to explore arrangement and value possibilities while painting on location. The lean of the tree is critical to movement and rhythm in the painting, and is tried in several directions. Several value patterns are also explored. Gerald F. Brommer, *Robinson Canyon Oaks.* 22 x 30" (56 x 76 cm).

Planning Your Composition

Once you have selected your subject, your picture planning can begin. Where are the elements to be placed? What will be featured and emphasized? How should things be arranged? These and other questions can be answered on scratch paper by exploratory drawings. (See Generating Dynamic Compositions, Chapter 5, for examples and ideas.)

Your task as an artist is not necessarily to imitate what you see, but to help others see things as you see and feel them. Draw and arrange your painting as you feel and sense it should be. Select what you wish to include. Then begin to arrange and rearrange the elements to express your point of view. Four or five major elements (rocks, bushes, water, sky and birds, for example) can be arranged in dozens of ways. Draw several and select the one with which you feel most comfortable.

When you are working from a still life or posed figure, you will not need to rearrange the subject, but sketch it quickly a few times to become familiar with shapes and size relationships.

When you are happy with the composition, draw it several times, using any medium with which you are comfortable.

Exploring Value Contrasts

Drawing can help you develop value patterns in your subjects prior to painting. Some artists like to build their value systems as their paintings develop, but most prefer to have a general idea of where they are going before they begin.

You can discern values in nature by squinting your eyes to eliminate detail, concentrating on areas (shapes) of light, medium and dark values. These areas can also be seen by looking through a sheet of colored plastic, such as red. Natural colors

will disappear and only value shapes will be visible. These shapes can be drawn on scratch paper or in a sketchbook, and shaded to approximate the value patterns in the subject.

Very seldom are the values in nature in perfect compositional relationship to each other. The artist must make adjustments to provide effective visual movement and interesting shape relationships. Try several revisions as you explore the possibilities. Lights can be made dark and darks made light to improve composition, express mood or make the composition more exciting. Be daring in your sketching, since now is the time to experiment, not after you have started the painting.

You can draw these sketches with great or minimal detail, depending on your needs. If you like to plan ahead carefully, work more diligently on your value sketches, so there will be no surprises when you start to paint.

Drawing to Begin a Painting

Once the looking, sketching, arranging and rearranging have taken place, the subject should be quite familiar, and your design concept should be pretty well established. The next drawing activity is to work directly on the watercolor paper, positioning the major shapes and elements, and indicating as much detail as you feel is necessary to construct the painting.

Naturally, the amount of drawing done before the painting starts varies from artist to artist. Some subjects require more detailed drawing than others. Many artists draw very carefully and with extreme detail, even using a grid plan to make sure everything from their sketches or photographs is located correctly. Some use carbon paper, or rub pencil or charcoal on the back of a full-sized sketch, to ensure the accuracy of their drawing on the watercolor paper. Others sketch quickly but roughly, only blocking in the major shapes, and not including any detail at all. The amount of

Two types of drawing are emphasized in this demonstration: 1) the location sketch, and 2) drawing to begin the painting process. The sketch was begun as a contour drawing on location in China. The value shading and textures were added later. The sketch was then used as resource material for a watercolor.

drawing done prior to painting is a matter of personal choice.

How much drawing and detail you wish to include will help determine the medium you use. You can draw with large, flat carpenter's pencils or thick or thin lead pencils. Some artists draw on watercolor paper with ballpoint pens; other use markers or pens with indelible ink. If simple, large shapes, gestures and movements are put down first, you can try drawing these with a pointed brush and a light-valued wash.

Experiment with this initial drawing phase of the watercolor process — it is critical to your painting, and you should be happy with it. If not, make changes immediately. It is far easier to change the shapes, proportions and locations now than it will be after the painting is under way. You need not feel locked into your drawing, because you may wish to make changes as the work progresses. In the work of some artists, you can see that the pencil lines were not followed when the color washes were brushed in; they only served as approximate edges for shapes.

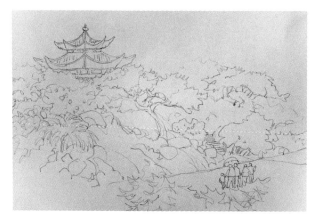

A detailed pencil drawing was done, with all the elements carefully placed. The relationships and proportions can be changed and adapted to the paper's proportions.

A gestural drawing with a large carpenter's pencil helps loosely position the major elements. Movement and flowing rhythms, rather than exactness, are stressed.

A gestural brush and watercolor drawing is used to place major shapes. The lines seem to be calligraphic and active and are a response both to the sketch and the remembered visual experience.

As with other aspects of painting, the initial drawing is a personal statement. Do not feel that you must forever start your paintings in the same way, or as someone else begins theirs. Experiment with various techniques until you find one that helps you start the painting process with confidence.

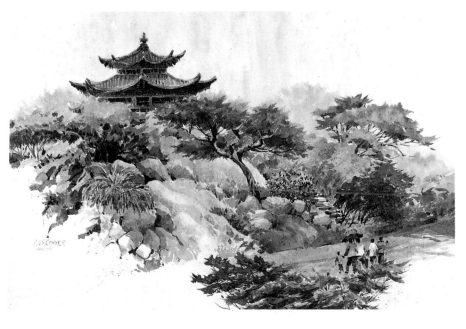

Colors, atmosphere and mood were recalled as the painting developed in the studio several months later. Gerald F. Brommer, *Garden in the Rain/Hangzhou.* 15 x 22" (38 x 56 cm).

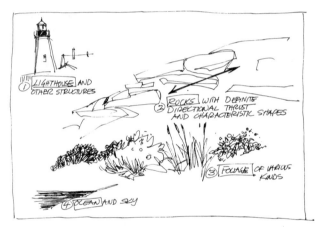

The photograph was taken with a painting subject in mind. Lighting is good; there is a fine gradation of sky value and color; strong diagonal lines add excitement; good contrast exists between rocks and foliage; there is a well defined focal area.

From Resource Sketch to Watercolor

The demonstration shown here summarizes the entire watercolor painting process: from subject selection, through drawings and sketches, to a finished painting. As you follow the demonstration sequence, you may want to refer to previous pages to help you tie the various aspects of preparation together: color selection, concepts, compositional elements and principles, drawing procedures and watercolor techniques. Remember that painting is not merely putting paint on paper, but involves thinking, preparation, knowledge, attention and skills. You should also realize that from a single subject (in this case a photograph taken on the coast of Maine) many satisfying paintings can be made.

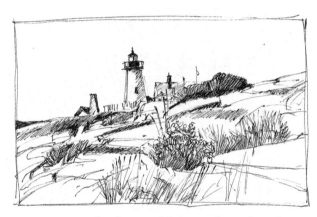

Sketching from the photograph helps me determine what parts I like best: color of foliage, structure of the buildings on the other side of the rocky hill; powerful rock forms; lighthouse; isolation; protection. The metal fence is an unwanted element and has been omitted.

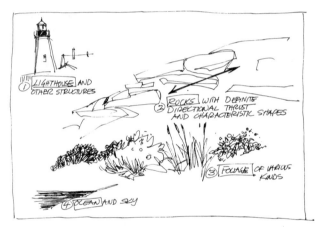

Selecting and isolating major elements helps me recognize and understand characteristic shapes and textures. These elements can be rearranged, emphasized, eliminated or made less important as my concept of the place and the painting develops.

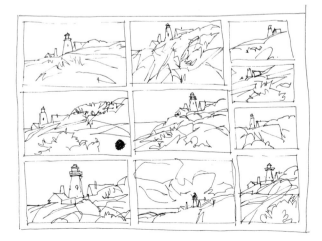

I arranged the major elements in different ways in several small drawings. The largest sketch is only 1½ x 2¾" (4 x 7 cm). By doing this, I can begin to sense what arrangement appeals most to me. (The one I used for the final painting has a large black dot in it).

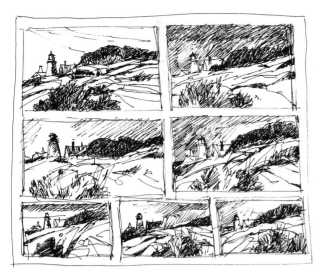

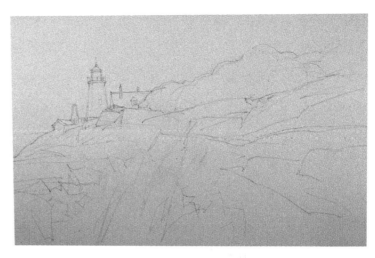

This group of value studies was made after I decided on an arrangement of elements. Mood and emphasis change as value patterns and arrangement change. By manipulating values, I can see that rocks, sky or buildings can be emphasized, as can mood. Such value studies offer a variety of approaches to visual movement toward the focal area of the lighthouse.

Using my small sketch (the one with the black dot) as a guide, I drew quickly and loosely with a large pencil on 15 x 22" (38 x 56 cm) watercolor paper.

The finished painting is based on the photograph, but was not copied from it. Colors changed as the feeling and concept developed. The sense of isolation and purpose of the lighthouse was intensified, and is the basic message of the work. All the parts of the painting (subject elements, color, value, structure, composition) reflect this concept: lighthouses are built in rugged places to protect ships from a dangerous shore, especially in foul weather.

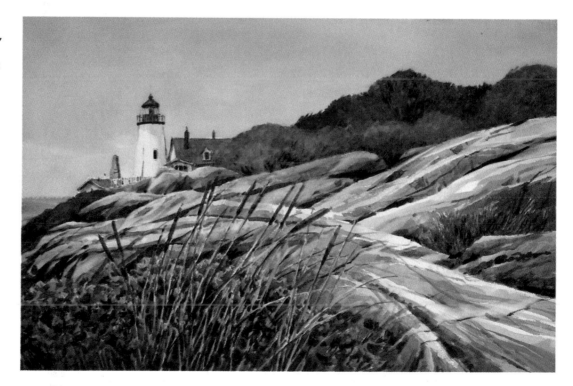

Exploring Subject Matter

Once you have become familiar with watercolor, understand the basic principles of design, and have learned the importance of looking, seeing, and drawing, you are finally ready to consider making paintings. Of course, anyone can make paintings by applying paint to paper, but when you have a knowledge and working understanding of media, techniques and design, you are prepared to create meaningful and effective expressions on paper.

Before you actually begin to paint, you must learn to see or imagine what you want to paint — your subject matter. That usually requires resource material, which helps trigger your visual responses. Where do you go to find subject matter? Once you have found it, how do you begin to paint it? Once you start your painting, how do you determine what you are going to say or express about your subject?

Favorite subjects vary from artist to artist, and you'll probably need to explore many subjects before you find those that feel comfortable or challenging to you. The rest of this book will lead you through an exploration of typical kinds of subject matter for watercolor paintings. You'll see how some artists have approached these subjects. Try to learn from their examples.

Use your drawing and painting skills to explore many different subjects. Make notes about how various subjects and treatments of them make you feel. Learn to express these feelings, and become aware of your abilities, likes, dislikes and skills, as artists for hundreds of years have done.

CHAPTER NINE

Sources of Subject Matter

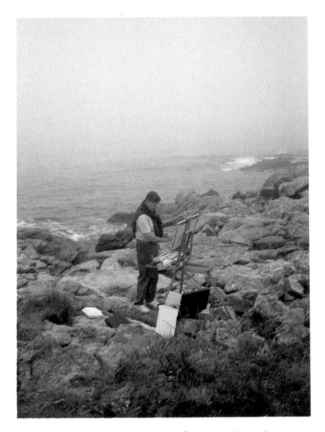

The author painting on the coast of Maine. His equipment includes a portable easel, drawing board, paper, palette, water container, box of tissues and brushes. Sketchbooks and a carrying case are on the ground. Whether they work standing or sitting, with the paper nearly vertical or at an angle, location painters share a love of working in the natural environment.

Previous page:
Edith Bergstrom, *Palm Patterns*, (detail).

Many watercolor artists consider location painting to be the premier art experience. There are just as many, however, who prefer to do all their work in studios. These are personal preferences.

Artists who work from location subject matter have several choices open to them. They can:
- Begin and complete paintings on location.
- Start on location and finish in the studio.
- Gather resource information on location and do the entire painting in the studio.

Studio painters have even more options from which to choose. They can:
- Work from sketches made on location.
- Work from photographs taken on location.
- Work from still lifes or set-ups in the studio.
- Work from models in the studio.
- Work from stored imagery (memory).
- Work from previous paintings.
- Work from pictures (from magazines or books).
- Work from imagination.

Subject matter includes everything paintable. If you have options, you generally choose subjects that appeal to you. Some subjects might offer a challenge or appeal to your sense of beauty; some require your interpretation; some arouse strong feelings; some might be commissioned by a buyer or assigned by an instructor. Whatever the circumstances, you should approach each subject with

enthusiasm and the desire to learn. Every subject, no matter how mundane it might seem, carries for you the potential for a greater understanding of your painting attitude, improvement of your skills, and a sharpening of your ability to communicate your feelings and ideas.

Direct Observation

Watercolor was first used as a field sketching medium, to produce color studies from which oil paintings were made in the studio. In other words, it was a resource gathering technique. Today, many artists still feel that working from direct observation is the best and most appropriate way to use the watercolor medium. Direct observation heightens your ability to see, to be selective and to interpret what you see and experience.

Direct observation may involve working on location or in the studio, working from a model or from still life or floral set-ups. Basic techniques include: 1) selecting the subject, 2) drawing the elements you wish to include, 3) composing the elements and designing the sheet, and 4) making the painting.

Most artists follow this or a similar procedure, although some work directly on the paper without any drawing at all.

You may travel to far away places to paint on location, but you can also do it in your own backyard. Your entire physical environment then becomes potential subject matter. In the studio you may observe still life objects, dolls, flowers or figures. No matter where you do your observation, looking at real objects will help you understand form and proportion, see physical relationships, and observe texture, color, shape and value contrasts.

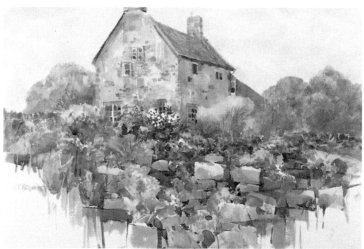

The photograph of a house in England was taken *after* the location painting was made. You can see that the subject was interpreted rather than duplicated: the foreground rock garden was given much more space and color, the background trees were moved and the light changed. Gerald F. Brommer, *Cottage at Combe Hay.* 15 x 22" (38 x 56 cm).

Your sketchbook is an ideal place to record the elements in your visual environment. Your sketches of people, places and things help you sense your subject matter preferences and provide insights into your own thinking and seeing. Most of the figure and landscape paintings in this book were done from direct observation.

The artist brought a natural element into the studio for observation and painting, and makes us feel its significance and importance. Ruth Burden, *Nest*. 14 x 19" (36 x 48 cm).

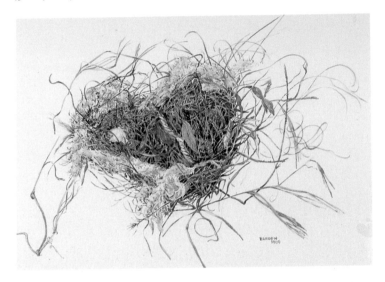

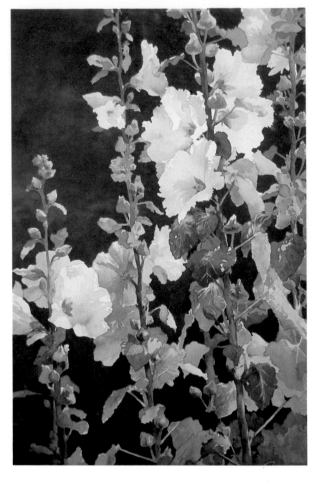

These white hollyhocks were painted on location, outdoors, using natural light. Observation of details is possible because a close-up and not a panoramic view is involved. Leo Smith, *White Beauties*. 30 x 22" (76 x 56 cm).

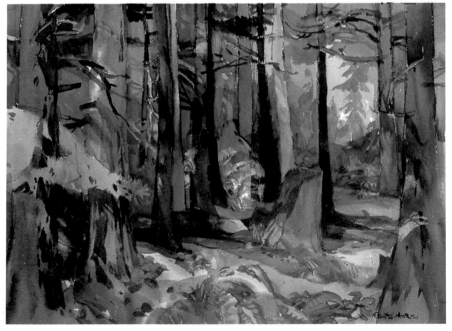

This artist paints most of his landscapes on location, changing and exaggerating colors, moving or leaving out major elements. But you can still feel and sense the muffled quiet and filtered light of a redwood grove. Robert E. Wood, *Sheltering Redwoods*. 22 x 30" (56 x 76 cm).

Explore painting designs, subjects, trial arrangements and visual formats in your sketchbook. Sketches such as these will help you arrange pictorial elements in comfortable groupings.

Sketches

The most direct way to gather subject matter information is to sketch. This is done most conveniently in sketchbooks, where visual information is organized, easily stored and readily available.

There are many kinds of sketching. Most of your sketches will be reactions to your subjects, but you should also spend time re-sketching, developing formats and motifs, recalling imagery and simplifying from remembered images. Using the sketch as basic resource material, you can:

- Rearrange and redesign the elements to make effective painting plans, re-sketching if necessary.
- Make value sketches based on your on-the-spot drawings, adapting them to suit your painting concepts.
- Use the sketch information to draw directly on your watercolor paper.
- Rely on your remembered imagery for colors, mood, emphasis and content.
- Make color notes and verbal notations in your sketchbook, as some artist do, to aid in recalling necessary details.

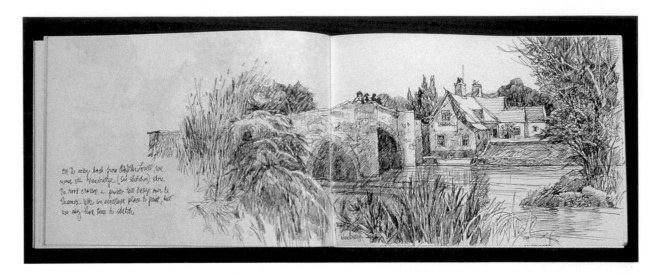

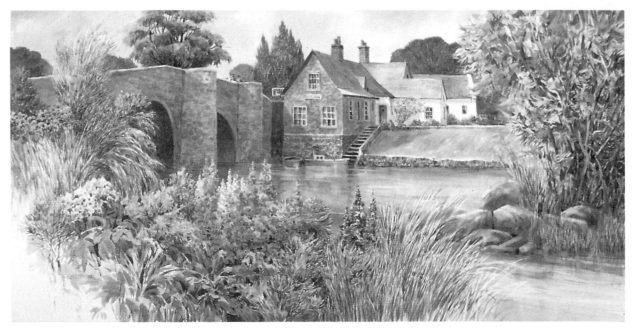

The sketch of a roadside pub in England was made on location. The painting was done in the studio later. Can you see how the final painting differs from the sketch? Gerald F. Brommer, *Crossing the Thames near Oxford.* 24 x 48" (61 x 122 cm).

• Use some or all of the above activities in combination to determine your treatment of the painting.

Sketches, therefore, are resource materials that can be as important as nature, models or objects. They can trigger ideas and concepts that are only distantly related to them. You need not copy a sketch exactly or even loosely. You may simply react to it and make a painting that differs from it in many ways. Consider your sketches and sketchbooks your visual encyclopedia — use the ideas to get you started, and then react to the painting as it evolves.

Photographs

Watercolor artists are notorious for braving severe topography and extreme weather in search of just the right outdoor location. But such fulfilling sketching and painting experiences are not always possible or desirable. Perhaps it is raining; light or mood is changing rapidly; there is not space to set up an easel; you are moving in an automobile or boat and see a great subject; animals refuse to sit still; you need time to study details. In these and other cases, photography comes to the rescue.

When Gustave Courbet, the nineteenth century French realist artist, was introduced to the camera and its possibilities, he excitedly said, "The camera will be my sketchbook." The role of the camera to artists, as Courbet indicated, is to help them remember and understand what they see.

You can work from a photo or slide the way you would from direct observation. Show slides in a partially lit room. Select the parts of the composition you wish to include, and then sketch to develop you ideas. Limit yourself to five or ten minutes to avoid too much detail. Work with large shapes. Paint from the sketches, not from the slides.

Your own photographs will be your best source for paintings, because they show the subjects you prefer and reveal your own sense of visual design, but you may also develop paintings from pictures in magazines or books. Work freely from the photographs of others: be selective, sketch, analyze, rearrange and develop the painting in your own way.

Both color and black and white photographs are usable. Black and whites help you see value contrasts, light and shadow, form and texture. They encourage you to be interpretive in your selection of colors. If you are painting in a photorealistic style — producing a painting that looks like a photograph — color photography will serve your needs best.

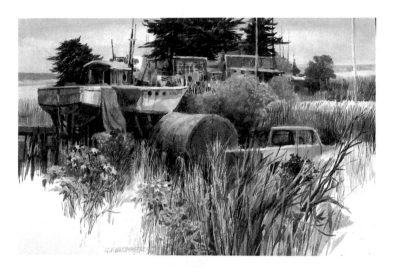

Components of two photographs were isolated, rearranged, and combined to create this watercolor painting. The painting was done as a demonstration in a workshop, and photographs were essential. Gerald F. Brommer, *Moss Landing Impression.* 15 x 22" (38 x 56 cm).

Cans and fruit were arranged on a beach towel to be photographed. The artist uses her photos as prime resource material for her stylized paintings. Sandra Beebe, *Litter Series: A Classic Still Life.* 22 x 30" (56 x 76 cm).

Photographs can help capture actions and expressions in animals and children. Karen Frey, *The Baby Yawning.* 12 x 16" (30 x 41 cm).

A photograph was the only resource material used in preparing this large painting. The artist cannot work from nature because the light and color constantly change, and her works often take many days to finish. Edith Bergstrom, *Palm Patterns 103.* 30 x 38" (76 x 97 cm).

Light, its reflection and refraction are the topic of this large watercolor, developed from a photograph. Duplicating the effects of light passing through glass is exacting work. Meg Huntington Cajero, *Crystal Flares.* 30 x 40" (76 x 102 cm).

A photograph of an old engine provided the subject matter for this watercolor. The artist has almost duplicated the photograph's textural detail, value contrasts and color. This style of painting is called photorealism. Alexander Guthrie, *How Long Will it Last?* 22 x 30" (56 x 76 cm).

Photography allows this artist to paint a still life that might not survive the several weeks it takes to finish the painting. Peggy Flora Zalucha, *Six Oreos & Milk on Funnies.* 40 x 26" (102 x 66 cm).

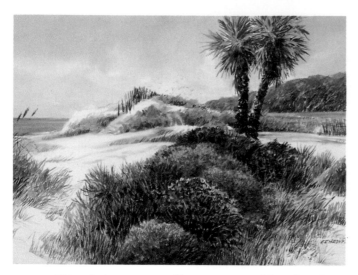

This painting was created from memory, without location sketches, after a half-hour walk along the coast. Gerald F. Brommer, *The Dunes at Myrtle Beach.* 15 x 22" (38 x 56 cm).

Painting Remembered Images

Remembered images are among the best and most useful resources available to artists. They are personal, instantly available and take up no space whatsoever. You may call it "working from memory," but it is actually working from stored visual images.

If you have really looked at your visual environment during your lifetime, you have stored hundreds of images in your memory bank. Most of what you store will remain untapped, but when you are painting or drawing in your sketchbook, you can access this resource material as potential subject matter. This process is called *imaging*.

Think of imaging as different from using your imagination: imaging is remembering things you have seen in the past; imagination generally involves flights of fancy and images that are not based on actual experiences.

Imaging is not the easiest way to develop paintings, because you have no actual visual material from which to work. You must rely on your memory and your painting experience to supply all necessary resource materials. The result will be the essence of the place, person or things as you remember them. You can often capture the feeling of the subject better by imaging than by working from it directly, because you will recall only the parts that you feel are essential.

Try imaging from a recent vacation, trip or drive. Think about the remembered subject and start to make thumbnail sketches. When one of the little sketches *feels* right, develop a larger sketch and then a painting. Or sketch a few remembered objects from your recollections of a place and arrange them carefully. These exercises will strengthen your ability to recall and sketch what you have seen.

The "imaging" process often begins with sketches and doodles. These thumbnail sketches of Oaxaca, Mexico were made to capture remembered images. One might be the basis for a full-page sketch or a complete painting.

Imagination

Painting from imagination implies working with "unreal" subject matter — things that do not exist or cannot be experienced. Fantasy paintings and many nonobjective paintings have their sources in the imagination of artists.

Sketching and doodling without resource material is a good way to start fueling the imagination. Emphasize the invention of new forms, weird creatures and plants, unreal contrasts and proportions, conjured images and fantastic landscapes.

Play with color, shapes, pattern and texture. Try finding and isolating subject matter from a background of colors and textures. See things where they do not exist and paint them into existence. Place representational or abstract forms in unnatural circumstances and relationships. Explore, experiment, invent and play with techniques and subjects, trying to refrain from traditional or representational approaches.

The absolute impossibility of this playful subject is the basic concept in this artist's work. He says, "Paint anything that flies, walks, runs, pops, jumps, falls, floats, hurts, laughs, etc.!" Miles G. Batt, *Over the Ampersands*. 23 x 30½" (58 x 77 cm).

Frequent flights over southwestern America inspired this artist's approach to landscape paintings. Charles Donovan, *Man's Marks #5*. 22 x 30" (56 x 76 cm).

The "trigger" for this work was the artist's encounter with Native American petroglyphs and a different culture; her imagination took over in developing the ancient marks into a painting. Annell Livingston, *Petroglyphs #10*. 30 x 66" (76 x 168 cm).

Concepts

A painting concept is a unique idea or plan, waiting for fulfillment on paper. It is not an existing situation (although existing things and situations can *trigger* concepts); it is a fresh, new thought, a new way of seeing.

Concepts are often built on previous paintings or ideas, so the best way to encourage conceptual thinking is to record all kinds of ideas in a sketchbook every day. Doodle, experiment, draw things that seem silly or impossible, react to your own drawings, extend flawed ideas. Nurture your subconscious thoughts and set aside time to think creatively. Every idea has the potential to become a painting concept.

Louise Cadillac works in many abstract series, all of which emphasize shallow space, subtle color and intriguing textures. She says of her *Ritual Series*, "To explore ritualistic behavior and how it relates to preservation, I use abstract or nonobjective structures and forms to fill the composition. The abstract forms allow for unlimited associations." The paintings' rhythms may suggest drum beats or the repeated motions of a dance. Textures are built up by layering watercolor and acrylic glazes until a satisfactory richness is achieved.

Previous Paintings

Your own paintings, successful or not, can provide subject matter for still more paintings. Just as photographs or sketches can be visual resource material, so can your previous paintings be used as subject matter. There are several ways that this can be done.

A completed painting can be painted again in its entirety. You can learn from your first effort and paint more freely and easily, perhaps altering your style or design, changing colors or size relationships or leaving out some elements.

Part of a previous painting can become subject matter by selecting a section of it to repaint as a full subject. Remember how we cropped a painting into many small subjects in Chapter 6? Any cropped image can trigger a new idea, a different

**Louise Cadillac, *Ritual IX*. Watercolor and acrylic, 30 x 22"
(76 x 56 cm).**

emphasis, completely new feelings and design formats.

Other possible uses of previous paintings as subject matter might include:
- Changing the format (from horizontal to vertical or square)
- Changing the size
- Changing color dominance (warm to cool, for example)
- Changing the time of day by altering shadow patterns
- Changing the key (from high to low; low to high)
- Changing the style (from hard-edge to impressionistic, for example)
- Rearranging the components
- Introducing a new element (people, for example)

A single painting can become the subject matter for dozens of other paintings. After a while you might become bored with this approach, but it is interesting to understand how a single idea can be developed in many directions.

Series

A series is created when an artist makes one painting after another, each based on a common subject or idea. Some series are easy to identify because all the paintings look more or less alike; others are more subtly related to previous paintings. Often, artists number the paintings in a series, such as *California Memories #18*.

A painting series can be an evolving process, with later works being somewhat different from

Louise Cadillac, *Ritual XII*. Watercolor and acrylic, 30 x 22" (76 x 56 cm).

Louise Cadillac, *Ritual XV*. Watercolor and acrylic, 30 x 22" (76 x 56 cm).

Electra Stamelos, *Flower Series #119, Unfurled Cabbage.* 14 x 20" (36 x 51 cm).

Crowded foliage is the common element in the work of Electra Stamelos. She says, "Using foliage as a take-off allows for comfort on my part, a subconscious response to variations of familiar shapes and colors. The viewer and I can explore a small area of our world, with its myriad intricacies." She works with grids, circles, geometric shapes, fracturing, insets, quilts and ribbons to challenge herself. Left: Electra Stamelos, *Flower Series #85, Hibiscus.* 28 x 32" (71 x 81 cm). Right: Electra Stamelos, *Flower Series #105.* 22 x 30½" (56 x 77 cm).

the first ones. At times, there is only a common thread that the artist senses, and viewers cannot easily feel the connection. Such series may be intermittent, because the artist will come back to the subject again at different stages of his or her development.

A painting series can be a parallel development, with all pieces having very similar subject matter, treatment, emphasis and design.

A painting series can be an expansion of concepts, with all the pieces having a common subject or emphasis. An artist might choose to work with leaves of plants, for example. Leaves would be common to each painting, but their handling in each work would differ in some way.

A painting series can be a conceptual sequence, with each work having a different look, but expressing a similar idea or opinion. An artist might feel this sequencing more strongly than a viewer, because the common concept becomes a working force in each part of the series.

Other Art

Over the centuries, artists have traditionally learned their craft by imitating other artists. Before there were art schools to instruct young artists in painting techniques and the principles of design, these important procedures were learned by copying.

Today, copying other paintings is thought to hinder individual expression. Our painting experiences should help us express ourselves better, help us think more independently.

Artists spend much time looking at the work of others — in magazines, books, galleries and museums. Every time you study paintings you are influenced by them. Although it may not be a good practice to copy art, it is often beneficial to pick up ideas and techniques through diligent study.

It can be advantageous to make sketches of other artists' paintings to help you understand the dynamics of composition. You can use another artist's color scheme to help expand your own understanding of color. Perhaps another painter's method of adding figures to a landscape would help your own work. Try working in the style of artists you admire, aiming for the looseness of one style, the simplification or painstaking detail of another. Things you learn from other artists can eventually be adapted to fit your own way of working. That is why so many examples of work by professional painters are included in this book — to help you understand the many processes and directions that watercolor painting can take. You are not expected to copy them, but to learn from them.

A student artist created this watercolor from a reproduction of an oil painting by Titian, the Italian Renaissance master. The student did not copy the painting but made use of its action, composition and subject matter. 24 x 18" (61 x 46 cm).

Expressing Feelings

All painters and their work can be placed on a huge linear scale. At one end of the scale is pure emotionalism, without design; at the other end is pure intellectualism, without feeling. These two extremes produce very different paintings, equally difficult to understand. The work of most artists fits somewhere in between.

To understand the place of personal expression and emotionalism in art, it is helpful to make some comparisons.

Features of an intellectual or classic approach to art are:
- An emphasis on design and composition
- A cool, analytical approach to the subject
- The use of rules and guidelines
- An emphasis on neat, clean arrangements and proper proportions
- Mastery of traditional drawing and painting techniques.
- An emphasis on logic, refinement, and harmony

Features of an emotional, expressive or romantic approach are:
- Personal and colorful interpretation of the subject
- An emphasis on emotions
- A reduced emphasis on design
- The use of distortion and dynamic movement
- The use of loose, gestural drawing
- Dramatic, organic and expressive elements
- Often a chaotic and unplanned appearance

You can see from these lists that a painting at one extreme would be of such a precise nature that it might lack feeling. At the other extreme would be a chaotic work that might lack control. One tends toward perfection, the other toward expression. The utter extreme at either end is less than desirable.

Expressionistic artists should have some sense of design, and structural artists should have some sense of personal expression. You and your work will fit somewhere on this imaginary scale. You'll find as your painting experience increases that any painting subject can be approached intellectually, emotionally, or with a little of both characteristics. Gradually, you will find your own balance.

Opposite:
This is much more than just a painting of a bridge; the artist wants us to feel and sense the qualities of the bridge that made it exciting to him. Motion and activity are communicated through irregular shapes and diagonal lines. Muted colors suggest stormy weather, without sunshine. John Marin, *Brooklyn Bridge*, 1910. Watercolor, 15½ x 18½" (39 x 47 cm). The Metropolitan Museum of Art, New York. The Alfred Stieglitz Collection, 1949.

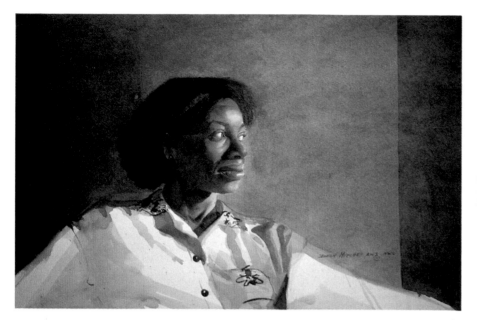

This watercolor was painted by a contemporary artist who can be placed about halfway on the emotional-to-intellectual scale. He paints skillfully, but also manages to suggest his model's character and personality. The painting is an expressive interpretation in admirable balance. Dean Mitchell, *Carolyn*. 15 x 20" (36 x 51 cm).

Look carefully at the church tower and then at the sky in this expressive watercolor. The artist has painted the sound of ringing church bells. The entire painting is a personal, symbolic response to a familiar event. Charles Burchfield, *Church Bells Ringing, Rainy Winter Night*, 1917. Watercolor, 30 x 19" (76 x 48 cm). The Cleveland Museum of Art, Ohio. Gift of Mrs. Louise M. Dunn in memory of Henry G. Keller.

Identifying Your Feelings

After you choose the subject for a painting, you should ask yourself several questions: What feeling does the subject give me? Why do I want to paint this subject? What excitement can I sense in this subject? What do I wish to say about it? What personal response will determine my approach? What colors will help express my feelings?

Even if you have an intellectual and structural dominance in your work, these are important questions; your response to them will help make your painting unique and personal.

By now you understand that most artists do more than duplicate their subjects on paper. Some respond to color, texture or physical arrangements; some respond to the meaning inherent in their subjects. Any subject can be approached from many directions, with differing results. You must learn to trust your own feelings.

What Are You Trying to Say?

You have looked at your subject, analyzed its visual characteristics and selected the major and minor elements to be included. Once these intellectual activities have been done, you have one other important aspect to consider: What do you want to say about the subject? This requires a true focusing on the reason you wish to make the painting. The answer will require an emotional response.

When you can answer that question, you can begin to push your painting toward an expressive conclusion. No longer are you merely copying nature, figures or things; you are starting to understand the meaning and purpose of visual expression — to create a personal and interpretive response to your subject.

Emphasis and expressive interpretations need not be gestural or gut-wrenching in their appearance and appeal. We often associate expressiveness with the expressionistic artists of Germany or the

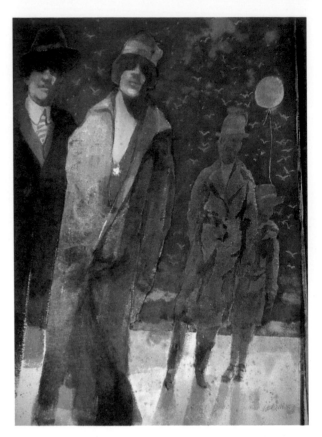

Many of this artist's paintings deal with the loneliness of individuals, even if they are surrounded by people. His work often has a disturbing quality that invites investigation. Lee Wexler, *Birthday for Hariette*. 39¼ x 29" (100 x 74 cm).

sensitivity of artists such as Vincent van Gogh, Willem de Kooning or John Marin. Their visual expressions are indeed powerful, organic, even chaotic. But artists can also focus on detail, smoothness, color, drama, fragility or other aspects of subject matter. Whatever it is you wish to emphasize becomes the focus of your expressive intent.

If ten accomplished artists were to paint in Yosemite Valley, you would see that beautiful national park through ten different sets of eyes, and depicted in ten different ways. One artist might concentrate on texture, rockiness or scale; another might be attracted to flowers, trees or summer shadows. Each painting would be an expressive interpretation of Yosemite, and each

This painting is about rhythmic, fluid movement. You can almost see and feel the artist's movements as she describes long arcs and short, staccato gestures with line and color. What is she trying to say? Sybil Moschetti, *Fire Dance*. 22 x 30" (56 x 76 cm).

could have a separate and individual emphasis.

In order to choose your own emphasis you need to rely on your emotions. Your intellect will answer questions about where, when or what, but your emotions are needed to answer "Why?" You need to *feel* the answer. Emotions are often easier to respond to if the subject is dramatic in content, lighting, color or meaning. Painting with focused emotions is generally intuitive: you respond rather than analyze. But you must respond in your own manner, not that of others.

Using Dominance

Think about some of the terms people use to describe a day. Often they refer to the weather, the atmosphere, or how they feel. Close your eyes and image days that are: soft, crisp, bright, depressing, invigorating, blindingly white, blazing hot, freezing cold and so on. Each of these terms produces an image that is based on a dominant attribute.

Envision a predominantly green landscape

painting; then image the same scene with a dominant orange hue. It changes the entire concept. Image two figures on a soft day, with a blue-gray dominance; then image the same figures on a crisp day with a yellow-orange dominance. Any expression or feeling can be drastically changed by altering the dominance in some way, even if the subject matter remains identical. When you understand this, you can readily comprehend how dominance of any kind can be beneficial in expressing your feelings about a subject.

Study existing paintings that use dominance to strengthen expressive qualities. Artists may use dominance of color, texture, space, scale, pattern or movement to help convey their ideas. They may employ intense value contrasts, soft edges, hard edges, symmetrical balance, high- or low-key value schemes, or monochromatic simplicity to dominate their work.

Color dominates this landscape painting. Hal Larsen, *Passage into Night*. Watercolor and acrylic, 40 x 50" (102 x 127 cm).

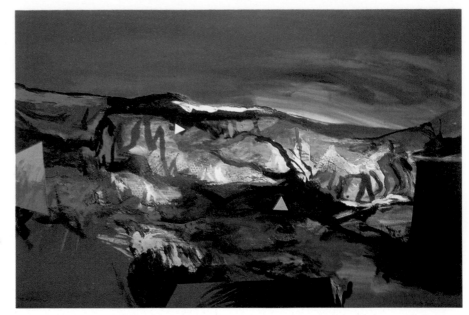

Texture dominates here. Little color range is employed, although warm and cool variations can be felt. The artist responds both abstractly and realistically to the subject. Katherine Chang Liu, *Canyon Walls #1*. 40 x 60" (102 x 152 cm).

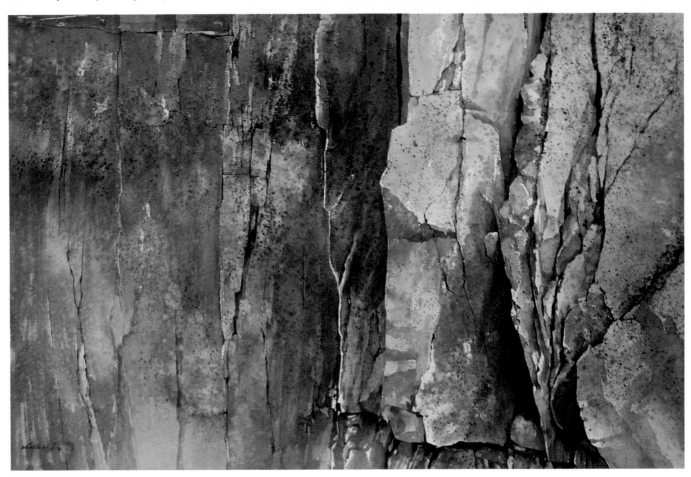

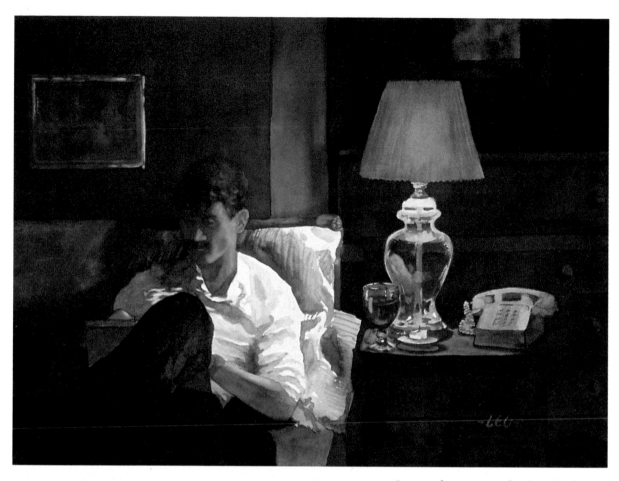

Strong value contrasts dominate in this painting. Darks and lights have been intensified to emphasize the sense of quiet and concentration. Like the reader whose eyes are directed only at the book pages, our eyes do not wander around the painting very much. Leo Smith, *Reading Time.* 22 x 30" (56 x 76 cm).

Low-key dominance produces a sense of mystery and undiscovered treasure in this painting. Imagine how different this same arrangement of objects would look if the colors were bright, value contrasts strong, and the feeling sunny. Jade Fon, *Attic.* 22 x 29" (56 x 74 cm).

"The day I sketched for this painting, the twisted pine trees seemed to dominate the landscape, looming out of the foggy white. But my initial painting concept was to *feel* the wet fog and damp coolness of a Pacific morning. The subject elements were rearranged several times to place emphasis on the large trees, but the cool atmosphere and sensation of wet fog are really what the painting is about." Gerald F. Brommer, *Silver Morning, Pacific Grove.* 22 x 30" (56 x 76 cm).

When you begin to develop a painting concept, consider dominance as a key ingredient in your overall plan. Go over some of the elements listed above, and others, to envision how they might help you express yourself about your subject. Moods can be generated by color and value dominance. Drama can be intensified with dominance of strong value contrasts; little value contrast helps create softness. Heat can be felt if warm colors dominate. And so on.

Analyze some paintings on these pages and in the rest of the book to see what role dominance has in the expression of feelings and the strengthening of concepts and convictions. Then you'll be more prepared to adapt your discoveries to your own work.

More Than Pictures

Paintings, as you have seen, reveal the artist and his or her sensitivity to a subject. With experience, you can often learn something about the artist by studying the work, just as you can learn something about a poet by reading the poems. Appreciate how artists observe and respond; how they see and record; how they introduce their personal feelings (and therefore themselves) into their work.

As artists, we can learn from other artists about ways to express ourselves in our watercolors. As viewers of art, we can learn to read what artists express through their work. This is how watercolor painting becomes expressive visual communication — and therefore art.

CHAPTER ELEVEN

Landscapes

Can you remember the last time you walked in a forest or drove across the desert? Can you remember the texture of pine needles or beach sand under your feet? Can you bring to mind a sunset or sunrise? Can you recall the sound of surf, feel the chill of fog, or remember the ominous sight of an approaching storm? These are all experiences you have had with landscapes.

Watercolor and landscape seem made for each other. The medium is easy to carry into the field, equipment is light and portable, and the paint dries quickly in most cases. Historically, artists have produced watercolor sketches on location and then painted from the sketches in the studio, either in watercolor or oil. Direct experience of nature has long been considered a fundamental part of watercolor painting.

Landscape painting in modern times began with English artists (see Chapter 1). Watercolor landscape painting as we know it today is basically an American contribution to art. It all began in the late nineteenth century, with the work of artists such as John La Farge, Winslow Homer, John Singer Sargent and Maurice Prendergast.

"Mr. Homer paints the rapids as if he had breasted them and got their strength into his brush," was a critical comment made of this work in 1898. Homer's use of color and value contrasts helps us *feel* the excitement of churning water. He often attempted to convey his conviction of the fragility of humanity and the power of nature. Do you sense it here? Winslow Homer, *Saguenay River, Lower Rapids*, 1897. Watercolor, 14 x 21" (36 x 53 cm). Worcester Art Museum, Massachusetts.

John Singer Sargent enjoyed bringing order out of chaos, and this loose impression of a jungle pool in Florida is a fine example. He controlled value contrasts to create the effect of filtered light. He carefully observed and used contrasts between crisp and soft edges. The palmettos are deftly painted. John Singer Sargent, *The Pool*, 1917. Watercolor, 15¾ x 21⅞" (40 x 55 cm). Worcester Art Museum, Massachusetts.

Opposite:
In 1890, American artist John La Farge travelled to the South Pacific to sketch and paint quick watercolor reactions to the exotic scenery. His work is quick and precise. He sketched with pencil to arrange the elements and brushed color on with simple, controlled strokes. John La Farge, *The Last Sight of Tahiti: Trade Winds,* 1891. Watercolor and gouache on buff paper, 8¾ x 16⅝" (22 x 42 cm). Worcester Art Museum, Massachusetts.

The flowing rhythm of the sea is dominant here. Although not photographic in appearance, there is no mistaking the power of the waves in this work. Mary Alice Braukman, *Waves and Rocks.* 18 x 28" (46 x 71 cm).

As you read and look through the next few pages, notice how artists have used watercolor to interpret the landscape. Some are painted realistically, some abstractly; some have great detail and use actual colors; others are loosely painted with heightened color. Explore several approaches in your own work with landscapes to help you comprehend how you see, feel and react to the natural environment.

Identifying Major Elements

Land, water, vegetation and the atmosphere are difficult to see as isolated entities. But for the purposes of study, observation and practice, we can break the landscape down into its component parts:
- *Land:* cliffs, rocks, hills, valleys, mountains, plains, mesas, palisades, and so on
- *Vegetation:* trees, shrubs, foliage, flowers, grass, cactus, all kinds of plants
- *Water:* rivers, streams, ponds, lakes, oceans, and so on
- *Atmosphere:* sky, clouds, storms, sunlight, fog, the seasons, and so on

As you can see, the landscape is full of paintable elements which are usually found in various combinations. The coast, for example, contains *land* (beach, cliffs), *water* (ocean, surf), *atmosphere* (sky, fog, etc.), and perhaps some *vegetation* (sea oats, iceplants, or trees). These elements give a place its particular look; viewers of a painting identify the scene by noting such characteristics.

Some artists paint landscapes from afar, including many elements and providing a panoramic view. They might choose to look at a scene from above, from eye level or from shoe-top level. They might include all of the landscape elements or select only several, rearranging them to suit the composition.

Artists can also select a single element of the landscape (flowers or leaves, for example) and zero in for a close-up look and interpretation. Such a painting would be completely different from a panoramic view and would probably contain much detail. Each artist sees the landscape in a personal way, and no two artists see it exactly alike. Look for yourself. What do you see from the nearest window?

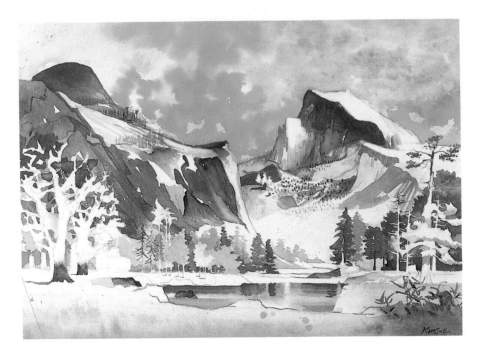

Although this artist's style is strongly personal and the landscape is not realistic, he has captured the sense of the place. Dong Kingman, *Yosemite in the Snow.* 22 x 30" (56 x 76 cm).

Whether you paint your landscape on location or in the studio, you first need to identify which parts of the total environment you wish to use. A close look at each of the major elements may help.

Land and Rocks

Land is the stage on which all landscape paintings are set. Gigantic mountains, hills and cliffs are powerful reminders of the dynamic energy of the earth. Smaller features also excite our minds and brushes into action. Crevices, stones, ravines, ditches, cracks, mounds and wind-blown sand are vital details in the land's surface. You should become aware of both large and small land elements if you are to use them effectively in your landscape paintings.

Whether you paint realistically or abstractly, you must be aware of two characteristics of the land: form and texture. If you study and translate them well, your depiction of earth features will be sensitive and expressive.

Awareness of form means awareness of the shape of the elements. You can see the shape of mesas, buttes or mountains, of rocks, boulders and palisades. Making those shapes into forms involves depicting them in three dimensions — using shadows and color to create the illusion of form, weight and mass.

Awareness of texture includes observation both of large surface areas and detailed, smaller formations. Use of texture can help you capture the feeling of a place.

Foliage and Flowers

Land is often made interesting by the vegetation that covers it. Indigenous plants give character and feeling to their particular locale: palms and palmettos suggest Florida; pines, balsams and maples are common in New England; saguaro and yucca flourish in the Southwest. Cactus, moss and reeds, shrubs, bushes and salt grass are all kinds of vegetation that embellish the land's surface.

Learn to observe the characteristic shapes of the vegetation you want to paint. Note, for example, how palms, pines and oaks have different, generalized shapes. If you take time to see them, you'll notice that every kind of tree has a characteristic shape.

Painting rounded rocks. Paint an interesting shape with a medium value of the rock color. While it is still wet, wipe the top of the shape with absorbent tissue, lifting off some color. This creates a form.

Add some darker values, with a little blue added, in shadow areas and lift color from the top edges to keep the form rounded.

Add characteristic textures and crevices.

Add the darkest values in deepest shadows to provide visual strength. Note how the bottom of the rock is painted to make it "sit" on the ground.

To paint a sharp-edged rock, the value transitions must be crisp. Paint an interesting crisp shape in the lightest value. Outside edges can be nearly straight and angular. Note again the bottom of the rock.

Add the next darkest value (not too dark too soon) in a few places — toward shadow areas, away from the light source. Do not soften the edges.

Add the next darkest value in shadowy places, and keep edges crisp.

Add the very darkest dark in crevices, under edges and for holes or cracks. Lines can help show contours. Darker values should be slightly cooler, not just deeper brown.

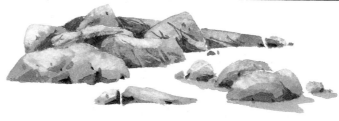

A group of rocks starts with a single rock, preferably the one closest to you. Paint the shape of the first rock and lift off the top part.

Add another rock shape above and behind the first one. Again, lift off the top part.

Continue until you have enough rocks in the group, and then add darker and cooler values to enhance the forms.

Finally, add lines and deepest-valued darks to create deep shadows. A few cast shadows can be added (see the group at right) to makes the masses convincing.

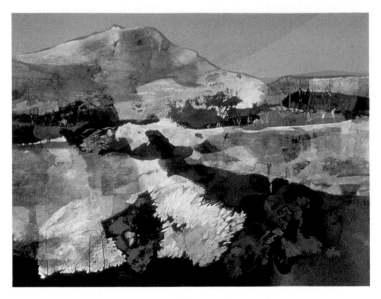

Collaged papers have been used here to build mountain scenery. Texture and form are powerfully emphasized. Sue Wise, *Western Landscape.* Mixed watermedia, 22 x 30" (56 x 76 cm).

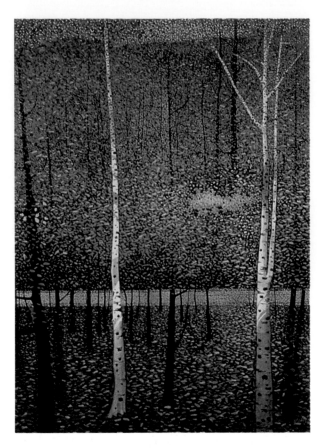

Texture receives emphasis in this interpretation of autumn color. Leaves are everywhere, and are held in check by trunks and branches. Lights are painted over darks by adding acrylic. Rolland Golden, *Autumn Symphony, Opus 1.* Watercolor and acrylic, 30 x 22" (76 x 56 cm).

Then notice the textural feeling of different plants and trees. Look at and try to draw small and large leaves, spindly grasses and split palm leaves. What kinds of marks will describe each kind of texture?

Study trunk and branch patterns and how branches support leaves. The proportion of trunk to foliage is important, because it is a recognizable characteristic of trees. Note how branches leave the trunks at different angles on different trees. Some trees are basically vertical, others horizontal, and still others rounded and balanced.

Become aware of leaf patterns, the play of shadow and light, and how masses of leaves create texture and form. Look at photos of trees and bushes, and study how other artists paint them.

Artists work with foliage and flowers at three distinct distances. At a great distance, foliage is massed and is seen as textural forms. No individual leaves are noticeable, so you must simplify and generalize these elements in your painting. Close-up, foliage and flowers can be seen as individual elements that make up larger forms. Flowers and leaves might be realistically detailed in one technique, but impressionistic in another. Search for characteristic shapes and colors so you can simplify the painting process. Look at the watercolor of palmettos by John Singer Sargent on page 130. Notice how he simplified and incredibly complex jungle of leaves, light and shadow.

Blowing up a small element (a flower, for example) and treating it in great detail is called creating a macro image. Emphasis is usually placed on color variations and design. The finished painting is almost a look *inside* the flower.

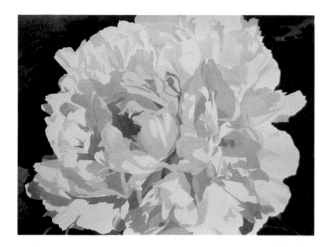

Intense value contrasts make this close-up painting arresting. Leaves, flowers and stems are carefully recorded and detailed. Linda L. Stevens, *Angelwing Begonias.* 40 x 60" (102 x 152 cm).

Above left:
A macro look at a single blossom excludes all other parts of the plant and of the landscape. The subtle color variations and petal configurations are strikingly revealed. Virginia Pochmann, *Peony.* 28 x 38" (71 x 97 cm).

Foreground flowers, although stylized, are identifiable by color and shape. Note how the distant trees are painted as a flat, uncomplicated shape. Carolyn Lord, *Harry's Bench.* 22 x 30" (56 x 76 cm).

Look at the shapes of trees and draw their contours. Study branching structures and proportions of trunks to foliage mass.

The movement of water is generalized here, with several kinds of marks describing its action on the beach. In the distance, the surf and open sea are treated with equal simplicity and power. Milford Zornes, *White Cliffs of Avila.* 22 x 30" (56 x 76 cm).

Note the rhythmic reflection patterns in different parts of this painting. What can you tell about the sky by looking at the water? Bob Tamura, *June Lake.* 21 x 29" (53 x 74 cm).

Water

Water is usually in motion, so you must observe the way it looks at one instant, and catch that look on paper. A nice thing about moving water is that its movement is rhythmic; the sequence repeats so you can catch that fleeting moment again . . . and again . . . and again.

Quiet water is like a horizontal mirror. Study its reflections and how water changes the reflected colors. Note how reflected light acts on objects around water. The colors and values of water come from several sources: reflected things around it, reflected sky, shadows cast over it, and soil, sand or rocks under the surface. Some water is colored because of its soil content and might be yellowish or brownish.

Stream water moves and slows, tumbles and flows. Study its movements carefully and then paint a generalization, letting brushstrokes follow the action of the water. Do not put down every rock and ripple, since rushing water looks most convincing when understated.

Open seas and crashing surf are in constant, recurring movement. Because of the agitated surface action, there is little reflection. Open sea water reflects the color of the sky overhead. The rougher the water the darker its color, but seas are usually darker than the sky above. Generally, the sea is darker up close and lighter as it recedes, unless sky conditions cause a variation.

The ocean is flat, so you should generally keep your brushstrokes horizontal. Distant water has few details; details increase as water gets closer to you. Waves nearby appear greenish, as do curling rollers. The white spray, splash, caps and surf can be masked out to preserve the whites, or can simply be left unpainted. Hardly any part of a wave is pure white, however, and some light-valued hues

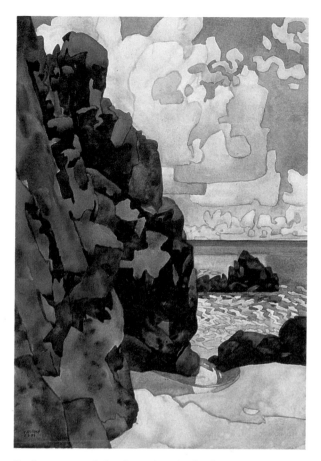

**Rocks, water and clouds receive similar, hard-edged treatment here. Clouds are overlapped and distant clouds are smaller, helping us sense the perspective and dimensionality of the sky. Carolyn Lord, *Honeymoon Beach.* 22 x 15"
(56 x 38 cm).**

will probably help give dimension and roundness to the crashing forms.

Simplify the movement and generalize the action. Paint *some* of the rocks, waves or splashes — don't try to incorporate them all. If painting water intrigues you, see the bibliography for suggestions; entire books have been written on the subject.

Skies and Clouds

The air above the landscape can simply be negative space behind trees or mountains, but most often it is filled with clouds or fog that determine the light and mood in the painting. Skies can be soft or crisp, light or dark, natural or fantastic in appearance. Because they are constantly changing, artists can manipulate clouds and skies to suit their needs.

First, a few generalities. Clear skies are generally darker above and lighter and warmer as they approach the horizon. Clear skies are often made with graded washes (dark above and light below) and should never be flat-looking, because the sky isn't flat. Clouds get smaller as they near the horizon. Skies generally look luminous rather than solid, and are usually lighter in value than the earth or water.

Cloudy skies can be powerfully dramatic or very gentle. Soft skies are brushed onto wet surfaces, crisp skies onto dry surfaces. Wet-in-wet skies are soft, particularly against a crisp row of hills or trees. Clouds on dry paper should be drawn lightly with pencil, if necessary, and the darker sky colors brushed in around the clouds. The gray or yellowish-gray of the clouds is brushed in the shadow areas and left alone. Keep the values light unless a dramatic effect is needed. Do not fiddle with damp sky or cloud washes, but let them dry and make alterations or overglazes later. Try using damp sponges or absorbent tissues to pick up sky colors and create cloud effects. Some edges can be softened by lifting with a damp, stiff brush and clear water. Do not overwork skies. It is a good idea to keep a file of cloud resource photographs or paintings.

You can put the sky in first or leave it until later; artists use both methods. If the foreground overlaps the sky and is quite complicated, put the sky down first to avoid problems later.

The placement of the horizon line will naturally determine how much sky will be in your painting. A low horizon allows more space to develop sky activity.

A dramatic sky makes an exciting backdrop. The dark sky values are brought down into the city to unify sky and land. George Gibson, *Taxco.* 22 x 30" (56 x 76 cm).

Opposite:
This wet-in-wet sky is wonderfully soft and makes a marvelous foil for the crisp dunes and mountains below. If you want color to stay where you've painted it, work on a nearly flat surface and leave it alone to dry. This sky is also graded from dark at the top to light at the bottom. Donal Jolley, *Dunes.* 22 x 30" (56 x 76 cm).

Weather and Seasons: The Importance of Light

Weather, the seasons of the year and the time of day are major factors in establishing the mood and character of a landscape. Vegetation is affected most visibly by the seasons, and colors provide important visual clues. Autumn colors are earthy and warm; summer colors are greenish, lush and bright; spring colors are light-valued and fresh; winter colors are cool and muted. The same landscape can be painted in four seasons simply by changing colors and characteristic details. As you work on seasonal paintings, recall the *feeling* of each time of the year, and try to recapture all of your sensations, not just what you see.

Light plays a fundamental role in establishing feeling and mood in your work. Light is brighter and warmer in summer, cooler and less intense in winter. The brightness and dullness of light is also determined by weather. Study the light prior to and during a storm, while it is raining and when it is foggy. Observe the light of dusk, dawn and noon.

Take photographs to help you remember certain kinds of light. The more aware you are of light and its effect on the landscape, the more you will be able to use it effectively in your watercolors.

In summer, the sun is high and shadows are short. In the morning and late afternoon, the sun is low and shadows are deep and long. At noon there are hardly any shadows. French Impressionist artists often painted their landscapes as though it were noon, and brightness filled the air.

The less light there is, the less intense the shadows and colors will be. The brighter the sun, the more value contrast there will be, and the shadows will be darker. If there is no sun, there will be no shadows.

Storms can be shown in a painting by making visible the effects of wind and the dominating influence of clouds on the light. Painting in the rain or fog will enable you to see that value contrasts are lessened and colors are muted.

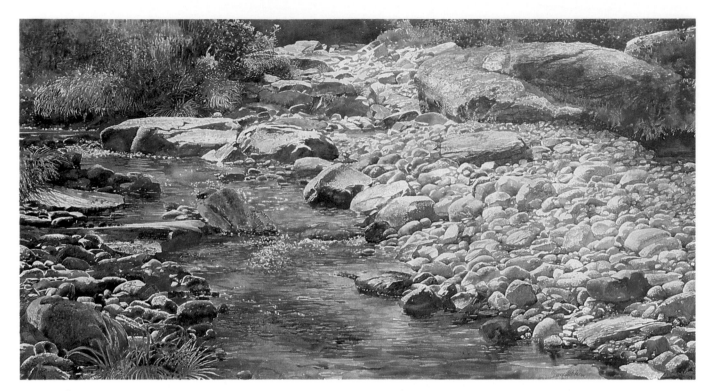

Lush summer vegetation crowds a rocky stream bed. The water reflects a broken sky. The light is clear, warm and intense. Larry Webster, *Summer Brook*. 23½ x 39½" (60 x 100 cm).

Soft spring colors are contrasted with the deep darks of evergreen firs. The light is soft and cool. Gerald F. Brommer, *Springtime Meadow*. 22 x 30" (56 x 76 cm).

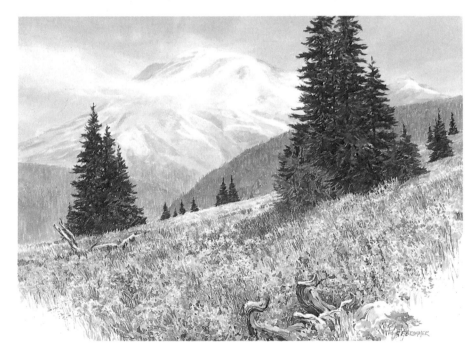

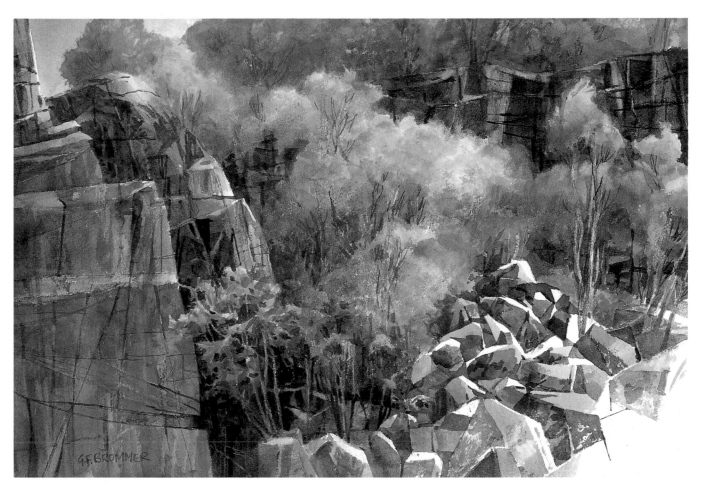

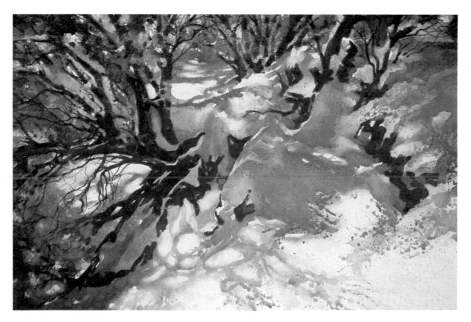

Warm colors, deep shadows and bright highlights typify a crisp autumn day. The light is clean and cool. Gerald F. Brommer, *Autumn Quarry.* 15 x 22" (38 x 56 cm).

Sun bathes the snow-covered earth with a clear, cool light. Note its forms and colors, and how shadows describe the surface. Karen Frey, *Manzanita in the Snow.* 21 x 29" (53 x 74 cm).

Adding Figures, Structures and Animals

There are many places in the world that do not show human influence, as examples on previous pages have shown. But in some natural environments humans are present, or their presence is implied through the inclusion of roads, buildings, fenceposts and the like.

When figures are included in a painting, they should become part of it. Paintings must retain their unity, and if figures stand out too much, or detract from the overall quality of the painting, they become distracting. Values in figures should be similar to some adjacent values in the painting; this helps pull human and natural elements together and provide passage.

The same treatment holds true for buildings, bridges, roads and other human-built structures. They should be integral parts of the landscape, tied into the painting by color and value. (For more on painting buildings, see Chapter 14.)

Human elements provide two distinct functions in a painting: scale and focus. Since you know the approximate size of a person or structure, the scale (relative size) of the landscape elements around it will be clarified. The smaller a person or house is, the larger adjoining trees will appear. You can change the relative size of trees by changing the size of a figure.

Focus is often provided by contrast. In a painting with mostly natural elements, the presence of a human form or a geometric building will naturally become a focal point. This feeling of focus can be emphasized (by using contrasting values and colors) or minimized (by using similar colors and values).

Animals can also be included in landscape paintings. Domesticated animals provide another suggestion of human presence. Wild animals can be portrayed in their natural environment. Like any other element, they should be fully integrated into the painting.

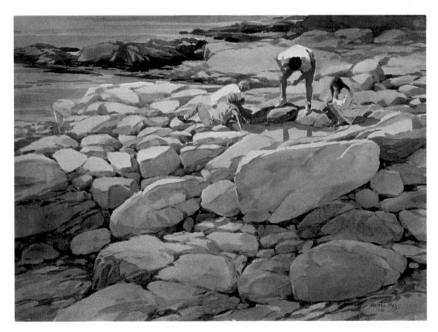

The figures blend into this landscape because passage (like-valued linkage) is used with each figure. Martha Mans, *Tidal Pool Explorers.* 22 x 30" (56 x 76 cm).

The highway firmly establishes human presence in an otherwise forbidding landscape. Rolland Golden, *Colorado Ascent.* 30 x 22" (76 x 56 cm).

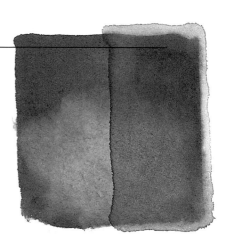

CHAPTER TWELVE

People

Artists have been painting human figures for centuries. Figures have been painted alone, in an environment, clothed, nude, young, old, as abstractions and realistically. There are two basic aspects of every painting involving figures: 1) the depiction of the figure(s), and 2) the composition of the total painting. If both are well handled, the work will be pleasing and visually successful.

Your own approach to painting people in watercolor will depend on your purpose. You may wish to make them realistic and recognizable, or generalized and nonspecific. You will gain confidence in your generalizations by drawing hundreds of figures and faces in your sketchbook. Draw friends, neighbors and people at bus stops and in airports. Draw them in contour, with values and in color. The more you draw the better you will be able to depict people and faces.

As you scan this chapter you will see many approaches to painting the human form. Study them all and note your own reaction to them. If you wish to study people more completely, look in some of the books listed in the bibliography.

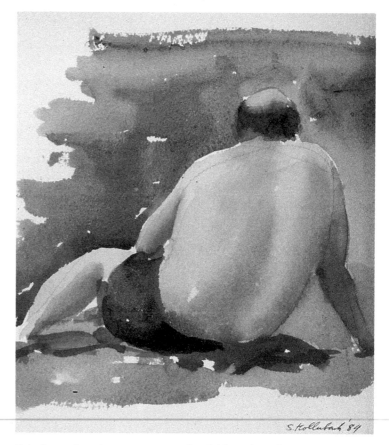

Painting on location, one must work quickly and surely. Look for generalizations that can be made more specific at a later time. Serge Hollerbach, *Fatman.* 10 x 8" (25 x 20 cm).

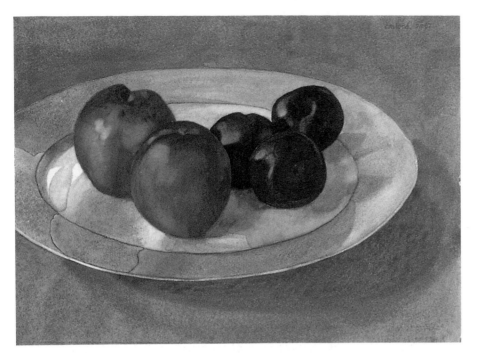

Opposite:
Reflections abound as light hits, passes through and bounces off glass surfaces. Note how rounded glass distorts color patterns. Meg Huntington Cajero, *Mirage II.* 22 x 30" (56 x 76 cm).

Simple still lifes can be surprisingly disarming. Here, intense colors are contrasted with light-valued neutrals to create a pleasing arrangement. Carolyn Lord, *Summer Fruits.* 11 x 15" (28 x 83 cm).

Soft, subdued light is suitable for this subject and helps create a serene mood. Edges in shadows are soft; edges facing the light are crisp and clean. Jane Burnham, *Kimono with Vase.* 22 x 30" (56 x 76 cm).

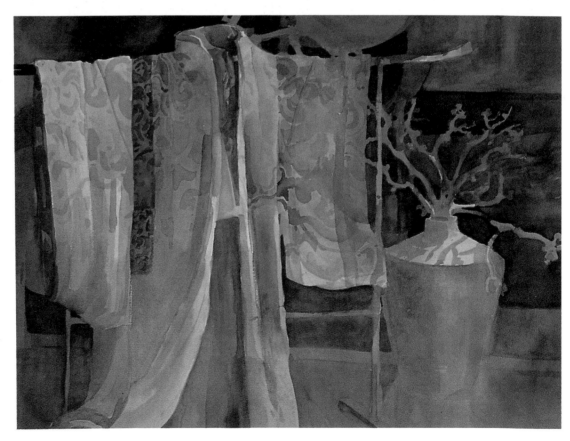

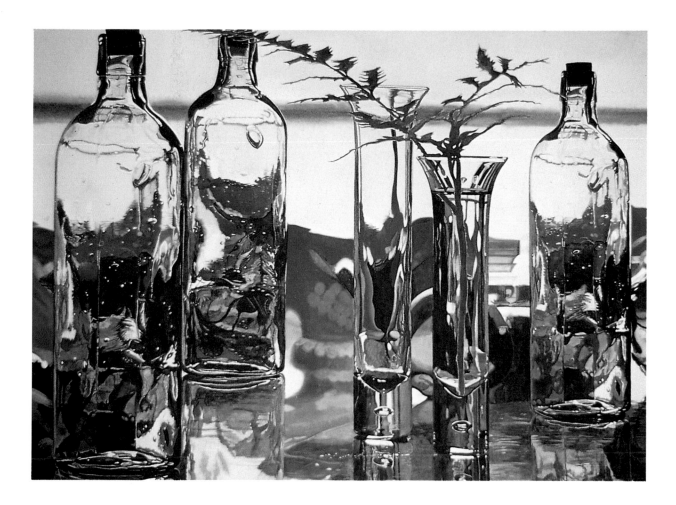

light strikes and object it produces highlight, shadow, reflected light and cast shadows. A general understanding of this system of light and shadow will help you paint rounded objects and increase your ability to use light to describe forms.

One spotlight produces a harsh light that casts dark, hard-edged shadows. Two or three spotlights will eliminate harshness and produce softer, more diffused light. Floodlights create softer light than spotlights; bouncing light off reflectors, wall or ceilings also helps soften the effect. Experiment with colored or filtered light. Move your light source or sources around, and note the effect this has on your setup. Some artists prefer the crispness of sunlight, and so choose to create a setup outdoors. Outdoors, of course, shadows move as the sun moves, so these artists generally photograph their setups in sunlight and reproduce shadow patterns by carefully lighting the same setups in their studios.

Pay close attention to the way light changes according to the object it hits. Light on metal looks quite different from light on fur, concrete or denim. When light shines on glass, it penetrates the object and passes through to the other side. Often the glass fractures the light rays and creates prismatic patterns on another surface. Painting this interaction of light and glass is especially difficult because you must paint from only one position. If you move, the light's reflections and refractions change. Photographs can be helpful in such situations, as they enable you to freeze the action of light and study it at length.

Selecting a Point of View

An uncommon viewpoint can add visual excitement to any still life setup. Objects change their relative positions as you move around them, stopping to observe. Stand on a chair and look down. Sit on the floor and look up. Find an angle that excites you. You control the point of view — use it to your advantage. Many still lifes are painted from slightly above the objects to allow the viewer to move into the setup visually.

Your point of view can also change as your distance from the setup changes. If you move in close you will see infinite detail, and perhaps the objects will run off the sides of the paper. This creates an *open composition* in which the frame cannot contain all of the subject. If you back away from the setup, you can include background or environment in your painting. The background can be left plain, derived from the actual surroundings or entirely imagined. This often produces a *closed composition,* where all of the setup components can be seen within the borders of the paper.

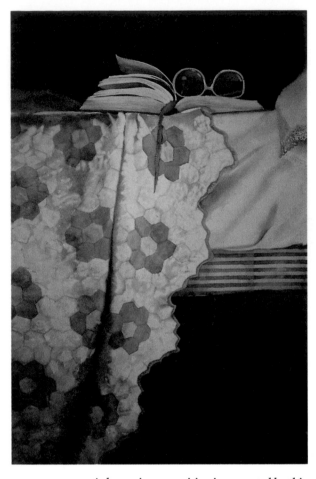

A dramatic composition is generated by this painting's head-on viewpoint and plain, dark background. Anne F. Fallin, *Bed Time Story.* 30 x 22" (76 x 56 cm).

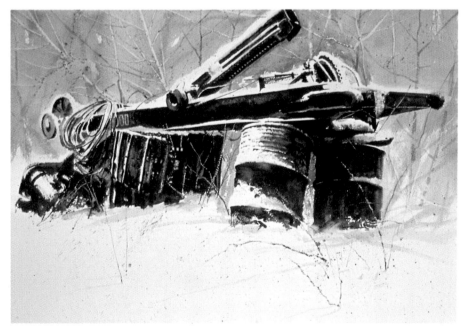

Construction objects were found by the artist and translated to a winter still life. Larry Webster, *Deceased Steam Shovel.* 21 x 29" (53 x 74 cm).

Deciding on a Concept

Still lifes are often thought of as arrangements of fruit in a bowl or conventional objects on a table. But they can go far beyond such traditional components in both complexity and concept. Because you are in complete control of every aspect of still life painting — the objects and their arrangement, the lighting, the environment and the viewpoint — a still life gives you the opportunity to express any idea you wish.

What objects have always fascinated you? What unusual juxtapositions might make a point or a humorous statement? Do you think an outdoor arrangement would be most effective? Do you like casual or formal setups? Should your still life subject be narrative in content? Do you like to "find" still lifes instead of arranging them yourself? You can "pull" a still life painting from an experimental or abstract arrangement of colors and shapes. You can pin objects on a wall, or hang clothes or fabrics from hooks or hangers.

The examples on these pages explain how some artists approach their still lifes. Observe how different concepts are handled throughout this chapter.

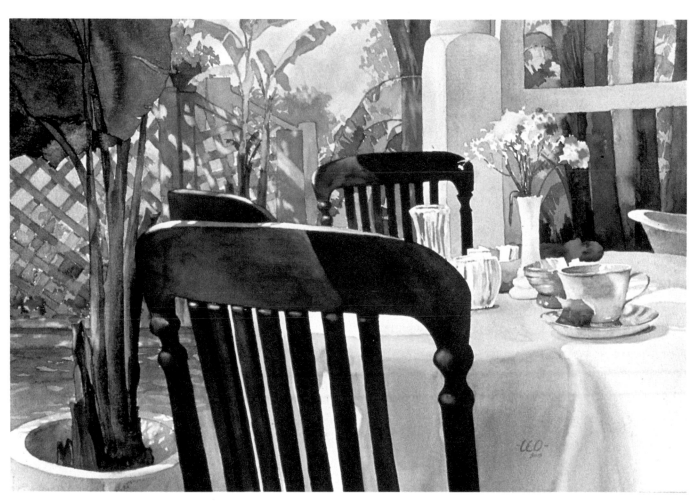

Leo Smith, *Patio Still Life.* 22 x 30" (56 x 76 cm).

A draped Japanese flag provides a powerful background for a simple still life. Objects and background are suitably united through use of color. Marbury Hill Brown, *Japanese Beer*. 21 x 28" (53 x 71 cm).

Two western shirts and a coat hanger are not traditional still life subjects, but the artist was intrigued by their shapes and draping fabrics. He has developed a series of paintings based on the way clothes reflect the people who wear them. Michael Ott, *Roy and Dale*. 41 x 29" (104 x 74 cm).

The pots in this painting are not as important as the patterns and reflective surfaces the artist has shown. Peggy Flora Zalucha, *Copper Pots with Artist Reflected.* 26 x 40" (66 x 102 cm).

The clutter on a tool bench may not be the subject of traditional still life paintings, but it can be fascinating nevertheless. Sandra Beebe, *Tool Pool.* 22 x 30" (56 x 76 cm).

In this nontraditional still life, the artist is dealing with flat space and oblique light in sharp focus. The objects chosen are not as important as the spatial concept. Kent Addison, *Still Life #994.* 22 x 30" (56 x 76 cm).

A few simple objects, clustered effectively, can make an elegant still life. Note how the vertical lines are placed over the harmonica and under the apple slices. Morris Shubin, *Chromonika III.* 22 x 30" (56 x 76 cm).

CHAPTER FOURTEEN

Other Subjects to Explore

The number and kinds of subjects to paint are limited only by one's imagination and the need to communicate ideas. In addition to the subject matter areas discussed and illustrated in previous chapters, there are many other subjects with which artists become fascinated. A few will be briefly noted here.

Current events intrigue some artists and get their ideas flowing. Natural disasters, wars, parades, ethnic and religious celebrations, accidents, sports and other events can be analyzed, sketched and made into painting subjects.

Toys of various kinds make interesting subjects, whether grouped together, isolated or in some sort of environment. Toy trains, instruments, stuffed animals, dolls and the like can make excellent subjects. You can also use toys or miniatures to create an architectural scene or landscape in the studio.

Clothing of various types can become interesting subjects. Native costumes (with or without people), flags, fabrics, baby clothes, lace, shoes, hats, etc. can provide material for studies of textures, colors and folds.

Literature can suggest painting subjects. Japanese Haiku and other short, descriptive poetry may get your ideas flowing. Short stories may provide ideas for illustrative paintings.

Your interests and hobbies provide excellent springboards to subject matter. Do you collect coins, dolls, stamps, matchbooks, masks? Any collection can inspire drawing and painting activities.

Musical instruments can be painted realistically or abstractly. Books can be painted, and even artwork (famous or otherwise) can be used in watercolor paintings in some way.

Look around you and study your own life, home and environment, and you will be analyzing dozens of possible painting subjects.

Architecture

Whether alone or massed, close or far away, familiar or exotic, buildings seem to hold a peculiar fascination for the watercolorist. Much of this penchant stems from watercolor's contrasts of dark against light, and the luminous quality of watercolor washes. These easily simulate sunlight, reflections and transparent shadows on buildings and surfaces.

If architecture interests you, you'll have noticed that buildings are important components of paintings throughout this book. If you're thinking of trying an architectural painting, here are a few tips. A knowledge of perspective is essential to reproduce the solidity of structures, but distortion can lead to interesting interpretations as well. Sketches will help you put down

major elements, but remember that a few simple shapes are better than a lot of little pieces. Most detail is painted in shadow areas, since the glare of sunlight tends to wipe out detail. If the sky is added after the buildings are painted, try turning the sheet upside down and running washes away from the buildings. Add people or trees for scale if you like, but include only small amounts of characteristic detail.

Close Up and Far Away

Buildings and cities can be viewed and painted from a wide range of distances. If you study a building at close range, you will see countless details and be influenced by color, texture, reflections and flattened space. As you walk away from the structure and look back at it, your perception of the building will change. From a block away, you will not be influenced by the same features as you were at close range. Details will be minimized, colors will be grayed, and the large forms and shapes will be more evident.

HANDLING DETAILS When painting buildings, artists usually want to simplify the elements and capture the characteristic qualities of the architecture. When working close up, however,

Native American decorative style and symbolism are often reflected in this artist's work. Fran Larsen, *Climb the Heights*. Watercolor in hand carved and polychromed frame, 32 x 38" (81 x 97 cm).

you'll notice many architectural details that are intriguing. How many should you use? How should you handle them?

Some artists like to get in extremely close and enlarge details dramatically, almost as if they were looking through a magnifying glass. (A door hinge painted on a 22 x 30" piece of paper is one example of this approach.) Dramatic, oblique lighting can be used to emphasize such details and make them appear monumental. Architectural details can also be painted from a middle-distance perspective, which allows you to emphasize the building's larger forms instead of its tiny components. Characteristic shapes, roofs, windows and stone-work can be painted with accuracy, yet not with photographic clarity, and still suggest great detail.

Paintings of architectural detail are best started as generalizations; develop the specifics as you go along. If your drawing is too tight at the start, the painting may lack enthusiasm. Study the works in this book and note how artists have painted wood, brick, stone and glass. Practice making marks that suggest the texture of shingles, stucco, concrete, tile and the like. You'll save time and energy if you learn to handle such details with confidence.

This artist's style includes several features: a close-up look at architectural forms; a color scheme of large areas of middle-valued, neutral hues with small, brightly colored accents; and an overall atmosphere of warm light. Judi Betts, *Romantic Overture.* 30 x 22" (76 x 56 cm).

Powerful geometric patterns on the side of a railroad car are made more interesting by using shadows and reflections to break up any possible monotony. Rolland Golden, *Sun Coach.* 22 x 30" (56 x 76 cm).

161

Opposite:
The abstract components of this painting are used to convey the artist's concept: by manipulating time and space, you can see the entire state of Indiana all at once. Miles Batt, *Indiana Roadmap*. 22 x 30" (56 x 76 cm).

The figures at the bottom of this work provide a scale to help us understand the hugeness of the facade of St. Peter's Basilica. George Gibson, *A Touch of Red*. 22 x 30" (56 x 76 cm).

Human Scale

Because architecture is usually built for human use, it is logical to put people or indications of human activity in paintings of buildings. Clothes hanging on a line, open windows, umbrellas, window-boxed plants, automobiles and so on all can be used to suggest a human presence.

A building's size is unknown if it appears alone in a painting. By placing objects or people of known sizes nearby, you can show the relative size of the structure. Several figures can be used to indicate distance from the viewer and from the buildings. If some figures are larger than others, a feeling of space is created between them.

The Importance of Environment

We often think of architectural subjects as synonymous with urban scenes, but this is not always the case. Many buildings are located in rural, mountainous, tropical or lonely settings and are surrounded by natural environments of various types. Relating such buildings to their natural environment can produce exciting results.

The structure may be only a small part of the total environment, or it may dominate its surroundings. In natural settings, geometric structures contrast sharply with an organic environment of foliage, trees, rocks and water. Because of these contrasts, human-built structures usually become focal areas (centers of interest) in paintings containing both.

Patterns

Loosely defined, pattern is the repetition of visual elements, or the simplified flattening of pictorial space and shapes. If pattern interests you, architecture is a good subject to explore. Shadows and light create patterns. So do repeated architectural details such as rooflines, walls and windows. Such patterns can be regular (a systematic repetition of shapes) or irregular (elements are repeated but not in a predictable sequence). If you analyze architecture carefully, you can learn to see its many patterns and use them to develop interesting surfaces in your paintings.

Nonrepresentational Watercolors

While many artists' paintings show the world as they see it, the works of others are not meant to represent nature or the real world at all. These works are called nonrepresentational, and are another area to explore in watercolor.

Nonrepresentational painting can be divided into two basic groups: abstract and nonobjective. These do not differ so much in appearance and feel as they do in their derivations and sources.

Abstracting from Nature
Abstract painters often use nature, objects or people as visual resources for their work. The resulting paintings are derived from representa-

tional subjects but do not quite look like them. Often the subject is simplified or reduced to its basic components.

An artist may go to the harbor and sketch for a while, and when returning to the studio, analyze the sketches and redraw them to reduce the boats and docks to simple shapes. These shapes might become the basis for a painting — not of the boats but of the shapes. Abstracting often pulls shapes, colors or textures from our visual environment and reduces them to their simplest terms. These simplified elements are arranged according to design principles. They may have been derived from nature originally, but now they have a life of their own.

Wassily Kandinsky, *Untitled*, 1910. Watercolor, 19⅔ x 25½" (50 x 65 cm). Musee National d'Art Moderne.

Nonobjective Painting

Nonobjective painting has no basis in representational subject matter at all. It has no outside source except the creative imagination and painting skill of the artist. A natural theme such as water, cliffs or sunshine may be the *impetus* for some nonobjective paintings, but the artist uses no visual resources as subject matter. The first known nonobjective painting in history was a watercolor, painted by the Russian artist Wassily Kandinsky in 1910.

Some artists who work nonobjectively find geometric shapes inspiring, and organize their painting surfaces into precise, crisp-edged geometric systems. They may even devise mathematical formulas to determine the size and placement of shapes and colors. Others work more loosely, preferring a fluid approach to nonobjective expression. Organic, free-form shapes, often with soft edges or no edges at all, seem to fit such goals.

This artist often works in series. Here she combines several media to express the textures, abrasions and overlays of an ancient wall surface. Katherine Chang Liu, *Ancient Rumors #5*. Watercolor, acrylic, collage and colored pencils, 30 x 40" (76 x 102 cm).

Other Sources

The emphasis in most nonrepresentational painting is on visual design — the arrangement of line, shape, color, value and texture on paper. If any of these art elements dominate, the paintings will be "about" them. The elements of design can therefore become the subjects for nonrepresentational paintings.

Feelings and emotions can also trigger nonrepresentational paintings. In such cases, design is not a dominant factor; instead, the emotions and expressive drive of the artist becomes the subject.

Nonrepresentational painting is sometimes triggered by the desire to experiment with different surfaces, or to try new media combinations. The exploration process then becomes the subject.

The meaning you find in nonrepresentational paintings depends upon your own sensitivity and background. You will not always "read" nonrepresentational paintings as others do; if you choose to paint abstractly or nonobjectively, others will interpret your paintings in many different ways. That is part of the intriguing nature of nonrepresentational painting.

These geometric shapes interact with each other and at times are almost organic in quality—yet the overall feeling is geometric. Annell Livingston, *Game of Hearts*. 45 x 45" (114 x 114 cm).

Sharp lines and wet washes create a calligraphic effect here. "Accidents" during media exploration are important to this artist's creative technique. Maxine Masterfield, *Moonrise*. Watercolor and ink, 22 x 30" (56 x 76 cm).

Opposite:
Bright light, deep shadows and a close-up viewpoint create dramatic impact here. Alexander Guthrie, *Missing Number*. 21 x 40" (53 x 102 cm).

Machinery and Metal Surfaces

Perhaps nothing seems as incongruous as using transparent watercolor to paint heavy-duty machinery, but in fact they are extremely compatible. The transparency of the medium can be used to advantage in painting the rust and corrosion of weathered metal or the shiny brightness of reflective surfaces.

Machinery of all sorts can be used as subject matter, from trains to tricycles to heavy-duty trucks. The shapes are often geometric, but rusting textures or reflected colors and distorted images make the combinations and contrasts very challenging. You must look carefully at details, but must also respond to large forms. Fill your sketchbook with your observations.

Metal surfaces also provide a challenge to the watercolorist. Aluminum cans, musical instruments, watches, keys, coins, tools, kitchen pans and utensils are all likely subjects. You'll probably need to sketch and draw them in detail before attempting any work with paint.

Use photography to supplement sketches and direct observation. Photographs can record lighting along with structural and textural details — effects which can change with even the slightest movement on the part of the painter. Photography is often vital to understanding how reflections of color and light work, and how they affect shadows. If you are painting a shiny trumpet and concentrating on reflections and light, a photograph will help you keep images from moving and changing.

Reflective surfaces also provide interesting color problems, because the color of the metal is combined with the colors of reflected objects. Study reflected colors carefully to determine how they overlay the metal's hues. Old metal surfaces often rust or have an oxidized patina. Painted metal surfaces create fascinating color problems when they begin to chip and deteriorate.

Animals

Like people, animals can be used to show scale in a painting, or they can become the principal subject. They can be set in typical habitats or against simple backgrounds as studies in form and movement. They can be painted realistically or expressively.

Make quick sketches first to determine the characteristic shapes of the animal you are painting. How is the torso shaped? How do the legs bend, how long are they, how do the head and neck work, how big is the head in relation to the body? Determine animal shapes from books or photographs, or, better yet, go to a zoo. If a zoo isn't available, a museum with stuffed animals is a great place to draw — and the animals don't move around or hide from you.

When painting animals, the tendency is to put down every detail, but the familiar warning persists: Keep it simple. Use the largest brushes as long as possible. Think back on other paintings or experiments and determine what techniques might be used for feathers, shells, fur, hide, claws or hair. Painting animals should be the natural outgrowth of sketching and drawing them. Know the animals you are going to paint. Check your local library for books on drawing and painting animals.

Animal groupings are often more interesting than single animals. Karen Frey, *Ben and Salsa.* 21 x 29" (53 x 74 cm).

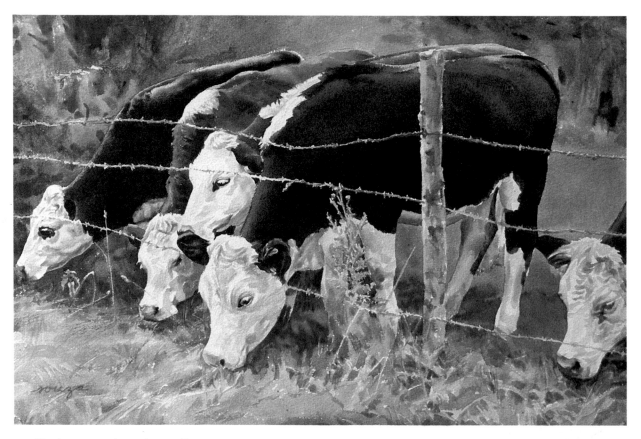

Familiar farm animals can be excellent
subjects. Paul Souza, *Grazing, England.*
22 x 30" (56 x 76 cm).

Here, the white of the goats is obtained by
not painting the paper at all. Judi Betts,
Barnyard Buddies. 22 x 30" (56 x 76 cm).

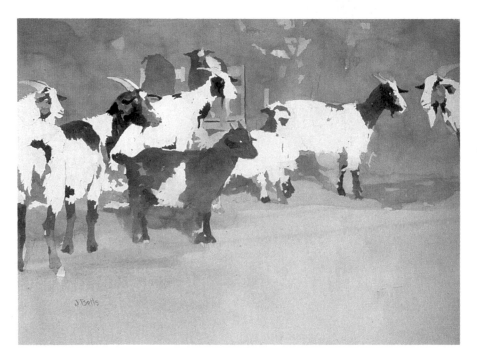

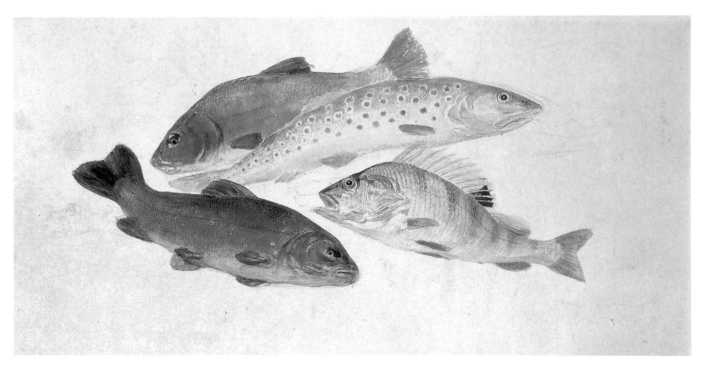

While this artist did not often work with much detail, he drew and painted with care and objectivity in this study. J. M. W. Turner, *Study of Four Fish*, 1825. Watercolor, 10 x 18" (25 x 46 cm). The Tate Gallery, London.

Birds and Fish

Fish and birds have been painted by generations of artists in many countries. Ancient Chinese artists included birds in many of their scroll paintings. The English artist J.M.W. Turner painted fish; American Winslow Homer painted both fish and birds in his favorite Adirondack Mountains. John James Audubon documented the birds of America in his watercolor paintings, which were made into prints to show American birds to the world.

Birds can be painted in their natural environments, standing, perched or flying. They are painted alone and in groups, as part of nature (flying across a swamp, for example) or as elements in a composition. They can be featured close up or from a distance.

Fish are usually painted in water, although some artists have shown them hanging on a string, on a plate or lying on the ground. When in water, they can be painted from above, or from the side, as if the artist were also under water. Tropical fish, which come in every size, color, shape and description, make especially interesting subjects.

You may wish to exercise your imagination and invent fish and birds, rather than use realistic models. But you can often borrow or rent mounted birds and fish from museums so you can study, sketch and paint them.

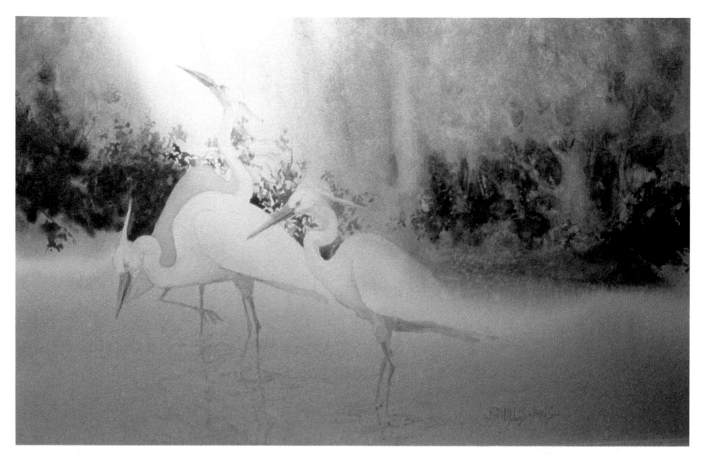

This artist began by flowing color on a wet surface in a non-objective manner. When dry, she found a heron-like shape and used it as a start. She lifted color to pull several birds out of the background and finish the swamp setting. Marilyn Hughey Phillis, *White Heron.* 14 x 20" (36 x 51 cm).

The close-up view and horizontal format give a familiar bird fresh interest. Will Bullas, *The Omelet Empire.* 12 x 48" (30 x 122 cm).

Gerald F. Brommer, *Dry Dock at Hastings Beach.* 22 x 30" (56 x 76 cm).

George Gibson, *Wan Chai Gossips.* 22 x 30" (56 x 76 cm).

Boats

Boats of all sizes, from small rowboats and kayaks to gigantic ocean liners and battleships, are fit subjects for watercolor paintings. Think of them as mobile structures that are often closely associated with their environment; most of the characteristics of architectural painting can be applied to them.

Boats are usually in water. Paintings of boat details may not need to include water, but artists will generally have to deal with water at sea, in rivers, lakes or harbors. In dry dock, a boat's entire shape can be studied and painted.

Whether you paint boats in clusters or individually, moving swiftly through turbulent waters or at rest in a calm and protected harbor, sketching beforehand is an essential activity. The curves of prows, the placement of sails and masts, the forms of hulls, and the tilt of boats in motion or at rest are details that must be observed, felt and drawn. If boats do not appear to be comfortably settled into their environment, they will be detracting elements in a painting.

Imagination

Wherever you paint, you exercise your imagination and make decisions that govern the development of your work. But some artists rely less on visible subject matter and more on their abilities to conjure up images that are uniquely theirs.

Imaginative approaches to subject matter may take several directions. Fantasy art and surrealism often portray unreal subjects or circumstances. Such work often involves personal symbolism that is meaningful to the artist, but may be difficult for viewers to comprehend. The work of artists such as Marc Chagall, Giorgio de Chirico, Paul Klee, Joan Miró, Salvador Dali, Rene Magritte and Yves Tanguy typifies imaginative approaches to painting. Most painted in oils, but you may find their subject matter inspiring.

Other imaginative work may emphasize personal approaches to common subjects. Combining unlikely visual elements, observing from impossible vantage points, making up story scenarios that require special illustrative treatment — these are ways to infuse imagination into your work.

The more familiar you are with a visual concept or subject, the more likely you are to develop a unique and imaginative treatment of it. Sketch and paint a single idea over and over again, gradually building on it as you go along. As you gain confidence in your ability to handle that idea, you'll find that embellishing or changing it becomes easier. Exercise your imagination by considering unusual viewpoints or circumstances. Think of viewing an object or scene from below or above (an ant's or bird's eye view). How would it look at night, or under water? Would a cartoon-like appearance be more interesting than a photographic image? Would distortion of size, color or shape be an exciting direction?

Many of the paintings in this book are imaginative interpretations of subject matter, even though they rely on actual objects at the start.

The unlikely combination of a fire truck and ducks can be enough to stir the imagination and prompt a play on words. Will Bullas, *The Ducket Brigade*. 24 x 40" (61 x 102 cm).

An Endless Supply of Ideas

No matter how long you work or how many watercolors you paint, you will never exhaust all possible subject matter. In the previous chapters you have seen the basic subjects painted in a variety of ways, but there are always more ways to handle them. In this chapter you have seen many other types of subjects, but there are always more.

Artists often look on subject selection as a challenge, trying to find new kinds of subjects or treating regular subjects in new ways. This quest for new painting experiences is stimulating and exciting. Think about these ideas: Explore pattern and design. Paint on woven paper — or cut paintings into strips and weave them together. Create three-dimensional watercolor constructions. Combine metals and paint; employ airbrushes and computers. Alter your format and paper shape — try painting on 6 x 30" strips, for example. There are always new ways to say what you want to say.

Experimentation is best carried out after you understand basic techniques, however. You will enjoy the freedom of exploration after the fundamentals of design are part of your visual vocabulary.

A Final Note

Whatever your personal desires in painting, you should be honest with yourself when making choices. Some artists enjoy experimenting with media and techniques. Others concentrate on conveying insights and interpretations of their subjects. You should be happy with what you are doing, and with the direction in which you are working. As American artist and teacher Robert Henri once said, "Works of art should look as though they were made in joy."

Wu Junquing, *Lotus, c.* 1900 (Qing Dynasty). Ink and wash. National Gallery, Beijing.

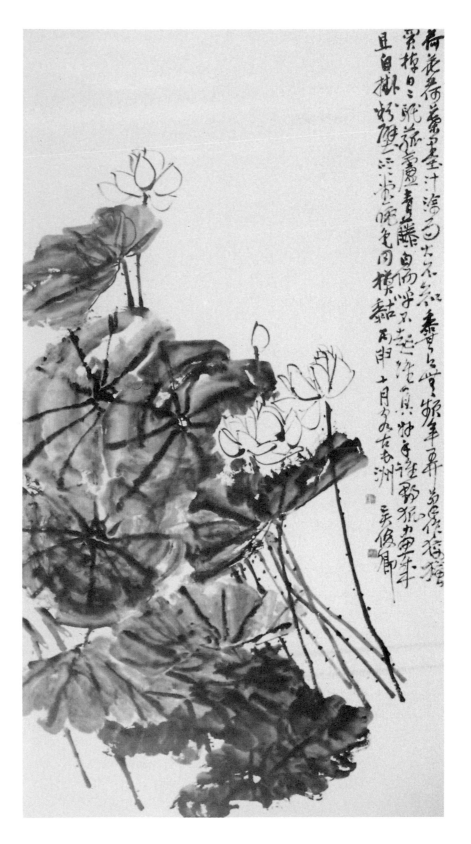

Bibliography

The following lists cite only a fraction of the books available, with most having been published in recent years. They are arranged by major topic. At least one book from each section should be part of your studio library.

Transparent Watercolor

Andrews, Don, *Interpreting the Figure in Watercolor*. New York: Watson-Guptill Publications, 1989.

Austin, Phil, *Capturing Mood in Watercolor*. Cincinnati, OH: North Light Books, 1984.

Batt, Miles, *Creative Watercolor*. Fort Lauderdale, FL: Creative Art Publications, 1988.

Brandt, Rex, *The Winning Ways of Watercolor*. New York: Van Nostrand Reinhold, 1973.

Brotherton, Naomi and Lois Marshall, *Variations in Watercolor*. Cincinnati, OH: North Light Books, 1981.

Couch, Tony, *Watercolor, You Can Do It*. Cincinnati, OH: North Light Books, 1987.

Gair, Angela, *The Watercolor Painter's Solution Book*. Cincinnati, OH: North Light Books, 1988.

Goldsmith, Laurence C., *Watercolor Bold and Free*. New York: Watson-Guptill Publications, 1980.

Harrison, Hazel, *Encyclopedia of Watercolor Techniques*. Philadelphia, PA: Running Press, 1990.

Kunz, Jan, *Painting Watercolor Portraits That Glow*. Cincinnati, OH: North Light Books, 1990.

Parramon, José M., *Painting Still Lifes in Watercolor*. New York: Watson-Guptill Publications, 1991.

—— *The Big Book of Watercolor*. New York: Watson-Guptill Publications, 1986.

Petrie, Ferdinand, *The Big Book of Painting Nature in Watercolor*. New York: Watson-Guptill Publications, 1989.

Porter, Albert W., *Expressive Watercolor Techniques*. Worcester, MA: Davis Publications, Inc., 1982.

Powers, Alex, *Painting People in Watercolor*. New York: Watson-Guptill Publications, 1988.

Reid, Charles, *Figure Painting in Watercolor*. New York: Watson-Guptill Publications, 1979.

—— *Flower Painting in Watercolor*. New York: Watson-Guptill Publications, 1979.

—— *Portrait Painting in Watercolor*. New York: Watson-Guptill Publications, 1987.

Silverman, Burt, *Breaking the Rules of Watercolor*. New York: Watson-Guptill Publications, 1991.

Taylor, Richard S., *Buildings in Watercolor*. Cincinnati, OH: North Light Books, 1990.

Wade, Robert, *Painting More Than the Eye Can See*. Cincinnati, OH: North Light Books, 1989.

Ward, Michael, *The New Spirit of Watercolor*. Cincinnati, OH: North Light Books, 1990.

Webb, Frank, *Watercolor Energies*. Cincinnati, OH: North Light Books, 1983.

—— *Webb on Watercolor*. Cincinnati, OH: North Light Books, 1990.

History of Watercolor

Brett, Bernard, *A History of Watercolor*. New York: Excalibur Books, 1984.

Finch, Christopher, *American Watercolors*. New York: Abbeville Press, 1986.

Hoopes, Donelson F., *American Watercolor Painting*. New York: Watson-Guptill Publications, 1977.

—— *Sargent Watercolors*. New York: Watson-Guptill Publications, 1976.

—— *Winslow Homer Watercolors*. New York: Watson-Guptill Publications, 1976.

Kingman, Dong and Helena Kuo Kingman, *Dong Kingman Watercolors*. New York: Watson-Guptill Publications, 1980.

McClelland, Gordon T. and Jay T. Last, *The California Style*. Beverly Hills, CA: Hillcrest Press, 1985.

Ratcliff, Carter, *John Singer Sargent*. New York: Abbeville Press, 1982.

Reynolds, Graham, *English Watercolors*. New York: New Amsterdam Books, 1988.

Stebbins, Theodore E., *American Master Drawings and Watercolors*. New York: Harper and Row, 1976.

Strickler, Susan, editor, *American Traditions in Watercolor*. New York: Worcester Art Museum/Abbeville Press Publications, 1987.

Mixed Watermedia

Brommer, Gerald F., *Watercolor and Collage Workshop*. New York: Watson-Guptill Publications, 1986.

Cobb, Virginia, *Discovering the Inner Eye*. New York: Watson-Guptill Publications, 1988.

Leland, Nita, *The Creative Artist*. Cincinnati, OH: North Light Books, 1990.

Masterfield, Maxine, *In Harmony with Nature*. New York: Watson-Guptill Publications, 1990.

—— *Painting the Spirit of Nature*. New York: Watson-Guptill Publications, 1987.

Quiller, Stephen and Barbara Whipple, *Water Media: Processes and Possibilities*. New York: Watson-Guptill Publications, 1986.

—— *Water Media Techniques*. New York: Watson-Guptill Publications, 1983.

Suppliers

Color

Dobie, Jean, *Making Color Sing*. New York: Watson-Guptill Publications, 1989.

Hill, Tom, *The Watercolorist's Complete Guide to Color*. Cincinnati, OH: North Light Books, 1992.

LeClair, Charles, *Color in Contemporary Painting*. New York: Watson-Guptill Publications, 1991.

Leland, Nita, *Exploring Color*. Cincinnati, OH: North Light Books, 1985.

Parramon, José M., *Color Theory*. New York: Watson-Guptill Publications, 1989.

Quiller, Stephen, *Color Choices*. New York: Watson-Guptill Publications, 1990.

Schink, Christopher, *Mastering Color and Design in Watercolor*. New York: Watson-Guptill Publications, 1981.

Drawing and Sketching

Blake, Wendon and Ferdinand Petrie, *The Drawing Book*. New York: Watson-Guptill Publications, 1980.

Brommer, Gerald F., *Exploring Drawing*. Worcester, MA: Davis Publications, Inc., 1988.

Goldstein, Nathan, *Figure Drawing*. Englewood Cliffs, NJ: Prentice-Hall, Inc., 1981.

James, Jane H., *Perspective Drawing*. Englewood Clffs, NJ: Prentice-Hall, Inc., 1981.

Johnson, Peter D., editor, *Drawing for Pleasure*. Cincinnati, OH: North Light Books, 1984.

Larsen, Karl V., *See and Draw*. Worcester, MA: Davis Publications, Inc., 1992.

Leslie, Clare Walker, *Nature Drawing* (animals and plants). Englewood Cliffs, NJ: Prentice-Hall, Inc., 1980.

Petrie, Ferdinand, *Drawing Landscapes in Pencil*. New York: Watson-Guptill Publications, 1979.

Porter, Albert W., *The Art of Sketching*. Worcester, MA: Davis Publications, Inc., 1977.

Sims, Graeme, *Painting and Drawing Animals*. New York: Watson-Guptill Publications, 1983.

Woods, Michael, *Perspective in Art*. Cincinnati, OH: North Light Books, 1984.

Design

Graham, Donald W., *Composing Pictures*. New York: Van Nostrand Reinhold, 1983.

Henning, Fritz, *Concept and Composition*. Cincinnati, OH: North Light Books, 1983.

Reid, Charles, *Painting by Design*. New York: Watson-Guptill Publications, 1991.

All of the following companies can supply you with a wide variety of painting materials and papers. Write for catalogs and get on their mailing lists so that you can compare prices.

Art Express
P.O. Box 21662, Columbia, SC 29921

Artisan/Santa Fe, Inc.
717 Canyon Rd., Santa Fe, NM 87501

ASW Art Supply Warehouse
360 Main Ave., Norwalk, CT 06851

Chaselle, Inc.
9645 Gerwig Ln., Columbia, MD 21046

Cheap Joe's Art Stuff
300A Industrial Park Rd., Boone, NC 28607

Daniel Smith, Inc.
4130 Fifth Ave. S., Seattle, WA 98134-2302

Dick Blick
P.O. Box 1267, Galesburg, IL, 61401

Jerry's Artorama
P.O. Box 1105, New Hyde Park, NY 11040

Napa Valley Art Store
1041 Lincoln Ave., Napa, CA 94558

New York Central Art Supply
62 Third Ave., New York, NY 10003

Paper Source, Ltd.
1506 West 12th St., Los Angeles, CA 90026

Sax Arts and Crafts
P.O. Box 51710, New Berlin, WI 53151

Utrecht Manufacturing Corp.
33 Thirty-Fifth St., Brooklyn, NY 11232

Glossary

The terms defined here are taken from the text, and are closely associated with transparent watercolor painting. This is not meant to be a complete dictionary of general art terms.

abstract art, abstractionism A style of art that emphasizes design, and shows objects as simple shapes and lines, often geometric. There is little or no attempt to represent forms or subject matter realistically.

accent color A small amount of contrasting color used against another color; for example, orange accent in a predominantly blue area.

achromatic Lacking color; black, gray and white are achromatic.

adjacent colors Hues next to each other on the color wheel.

aerial perspective Making things seem far away by painting them less clearly and with less color. Also called **atmospheric perspective**.

airbrush A small, precise spray gun attached to an air compressor. Used to spray a smooth area of paint or to create gradations in value and color.

analogous colors Colors that are closely related, such as blue, blue green and green; three or four colors that are adjacent on the color wheel.

aquarelle The French word for transparent watercolor.

archival Referring to the high quality and permanence of certain papers and painting materials, such as acid-free materials that resist aging.

asymmetry, asymmetrical balance An informal balance of elements in a painting. The right half of the painting is different from the left half, yet is in balance.

atmospheric perspective See **aerial perspective.**

background The area farthest away in a landscape; also the area around the principal subject in a painting.

backlight Light coming from behind a subject.

back run See **blossom.**

balance A principle of design that refers to the visual equalization of elements in a painting. There are three kinds: **symmetrical** (formal); **asymmetrical** (informal); and **radial.**

bead A pool of color that forms at the bottom of a watercolor wash applied to a slanted sheet.

bichromatic A term describing a painting created with just two colors.

binder An adhesive used to hold particles of pigment together in paint, and to hold color to the support. Gum arabic is the binder in the watercolor medium.

bleed Paint that runs into an adjoining area; also refers to fuzzy edges in a painting.

blocking in Placing the major elements of a painting with simple tone, color and/or line.

block out Any material (liquid or stencil) used to prevent watercolor from making marks on paper. It preserves the white paper when painting.

blossom The feathered edge that occurs when a wash creeps back into a damp surface; also known as **bloom** or **back run.**

broken color Two or more colors placed side by side in a painting so they seem to create a third color, without actually being mixed on the palette.

calligraphy The art of fine handwriting. Handwriting-like line work used in a painting is called **calligraphic line.**

center of interest The main area of interest in a painting, toward which all visual movement is directed; the focal point.

charge A term used in watercolor painting meaning to fill the brush with color; also to add intense color to a wet wash.

chiaroscuro Strong contrast of dark and light values in a painting. A technique for modeling forms in painting, by which the light parts seem to stand out from dark areas.

chroma The intensity, strength or saturation of color. A color's brightness or dullness.

chromatic Having color or hue.

cityscape A painting that uses elements of the city as subject matter.

closure The ability of the mind to complete a pattern or line where only suggestion is shown.

contour The outer limit of a figure, form or object.

contour lines Lines on paper that describe the imaginary lines around the edges of an object or person; lines that describe form.

contrast A principle of design that refers to differences in values, colors, textures and other elements to create emphasis and visual impact.

cool colors The hues which contain blue and green, located on one side of the color wheel.

critique The process of critical analysis.

cropping Cutting a picture down or trimming its size.

damping the paper In watercolor, putting water on paper with a brush or sponge, prior to adding color; wetting or dampening paper.

deckle, or deckle edge The decorative, ragged edge on some papers.

design The arrangement of elements in a painting; also the system of principles used to establish order on the painted surface. The structure of a painting.

designer's colors Gouache. A very fine quality of opaque watercolor.

dimension The illusion of depth depicted on a flat sheet of paper.

direction Horizontal, vertical or oblique movement into the space or across the surface of a painting.

direct painting Working from the subject, directly on paper, without much drawing or underpainting; responsive painting.

double complementary A color scheme made up of two colors, adjacent to each other on the color wheel, and the two adjacent colors directly opposite them.

dry brush A watercolor painting technique in which very little color or water is on the brush, creating a "skipped" effect.

dyad Color scheme having two colors.

earth colors Pigments made from natural minerals; colors such as yellow ochre, burnt sienna and the umbers; brownish and yellow-brownish hues.

easel A freestanding structure used to hold a drawing board while the artist is painting.

edges, hard Sharp lines and shapes that do not blend into nearby areas.

edges, soft Allowing a value or color to blend and blur into nearby areas without a definite line of separation.

elements of art/design The basic components an artist uses in painting: color, value, shape, space, line, form and texture.

emotional color Color used for its emotional and expressionistic effect rather than for realism. Personal color selection.

emphasis A principle of design by which the artist may use different sizes, shapes, contrasting colors or other means to place greater attention on certain areas, objects or feelings in a painting.

expressionism Any style of painting in which the artist tries to communicate strong personal and emotional feelings.

feather To blend an edge so that it fades off or softens.

figurative Representational painting. A painting showing a human figure that is more real than abstract.

flat To apply paint without variations in value or color, with no brush marks showing.

focal point, focal area The center of interest in a painting; the area toward which visual movement is directed.

foreground The area in a painting that seems to be closest to the viewer.

format The shape of paper (vertical, horizontal, square); also a generalized scheme or plan for organizing the painting elements.

free-form Irregular in shape; not geometric; organic.

fugitive color A pigment that fades under normal light conditions.

geometric abstraction The use of geometric shapes to design a composition.

gesso A mixture of finely ground plaster and glue that is often used as white paint in mixed watermedia techniques.

gestural drawing (painting) Drawing or painting that expresses the feeling of movement, not of detail.

glaze A transparent wash of color over another color, modifying the underlying color.

gouache French term for opaque, permanent watercolors. Designer's colors usually are called gouache. The binder is gum arabic, the same as with transparent watercolor. In England, known as body color.

gradation (graded or gradated wash) Any gradual change in hue or value.

granular wash A wash made with pigments that settle out, creating a textural pattern on rough paper.

ground The surface on which a painting is done.

gum arabic A natural gum material from the acacia tree, used as a binder in making transparent watercolor paints.

hard-edge painting See **edges, hard.**

harmony Pleasing effects; balanced relationships in a painting, creating a sense of unity.

high-key painting The use of light values in a painting, making a pale or pastel image.

highlight A spot of the highest or lightest value on a subject in a painting.

high surface A very smooth surface on paper.

horizon line An imaginary line that runs across a painting from left to right, and shows the place where sky and earth come together.

hue The name of a color, such as red, orange, blue, etc.

illumination An effect caused by a light source.

impressionism A style of painting that features quick glimpses of the subject, and often shows the momentary effects of light on color.

informal balance The arrangement of elements in a painting without using bilateral symmetry. See **asymmetry.**

intensity The strength, brightness or purity of a color; its **chroma.**

intermediate colors Colors made by mixing neighboring primary and secondary colors on the color wheel; for example, mixing red and orange to get red-orange.

juicy Describes paint that is liquidy, succulent and workable. Might also describe the quality of a painted surface.

juxtaposition In painting, the close placement of colors or forms, side by side.

key The dominant tone or value of a painting; high-key (light), medium-key or low-key (dark).

landscape A painting that emphasizes the features of the natural environment.

lay in To apply paint in large, broad strokes; the first steps of painting.

lift To take out or remove unwanted pigment in a watercolor. Lightening values and colors by sponging, scraping or scrubbing.

light source The place from which light appears to originate, as shown by cast shadows and highlights.

limited palette Selection of a small number of colors for a painting.

line An element of design that is a continuous mark made by a pencil or brush. The contour or edge of a shape.

linear Having to do with lines. A painting that contains much line work is said to have a linear quality.

linear perspective A system of painting to create dimension on a flat surface. All parallel lines moving backward into the distance are drawn to one or more imaginary vanishing points on the horizon.

linkage Connecting areas of the same or similar value in a painting.

liquid mask A liquid frisket (stencil) used to block out areas in watercolor paintings; can be removed by rubbing with fingers or an eraser. Produced under a variety of trade names, such as Miskit, Maskoid, etc.

local color The color of an object seen in natural light, without reflected colors and shadows.

location painting Painting done on location, from the natural landscape.

lost and found A painting quality in which lines and edges fade or blend into each other, and then reappear.

low-key painting Using the darker part of the value scale; likely to be subdued and moody.

luminosity A radiant glow of light in a painting; evident when white paper glows through a wash.

masking tape A paper adhesive, pressure-sensitive tape that can be removed without damaging the painting.

mat Heavy paper or board used to frame watercolors when placed under glass.

mat board The board used to mat paintings.

medium Material used to make paintings, such as watercolor, acrylic, etc.

middle ground The middle-distance area in a painting, between foreground and background.

middle-key The middle values on a value scale (as opposed to high-key and low-key).

mingle To blend watercolor pigments without excessive mixing on the paper or palette.

Miskit See **liquid mask.**

mixed media Two or more media used in one painting, such as combining gouache and transparent watercolor.

monochromatic Refers to painting done in variations of a single color.

motif The main idea or theme in a painting. Also, a repeated design or pattern.

movement See **direction.**

narrative painting Painting that tells or suggests a story.

naturalism Realism in painting, not influenced by distortion, personal feelings or romanticism. How things actually look.

negative space The space in a painting not occupied by subject matter, but still used as part of the overall design.

negative painting A watercolor painting technique in which the artist paints around and behind an object, allowing it to stand out.

neutral In color mixing or pigments, refers to beiges, tans, puttys, etc.; color mixes that have no color identification with spectrum hues.

neutralize To alter the intensity of a hue by mixing its complement with it.

nonfigurative Without figures. Sometimes refers to nonrepresentational.

nonobjective painting Painting that has no recognizable subject matter. Also called **nonrepresentational** painting.

nuance The quality of subtle variation in color or value.

objective In painting, showing the subject as it appears to the artist. Representational.

one-point perspective Perspective in painting that has only one vanishing point. Painting objects that are perpendicular to one's line of vision.

opaque Opposite of transparent; not allowing light to pass through.

optical mixing Placing one color next to another so the eye mixes them and sees them as a single intermediate hue; also seen when one color shows through a transparent glaze of another color.

organic Refers to free flowing lines or free-form shapes. The opposite of mechanical or geometric lines or shapes.

overlapping One object placed in front of another to show depth; also laying one color wash over another.

overpainting Color applied on top of another color.

painterly Appearing free in style or technique. The quality of a painting that allows brush marks to be seen on the painting's surface.

palette The colors an artist chooses to work with. Also the box and surface on which colors are stored and mixed.

passage Connecting shapes of equal value in a painting, producing visual movement. See also **linkage.**

pattern A principle of design in which shapes, lines or colors are repeated at regular intervals.

perspective A way to show three-dimensional forms on a flat paper surface.

photorealism A type of painting in which the objects look so real that the painting looks like a photograph.

picture plane The imaginary plane, like a sheet of glass, at right angles to the viewer's line of vision, on which an image is positioned. It is not the actual surface of the paper.

pigment Coloring matter, suspended in a liquid (water); colorant applied to the paper surface; powdered coloring matter.

polychrome Many colors, rather than one or two; multicolored.

portrait A painting of a person, usually three-quarter or full length, but also can be a bust, showing only shoulders and head, or only a face.

positive space The area containing the principal subject matter in a composition.

primary colors The hues from which all other spectrum colors can be mixed; red, yellow and blue.

properties of colors Hue, value, intensity and temperature.

proportion A comparative size relationship among several objects or between several parts of a single object or person.

quire Twenty-five sheets of paper.

radial balance Composition based on a circle, with the elements radiating from a central point.

rag Archival quality watercolor paper made only from cloth fragments.

raw color Color straight from the tube, unmixed and undiluted.

realism Painting things just the way they look.

receding colors Cool colors, which seem to move back in a painting. Warm colors seem to move forward.

reflected color Color on an object that is influenced by the colors of adjacent objects.

render To make a detailed and accurate painting. Also, to draw or paint a given subject with great detail.

repetition Recurrence of nearly identical elements to enhance a composition.

representational painting Painting in which the artist wishes to show what he or she sees. Also called **objective painting.**

resist A painting technique that relies on the fact that wax or oil will resist water, causing color washes to puddle in clean areas.

rhythm A principle of design that relates to a type of movement in a painting, often created by repeated shapes or colors.

rice papers Japanese handmade papers of different textures, sizes, weights and colors. Used for printmaking, watercolor and collage.

rough A quick, incomplete sketch, used to explore ideas. Also, a type of watercolor paper that has a textured surface.

sable brush A watercolor brush made of Kolinsky, a Siberian mink. This highest quality brush is expensive, has good "spring" and comes to a fine point.

saturation Also called **intensity** or **chroma.** The measure of brilliance and purity of a color.

scrubbing Applying paint with a brush in a back-and-forth rubbing motion. Also a technique for lifting dry watercolor from a paper surface.

scumbling A technique of applying a thin layer of paint using a pushing or thrashing movement of a brush on paper.

seascape A painting that features some part of the sea as its subject.

secondary colors Orange, green and violet. Made by mixing two of the primaries in equal amounts.

sedimentary color A watercolor with somewhat opaque pigment; it settles in granular washes.

semi-transparent Slightly transparent.

shade A low-valued color mixture, made by adding black to a hue.

shape An element of design that is an enclosed space, having only two dimensions. Can be geometric or organic.

silhouette A flat shape in profile, usually of one value.

simultaneous contrast The apparent change in hue, value or intensity created by adjacent colors.

size A gel used to seal the surfaces of papers. Also called **sizing.**

size perspective Creating the illusion of distance by making similar-sized objects (trees or telephone poles, for example) diminish in size as they recede in space.

space An element of design that indicates areas in a painting (positive and negative). Also, the feeling of depth in a two-dimensional painting.

spectrum Bands of colored light created when white light is passed through a prism. Also, the full range of colors.

split complement A color scheme using three colors: one color and the two colors on each side of its complement.

stain A strong transparent colorant, that absorbs into the paper and is difficult to lift. Staining colors are powerful tinting agents.

stencil Any material that masks certain areas and allows color to be applied to the open areas.

stipple A texture made of tiny dots. Also, the act of making such texture.

stylize To modify natural forms and make a representation in a certain predetermined manner or style.

structure See **composition.**

subjective color Color the artist chooses to use, without regard to the actual colors of the objects being painted.

sumi-E Japanese brush painting with ink or watercolor.

superrealism A style of painting that emphasizes photographic realism.

support The paper on which a watercolor is painted.

surrealism A style of painting in which artists show their inner thoughts. Often, the paintings contain realistic objects in unnatural settings.

symmetrical Formal balance, in which the right half of a painting is similar to the left half.

tape Any of several types of adhering material (paper, plastic, cloth) used to stick to paper. Often used as stencils or block-outs in watercolor.

temperature In painting, refers to the relative "warmth" or "coolness" of colors.

tension In composition, the visual sensation of strain or pull. The dynamic relationship between any of the visual elements.

tertiary colors Originally, tertiary colors were those created by mixing two secondary colors (green and orange, for example). Now, the term often refers to colors mixed with a primary and an adjacent secondary hue.

tetrad Color scheme based on four colors — every fourth color on a 16-unit color wheel.

texture The element of design that refers to the quality of a surface; both tactile and visual.

thumbnail A very small, rough sketch.

tight The quality of a painting that is exact, carefully detailed, and usually made with small brushes.

tint A light value of a hue, made by adding water or white to the original color.

tinting strength The power of a pigment to influence mixtures; the ability of a hue to retain its identity in a mixture.

tone Modifying a color by adding neutrals to it. Also, the relative lightness or darkness in a painting.

toned ground A thin glaze or wash put over a paper's surface prior to painting.

tooth The texture of watercolor paper.

translucent Allowing some light to pass through, but not transparent; (the quality of paper or washes, for example).

transparent Permitting light to penetrate. In watercolor, allowing the white surface of the paper or underpainting to show through applied washes.

triad Any color scheme with three colors, having some logical relationship on the color wheel.

two-point perspective The type of perspective in which objects are at an angle to the viewer, and will each have two vanishing points. Also called angular perspective.

underpainting The first paint applied to paper, to be overpainted with other colors or glazes.

unity A principle of design that relates to the sense of oneness or wholeness in a painting.

unsized Refers to paper without any sizing or filler.

value An element of design that relates to the lightness or darkness of a color or tone.

value scale The range from light to dark, including white, grays and black. Colors can also be evaluated on this scale. Value scales are usually constructed so that black = 0, and white = 10. Some scales, however, reverse these numerical designations.

vanishing point In perspective, a point or points on the horizon at which parallel lines seem to converge.

vehicle The liquid that is ground with dry pigment, and which holds it in suspension to make it paintable.

vibration A visual effect caused by placing two colors of maximum intensity and equal value side by side.

viewfinder A small cardboard frame used to isolate or frame a scene prior to painting it. Also called a **finder.**

vignette A painting with a soft, irregular outer shape, placed on a conventional, rectangular ground, leaving negative space around it.

viscosity The degree of thickness in paint.

warm colors Colors in which red, orange and yellow predominate.

wash A thin, liquid application of watercolor. A **graded wash** varies in color or value from light to dark, or dark to light. When applied over dry underpainting, a wash is often called a **glaze.**

wash out To remove a painted area of a painting by applying water and washing out the color with a sponge, brush or damp cloth.

watermedia Any paint which uses water as its medium.

wet-in-wet A watercolor technique in which color is applied to a wet surface, creating a soft effect.

worm's eye view A painting with a very low eye-level; looking up at the world.

Index